The Patrick Moore Practical Astronomy Series

Series Editor
Gerald R. Hubbell, Mark Slade Remote Observatory
Locust Grove, VA, USA

The Patrick Moore Practical AstronomySeries is a treasure trove of how-to guides for the amateur astronomer. The books in this series are written for hobbyists at all levels, from the enthusiastic newcomer to the veteran observer. They thus go far beyond more general, popular-level books in both scope and depth, exploring in detail the latest trends, techniques, and equipment being used by amateur astronomers around the world.

You will find herein a diverse list of books on constellations, astronomy catalogues, astrophotography, eclipse chasing, telescope equipment, software, and so much more. All books in the series boast full-color images as well as practical sections for putting your newfound knowledge to use, including star charts and target objects, glossaries, hands-on DIY projects, troubleshooting walkthroughs, and a plethora of other helpful features.

Overall, this series bridges the gap between the many introductory books available and more specialized technical publications, providing digestible, hands-on guides for those wishing to expand their knowledge of the night skies.

James Dire

Exploring the Universe

A Practical Guide for Hobbyists

James Dire
Bryan, TX, USA

ISSN 1431-9756 ISSN 2197-6562 (electronic)
The Patrick Moore Practical Astronomy Series
ISBN 978-3-031-65345-2 ISBN 978-3-031-65346-9 (eBook)
https://doi.org/10.1007/978-3-031-65346-9

© The Editor(s) (if applicable) and The Author(s), under exclusive license to Springer Nature Switzerland AG 2024
This work is subject to copyright. All rights are solely and exclusively licensed by the Publisher, whether the whole or part of the material is concerned, specifically the rights of translation, reprinting, reuse of illustrations, recitation, broadcasting, reproduction on microfilms or in any other physical way, and transmission or information storage and retrieval, electronic adaptation, computer software, or by similar or dissimilar methodology now known or hereafter developed.
The use of general descriptive names, registered names, trademarks, service marks, etc. in this publication does not imply, even in the absence of a specific statement, that such names are exempt from the relevant protective laws and regulations and therefore free for general use.
The publisher, the authors and the editors are safe to assume that the advice and information in this book are believed to be true and accurate at the date of publication. Neither the publisher nor the authors or the editors give a warranty, expressed or implied, with respect to the material contained herein or for any errors or omissions that may have been made. The publisher remains neutral with regard to jurisdictional claims in published maps and institutional affiliations.

This Springer imprint is published by the registered company Springer Nature Switzerland AG
The registered company address is: Gewerbestrasse 11, 6330 Cham, Switzerland

If disposing of this product, please recycle the paper.

Foreword

This delightful book offers a valuable, practical, introductory guide to astronomy for everyone. You're reading a book written by an experienced practitioner of the hobby of astronomy along with a deep understanding of the subject. You will find a clear and concise introduction to all aspects of astronomy, from how to select a telescope, to understanding why stars shine the way they do. James Dire writes in a very clear accessible and direct way, and you'll enjoy the clarity and directness of the style in this book.

Astronomy is the most accessible scientific subject that is open to everyone, no special tools are needed, but there are a growing number of more affordable instruments today than ever before, and that's part of the excitement. Once you dive into astronomy, you'll enjoy a lifetime of exploration, and there's no better place to star than with this book by Dr. Dire. While his academic credentials are excellent, Dr. Dire doesn't speak down, but across to you, as a fellow explorer of the universe. He introduces all the topics with clear language and from direct experience. This is a refreshing volume, rekindling some of the early enthusiasm I myself experienced as a newcomer to astronomer many decades ago.

It's filled with helpful clear diagrams along with excellent photographs of equipment, so that diagrams take on real life. The first chapter on telescopes is an excellent and concise review of all the features. The author dives right into the practicalities of taking photographs of the night sky with a camera, followed by an introduction to all the star map and atlas tools to guide you on your exciting journey through the heavens.

If you've ever wondered about how astronomers learn about stars from the light they emit, Chaps. 4 and 5 offer a direct introduction and it's an easy ride. Each technical aspect is clearly described in understandable terms.

Now that we have the toolkit explained, Dr. Dire dives into the two most obvious features of the sky, the Moon, and the Sun, illustrated with excellent photographs by the author using instruments he's already described. This feature makes this guide a practical introduction, showing that you can do this too.

Next he dives into "deep sky," a term used for the fainter features of the night sky like nebulae, star clusters, and even the rarities of our universe, supernovae. The chapter on planetary nebulae and supernovae are tied together elegantly, describing star death and all the features leading up to it, and how to view an array of deep sky splendors, again illustrated by the authors' fine photographs.

The beautiful images on every page help drive the reader along on an adventure that visits more famous nebulae, like Orion and others, in full color rendered by today's digital cameras. Relishing these spectacular objects encourages you, the reader, to get outside and try for yourself.

Star clusters abound in the two chapters on open and globular clusters. What is appealing here is the beautiful range and variety so well illustrated in the photographs, along with practical details of the instrument, camera, and exposure times used.

Comets hold special attention for skywatchers everywhere and this book sets sensible expectations for these often-hyped objects.

Finally, we come to wonderful galaxies, often revealed in spectacular fashion by the Hubble Space Telescope. Packed with more realistic images illustrating what is generally revealed by amateur photographs, Chap. 14 is a welcome feature. You don't need hours of processing to achieve what is shown here, and that's the appeal of this book. Spiral and elliptical galaxies abound, and you'll learn why galaxies look the way they do, again with clear explanations.

Settle back and enjoy the ride across the universe in this lovely volume, you won't regret it.

[Martin Ratcliffe has authored the Sky Show column in *Astronomy* magazine for more than 25 years.]

Salt Lake City, Utah, USA Martin Ratcliffe

Contents

1	Telescopes	1
2	Astrophotography	23
3	Star Atlases, Constellations, and Celestial Nomenclature	49
4	Light, Color, Filters, Seeing, and Transparency	83
5	Stars	97
6	The Moon	111
7	The Sun	123
8	Eclipses	133
9	Planetary Nebulae and Supernovae Remnants	149
10	Emission, Reflection, and Dark Nebulae	169
11	Galactic Star Clusters	191

viii Contents

12 Globular Star Clusters . 217

13 Comets . 241

14 Galaxies. 257

Index . 297

1

Telescopes

We do not know who invented the telescope. The first patent for one was made by Dutch eyeglass maker Hans Lippershey (1570–1619) in the year 1608. Hearing about this, Galileo di Vincenzo Bonaiuti de' Galilei (1564–1642) designed his own telescope in 1609. Using it to explore the heavens, Galileo then became the first telescopic astronomer. Galileo is known as the father of modern science and the only scientist whom this scientist is aware of, other than Tycho Brahe (Danish astronomer; 1546–1601), who is known predominantly by his first name. Today, millions of people worldwide own telescopes. Most telescopes are manufactured in Asia, Europe, and the United States. You would be hard-pressed to find a county that did not have amateur and professional astronomers with telescopes!

Telescopes can be classified into three main types: refractors, reflectors, and catadioptrics. Like those built by Lippershey and Galileo (Fig. 1.1), refractors are telescopes that use only lenses, i.e., ground glass elements used to refract light to focus distant objects for viewing.

The end of a refractor pointed toward the sky contains the objective lenses. The distance it takes for the light to reach focus is called the focal length and is usually measured in inches or millimeters (mm). Often, telescopes are referred to by their objective diameter, also in inches or mm, and a parameter called the focal ratio (sometimes called the f-number). The focal ratio is the focal length divided by the objective diameter.

$$\text{Focal ratio} = \frac{\text{Focal length}}{\text{Objective diameter}}$$

© The Author(s), under exclusive license to Springer Nature Switzerland AG 2024
J. Dire, *Exploring the Universe*, The Patrick Moore Practical Astronomy Series,
https://doi.org/10.1007/978-3-031-65346-9_1

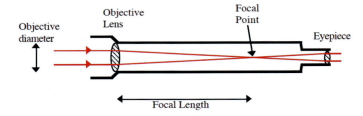

Fig. 1.1 Schematic of a refracting telescope. The eyepiece is where you look through the telescope

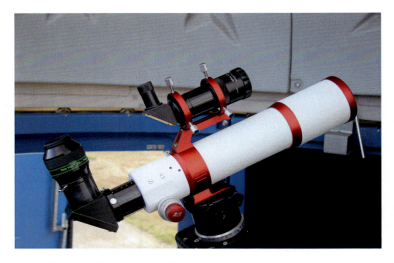

Image 1.1 A 70-mm f/6 refractor with a 50-mm right angle finder scope. The knob with the swan emblem moves the focus drawtube in and out to focus the telescope. A diagonal is attached to the end of the drawtube and contains a flat mirror to redirect the light to the eyepiece, in this case a 26-mm Televue Nagler

The focal ratio is a unitless quantity. It is typically written as f# or f/# where the number sign is replaced by the actual value of the ratio.

Image 1.1 shows a typical modern refracting telescope. The telescope has a 70-millimeter objective lens and focal ratio of 6 (f/6). Using these two numbers in the above formula, the focal length of the telescope is 70 mm multiplied by 6, or 420 mm.

Refractors require more than one piece of glass due to a property of light passing through glass called dispersion. Dispersion causes different colors of light to refract, or bend, differently as light passes through glass. This leads to an effect in refractors called chromatic aberration (Fig. 1.2). Adding a second or third piece of glass allows more colors to be focused at the same point.

1 Telescopes 3

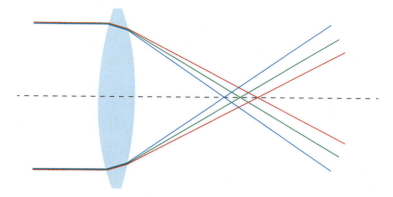

Fig. 1.2 Chromatic aberration is the failure of a lens to converge all colors at the same focal point

Image 1.2 An 8-inch f/12 achromat originally built in 1885, but refurbished in 1991. It is housed in an observatory at the US Naval Academy in Annapolis, Maryland

Early refractors, such as the one in Image 1.2, used two elements of glass in the objective. One element is diverging while the other is converging. For large focal ratios, two elements minimize chromatic aberration so that all colors appear to the eye to be in focus. Two element refractors are called achromats.

Image 1.3 The objective lens of a 132-mm f/7 APO

High-quality modern two-element refractors typically use low dispersion or extra-low dispersion (ED) glass for one or both of the objective elements to all but eliminate chromatic aberration.

Refractors that use three or more lenses, in the objective, such as the one in Image 1.3 are called apochromats. Amateur astronomers affectionately call them APOs for short. Since chromatic aberration is more severe with smaller focal ratio telescopes, three elements are needed to ensure that the entire visible spectrum is focused at the same point. APOs are more expensive than achromats since they have more glass. Likewise, apochromats and achromats cost more if ED glass is used since it is more expensive to produce.

Unlike refractors, reflectors use mirrors to collect and focus light. Reflectors usually have two mirrors. The larger mirror serves as the objective, whose main purpose is to collect light. The larger mirror is also known as the primary mirror. The smaller mirror, called the secondary, is used to redirect the light toward an eyepiece and in some cases assists in convergence of the light to a focal point. Like refractors, reflectors are known by the diameter of the objective (in this case the primary mirror) and the focal ratio.

Reflectors fall into two main categories: Newtonians (Fig. 1.3) and Cassegrains (Image 1.4). The English mathematician and scientist Isaac Newton (1642–1727) designed the first reflecting telescope in the year 1668 and constructed a working model. Newtonian reflectors use a parabolic mirror as the primary light gathering surface. A flat elliptical shaped secondary

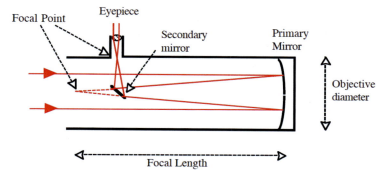

Fig. 1.3 Schematic of a Newtonian telescope. Images are viewed with an eyepiece

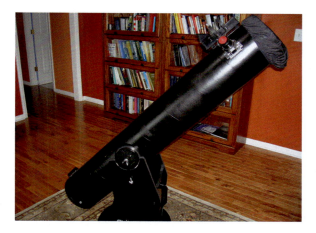

Image 1.4 An 8-inch f/7 Newtonian telescope

mirror redirects the light toward the eyepiece, which is on the side of the tube near the top.

Newtonians are simple to build and the least expensive telescope to buy per inch of aperture. Newtonians suffer from an aberration called "coma." Coma causes off-axis point sources, i.e., stars away from the center of the visual image, to have a distorted shape. The distortion increases the further off-axis (away from the center), and the stars appear in the eyepiece. Visually, coma is not too noticeable for Newtonians with focal ratios greater than or equal to 6 (like the one pictured in Fig. 1.4). It is also less apparent when using higher magnifications.

To keep the length of a telescope manageable, many Newtonians with primary mirrors 10 inches [25 centimeters (cm)] or larger are made with focal

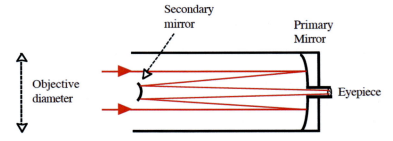

Fig. 1.4 Schematic of a Cassegrain telescope

ratios smaller than 6. This requires greater curvature in the primary mirror; thus, more coma is created. Fortunately, coma can be corrected by placing a specially designed set of lenses, called a coma corrector, between the eyepiece and secondary mirror.

Cassegrain telescopes were invented by Laurent Cassegrain (1629–1683) in 1672. Cassegrain's design incorporated a parabolic primary mirror with a hole drilled in the center. A hyperbolic secondary mirror directs the light through the hole in the primary mirror to the eyepiece.

Note that in the Cassegrain telescope, light travels the length of the tube three times. For the same focal length telescope, a Cassegrain will have a much shorter tube than a Newtonian. Like Newtonians, Cassegrains suffer from coma. Cassegrains are typically made with focal ratios of 10 or higher to minimize coma.

Today, Cassegrain's original design is known as the Classical Cassegrain. A modern one is pictured in Image 1.5. Other Cassegrain telescopes include the Ritchey–Chrétien Cassegrain, which uses a hyperbolic primary and hyperbolic secondary mirror and the Dall-Kirkham Cassegrain, which uses an elliptical primary mirror and a spherical secondary mirror. Ritchey–Chrétiens can be made with smaller focal ratios than Classical Cassegrains since they suffer much less from coma. A typical focal ratio is 8. This results in a larger secondary mirror than a classical Cassegrain as can be seen in Image 1.6. Dall-Kirkham Cassegrains typically have focal ratios of approximately 15 or larger to minimize coma.

In all reflectors, Newtonians or Cassegrains, the secondary mirror blocks some of the light from reaching the primary mirror. Therefore, for the same size objective, a refractor actually collects more light than a reflector. Mirrors are less expensive to make than lenses are. So reflectors typically cost much less than refractors. Because mirrors can be supported from behind, while lenses are supported only on their edges, refractors are not manufactured at sizes

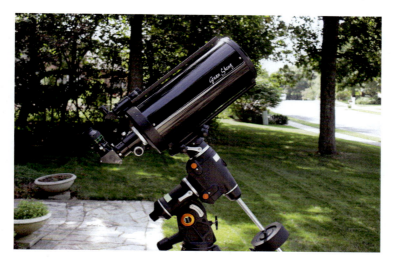

Image 1.5 An 8-inch f/12 classical Cassegrain telescope

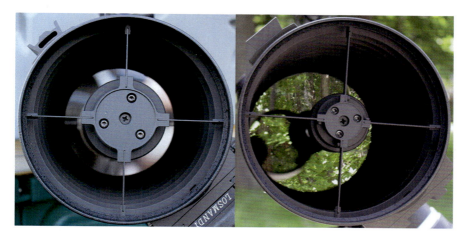

Image 1.6 An 8-inch f/8 Ritchey–Chrétien Cassegrain on the left compared to an 8-inch f/12 Classical Cassegrain on the right. Note the smaller focal ratio telescope requires a larger secondary mirror. This is true of all reflectors, Newtonians or Cassegrains

much larger than 6–8 inches (15–20 cm) in diameter. Amateur reflectors typically run 6–16 inches (15–41 cm) in mirror diameter. The largest observatory refractor ever made is the Yerkes Observatory 1 meter telescope in Wisconsin, while the largest reflector is the 10.4-m telescope at the Roque de los Muchachos Observatory on the island of La Palma, in the Canaries, Spain.

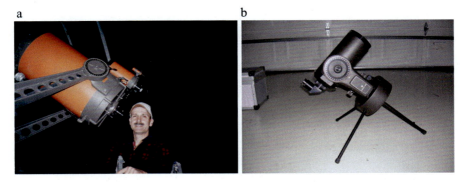

Image 1.7 (a) A 14-inch f/11 Celestron Schmidt-Cassegrain circa 2001. Sitting on top of the 14-inch telescope is a 5-inch Schmidt-Cassegrain. (b) A 4-inch f/10 Schmidt-Cassegrain with a table-top tripod. A diagonal (a flat mirror) is attached to the back of the telescope on the right to redirect the light 90° to a more comfortable viewing position

The last category of telescopes to discuss is catadioptrics. Catadioptrics are telescopes that use both lenses and mirrors. Four popular catadioptric designs are Schmidt-Cassegrains (Image 1.7), Maksutov-Cassegrains, Maksutov-Newtonians, and Schmidt-Newtonians.

By far, the Schmidt-Cassegrain is the most popular catadioptric telescope sold. The first Schmidt-Cassegrains were mass manufactured by Celestron in the 1960s, followed by similar models from Criterion and Meade in the 1970s and 1980s. The most popular size sold was the 8-inch model. Today, they can be found in 5-, 6-, 8-, 9.25-, 10-, 11-, and 14-inch primary mirror diameters. Schmidt-Cassegrains are easy to manufacture because both mirrors have spherical figures. A glass corrector plate at the top of the tube corrects for aberrations caused by using spherical mirrors. Most Schmidt-Cassegrains are made with focal ratios of f/10 or f/11, which are smaller than the focal ratios of Classical Cassegrains or Dall-Kirkham Cassegrains. Like Newtonians, Schmidt-Cassegrains suffer from coma. Many new models come with additional lenses between the secondary mirror and the focuser to correct for the coma.

Maksutov-Cassegrains are next in popularity. Maksutov-Cassegrains also use spherical primary and secondary mirrors. However, the glass corrector place is curved and has a meniscus shape. This design yields a much larger focal ratio than a Schmidt-Cassegrain, typically f/15. They are commonly sold in sizes ranging from 90 to 180 mm.

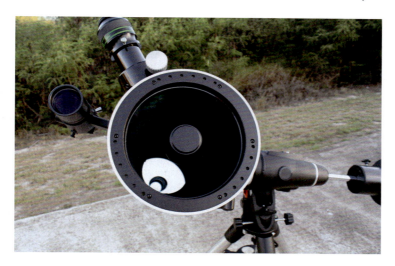

Image 1.8 A 190-mm f/5.3 Maksutov-Newtonian reflector

Maksutov-Newtonians have a spherical primary mirrors and flat secondary mirrors. A glass corrector plate corrects for aberrations in the spherical mirror. One is pictured in Image 1.8. Maksutov-Newtonians suffer little from coma even at their fast focal ratios, typically approximately f/5. They are not sold in very many sizes and can currently be found with 6-inch and 190-mm diameter objectives.

Schmidt-Newtonians are configured like Maksutov-Newtonians. The primary mirror is spherical while the secondary mirror is flat. The difference is the location of the corrector plate. On a Maksutov-Newtonian, the corrector plate is located inside of the primary mirror's uncorrected focal point. On a Schmidt-Newtonian, the corrector plate is located outside of the uncorrected focal point of the primary mirror. No company today currently manufactures Schmidt-Newtonians, although some were manufactured by Meade Instruments earlier this century and may be found in the used telescope marketplace.

At the back end of the telescope, a removable set of lenses called the eyepiece is used. The eyepiece is where you look at the image captured by the objective. The eyepiece also works with the objective to magnify the image. Each eyepiece has a focal length. To calculate the magnification delivered by the telescope-eyepiece combination, the focal length of the eyepiece is divided into the focal length of the telescope. Care must be taken to ensure both numbers are in either inches or mm before performing the calculation.

$$\text{Magnification} = \frac{\text{Objective focal length}}{\text{Eyepiece focal length}}$$

Recall the telescope in Fig. 1.1 had a 420-mm focal length. In the image, it has a 26-mm focal length eyepiece. So the magnification would be 420/26 = 16. Typically, magnification is displayed as a number followed by an "x." Therefore, we would say the magnification is 16×. While the focal length of a telescope is fixed, the eyepiece can be swapped out for another with a different focal length. A 5-mm eyepiece in the same telescope would yield 84×. This eyepiece would be better for viewing the rings of Saturn since Saturn is so far away and tiny in the 26-mm eyepiece. However, 16x might be better viewing the Andromeda Galaxy (Image 1.9) with its two satellite galaxies in the same field of view, since it spans the width of five full moons.

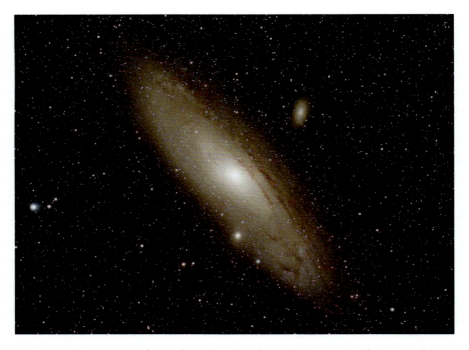

Image 1.9 The Great Andromeda Galaxy (M31). In this image, north is up and east is to the left. All celestial photographs contained in this book will have the same orientation unless noted otherwise. This image was captured with a William Optics 61-mm f/5.9 APO using a SBIG STF-8300C CCD camera. The exposure was 40 min. M31 has two small satellite galaxies. One is M32, which looks like a bright star below the core and on the edge of M31 above. The other is M110, above and to the right of M31

As you might guess, a long focal length telescope will provide a greater magnification with the same eyepiece than a short focal length telescope. Most astronomers have numerous eyepieces of varying focal lengths so that different magnifications can be used. There is a limit to the maximum useful magnification for a telescope. To calculate the limit, multiply the objective diameter in inches by 50, or the objective diameter in millimeters by 2. These calculations are approximate and depend on the quality of the telescope and eyepiece optics, and the atmospheric conditions when observing.

Magnification is only one of three important properties of a telescope system. Many would argue that it is the least important. Light gathering power is usually considered the most important factor. Light gathering power is essentially the area of the objective, either the lens for a refractor or the primary mirror for a reflector that collects light. The area (A) is calculated by the formula $A = \pi\, r^2$, where "r" is half the diameter (i.e., the radius) of the telescope's objective. Recall reflectors have secondary mirrors that block some of the area on the primary mirror from receiving light. So to calculate the light gathering power, the area blocked by the secondary mirror assembly must be subtracted from the area of the primary mirror.

Consider a 3-inch versus a 6-inch refractor. The ratio of their diameters is 2:1. But the 6-inch has four times greater area than the 3-inch telescope. Therefore, it has four times the light gathering power. Size does matter!

The final property of a telescope is resolving power. Resolving power is related to how close together two stars can be to each other, and the telescope splits them into two distinct stars. The resolving power is directly proportional to the diameter of objective of a telescope. The larger the diameter of the objective lens or mirror is, the better the resolution. Resolving two close stars also depends on atmospheric turbulence or twinkling. The more twinkling, the further apart two stars can be, and no telescope can resolve them since they get blurred together. The average atmospheric turbulence for a telescope at sea level limits resolution to that of a 5-inch telescope.

Note the spikes coming off of the brightest stars in Image 1.10. These are caused by diffraction of starlight on the vanes holding the secondary mirrors on Newtonian and Cassegrain telescopes (see Image 1.6). Diffraction spikes can hinder resolving close-together stars. Curved vanes (Image 1.11) can reduce the effect of diffraction. However, refractors typically resolve better than reflectors.

Eyepieces (Image 1.12) are just as important as telescope optics for obtaining excellent views of celestial objects. Early eyepieces had only two to three elements of glass in them. Their designs included names such as Ramsden, Erfle, Huygen, Kellner, König, and Orthoscopic, to name a few. Many of

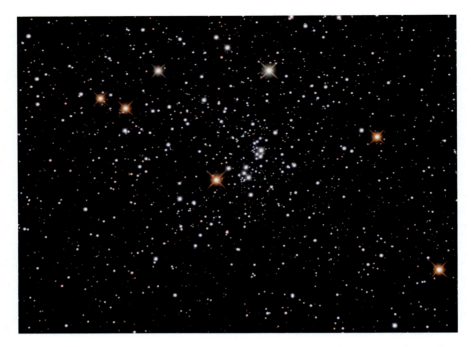

Image 1.10 Star cluster NGC884. The image was taken using an 8-inch f/8 Ritchey–Chrétien Cassegrain with a Televue 0.8× focal reducer/field flattener yielding f/6.4 using a SBIG ST-2000XCM CCD camera. The exposure was 30 min

them, especially shorter focal length models, had very small diameter lenses, making it difficult to center an eye over it in the dark.

In the 1980s, Plössl eyepieces started showing up everywhere and became very popular. Plössls provided a then large 50° or more apparent field of view (FOV). With high-quality glass and lens coatings, Plössls provide high-contrast, symmetric views. They are still made and sold today. Many eyepieces today contain six or seven elements and have apparent fields of view ranging from 70° to 120°. This is provided by the high-quality, large-diameter lenses they contain.

The apparent field of view is how far an eye would have to rotate to move from one edge of the field of view in the eyepiece to the other edge. The true field of view of the sky visible in an eyepiece depends on the magnification it provides and its manufactured apparent field of view. The formula is:

$$\text{True field of view} = \frac{\text{Apparent FOV}}{\text{Magnification}}$$

Image 1.11 Some Newtonians use curved vanes to hold the secondary mirror to eliminate diffraction spikes

Consider a 20-mm eyepiece with an 82° field of view used in a 1000-mm focal length telescope. The eyepiece delivers a magnification of 50× (1000/20). The true FOV in the eyepiece is 1.64° (82/50). In other words, the view in the eyepiece spans 1.64° of the sky.

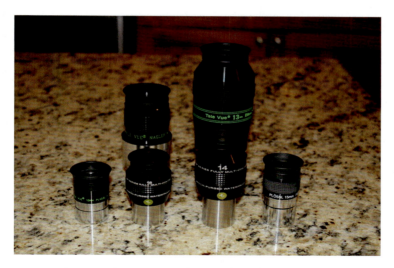

Image 1.12 A selection of eyepieces. Back row L-R: 5-mm 82° FOV and 13-mm 100° FOV eyepieces. Front row L-R: 15-mm 50°, 16-mm 68°, 14-mm 82°, and another 15-mm 50° FOV eyepieces

Another important eyepiece property is eye relief. Eye relief is the distance from the last surface of the eyepiece lens (the surface closest to your eye) to where the image is formed. Eye relief is usually expressed in millimeters. If the eye relief is too small, the eye cannot get close enough to see the image. Larger eye relief is better, especially if glasses are worn. If the eye relief is too large, it may be difficult to center one's eye over the center of the eyepiece, especially in the dark.

Finally, another factor to consider when selecting an eyepiece is the exit pupil. The exit pupil is the diameter of the light cone exiting the eyepiece and is usually expressed in millimeters. The exit pupil is calculated from the eyepiece focal length and the telescope's focal ratio:

$$\text{Exit pupil} = \frac{\text{Eyepiece focal length}}{\text{Telescope focal ratio}}$$

Functionally, the exit pupil provides an indication of the brightness of an object in the eyepiece. The recommended telescope/eyepiece combinations depend on the objects being viewed. A sample table appears below:

Table 1.1 Recommended exit pupils for various objects

Target	Exit pupil
Large star clusters, complete lunar disk	3–5 mm
Small deep-sky objects (especially planetary nebulae and smaller galaxies), double stars, lunar detail, and planets on nights of poor seeing	2–4 mm
Double stars, lunar detail, and planets on exceptional nights	0.5–2 mm

A discussion on telescopes would be incomplete without talking about telescope mounts. Since the sky appears two-dimensional, i.e., all objects appear to be located on the inside of some grand celestial sphere; telescope mounts need to have two axes to be able to point anywhere on the celestial sphere. The two mount types commonly in use are altitude-azimuth (alt-az for short) and equatorial.

Like the ones pictured in Images 1.13, 1.14, and 1.15, alt-az mounts can rotate in altitude from 0° to 90°. They also rotate 360° around a vertical (azimuthal) axis. Many slew by hand while others have motors on each axis, which can be controlled with a handheld keypad, smart phone, tablet, or computer.

Image 1.13 14-inch f/6 truss tube Newtonian. This type of alt-az mount is called a Dobsonian after its inventor, amateur astronomer John Dobson (1915–2014). The box that holds the primary mirror (called the rocker box) has the altitude (vertical plane) bearings. The azimuthal (horizontal plane) bearings sit on the platform which rotates 360° in azimuth. When properly balanced, slewing (moving the telescope to point at different objects) is easily performed manually by grabbing the top of the telescope

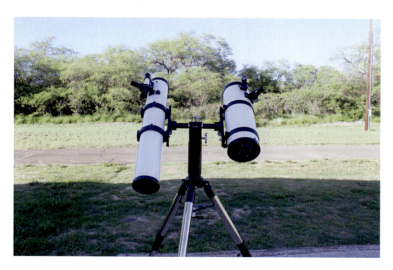

Image 1.14 114-mm f/10 and 6-inch f/4 Newtonians on a simple alt-az mount. The knob on top of the pier extension locks the altitude axis while the knob on the side of the pier locks the azimuth axis

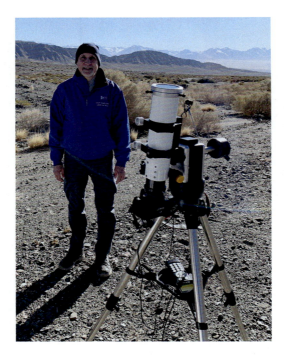

Image 1.15 A motorized alt-az mount is used with a 70-mm f/6 refractor to photograph the 2019 total solar eclipse in the Andes Mountains near Bella Vista, Argentina

The two axes allow alt-az mounts to point anywhere in the sky. However, pointing to objects near the zenith (straight up) is difficult, especially for manually operated mounts. Amateur astronomers refer to the region around the zenith as Dobson's hole and do not attempt to view objects there. Since the Earth rotates around its axis 15° every hour, objects in Dobson's hole will be reachable after waiting an hour or two.

Equatorial mounts also have two rotational axes. The mounts must be aligned so one axis is parallel to the Earth's spin axis. The method to achieve such is called polar aligning the mount. This axis is called the right ascension (or polar) axis. Motion around this axis slews the telescope east or west along the celestial sphere. The other axis is called the declination axis. The declination axis is perpendicular to the right ascension axis. Motion around the declination axis moves the telescope north or south.

One type of equatorial mount is called a fork equatorial mount. The telescopes in Image 1.7 are on fork-equatorial mounts. The two arms attached to the sides of the optical tube assembly (OTA) make up the fork. Both arms are

parallel to the right ascension axis and point toward a celestial pole, in this case, the north celestial pole. The bearings on the side of the OTA, where the fork arms attach, allow for rotation around the declination axis. In the image, note the small metal counterweights underneath the OTA near the open end of the tube. It is important for the telescope to be balanced around the declination axis. Counterweights need to be adjusted if cameras, spectrographs, or other instruments are attached to the telescope.

In looking at the mounts in Image 1.7, one can see that if the telescope were pointed at or near the celestial pole, the eyepiece would be in the middle of the fork. It would be difficult to reach for viewing. Similar to alt-az mounts not being great for objects near zenith, fork mounts are not good to view objects near the celestial pole when used with refractors or Cassegrain telescopes. One's head cannot reach the eyepiece when it is inside the fork.

Some alt-az mounts also attach to telescopes with a fork arrangement. Whether used on an al-az mount or equatorial mount, some smaller, lightweight amateur telescopes use a single-arm fork instead of a two-arm fork. This saves on the overall weight of the instrument for transport and setup. However, can it truly be called a fork if it only has one arm? The manufacturers seem to think so!

The other popular equatorial mount (Image 1.16) is the German equatorial mount (GEM). This design is attributed to the Bavarian physicist and

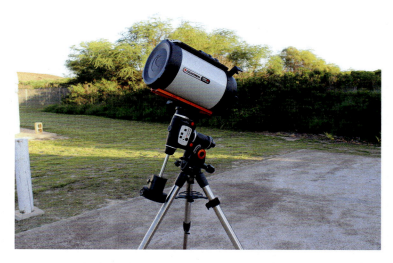

Image 1.16 A typical German equatorial mount with a built-in polar alignment scope set up at latitude 22°N. If much closer to the equator, the telescope and counterweight would exert too much torque on the north side of the mount and the counterweight shaft might hit the north tripod leg

telescope maker Joseph Ritter von Fraunhofer (1787–1826). He invented this mount in the early nineteenth century. The first one appeared with the Great Dorpat refractor in 1824. This telescope was the first modern achromat and had a diameter of 9.6 inches (24 mm). It was housed in a then-new observatory in Tartu, Estonia.

German equatorial mounts also make use of right ascension and declination axes. Therefore, the right ascension axis must be polar aligned. For manually slewed telescopes that have no drive motors, the polar alignment need not be perfect. If the mount has a latitude scale readout, it just needs to be set to the observer's latitude with the polar axis oriented north (or south if in the Southern Hemisphere). German equatorial mounts do not work well at or near the equator. Near the equator, alt-az mounts should be used!

Some GEMs have built-in polar alignment scopes that work wonderfully if the celestial pole is visible from the setup location. Some GEMs with computerized hand controllers may have polar alignment routines built into the firmware that also make it simple to align the polar axis. When properly polar aligned, a motor is required only on the right ascension axis to track a celestial object as the Earth rotates. However, declination motors are useful for slewing to objects, especially with software that can slew a telescope to any object called up. For this reason, all but the very basic models use motors on both axes.

Images 1.2, 1.5, 1.8, and 1.16 all show German equatorial mounts. The distinct characteristic of GEMs is that the counterweight shaft holding a large weight to balance the mass of the optical tube assembly (OTA). The counterweights can be moved up or down the shaft to accommodate varying mass telescopes. The counterweight shaft points along the declination axis and is perpendicular to the right ascension axis.

There is a maximum size where GEMs are usable. The largest commercially available GEMs can hold payloads in excess of 400 pounds (180 kg). This limits the size of telescopes on GEMs to about 1 meter (40 inches) in size. Telescopes larger than 1 meter typically use alt-azimuth mounts. There are exceptions found in older observatories. Most use fork equatorial mounts such as the 200-inch Hale telescope at Mount Palomar.

At this point, the reader has probably come to understand all the options in the telescope and mount designs; there is no "best" type of telescope system. Otherwise, there would not be so many variations and sizes sold. The choice of a telescope depends on the intended use, type of objects studied, and ability of the user to set it up in the field and find targets.

Below, I list some points to consider when choosing a telescope system.

Achromat Refractors

- Less expensive than triplet refractors.
- Very portable.
- Suffer from chromatic aberration (CA) and field curvature (the larger the focal ratio the less these are a problem).
- Models with low dispersion glass are more expensive but have reduced CA.
- Excellent for viewing planets, the Moon, and resolving double stars.
- Only come in small aperture sizes usually 3–6 inches—does not bring out fainter galaxies and nebulae.
- Eyepiece height varies significantly with pointing elevation for long focal length instruments.
- Suffer from field curvature, especially low focal ratio models (< f/7).
- May require dew management in locations with high humidity.

Apochromatic Refractors

- Very portable.
- Very good color correction, especially models with low dispersion glass.
- Excellent for viewing planets, the Moon, and resolving double stars.
- Can be used visually or for astrophotography.
- Only come in small aperture sizes usually 3–6 inches—does not bring out fainter galaxies and nebulae.
- Eyepiece height varies significantly with pointing elevation for long focal length instruments.
- High cost per inch of aperture.
- Suffer from field curvature, especially low focal ratio models (< f/7).
- May require dew management in locations with high humidity.

Newtonians: Equatorial Mounts

- Lower costs per inch of aperture than other designs.
- Bulkier to handle than small refractors.
- Tube has to be rotated when slewing around to get eyepiece to good viewing location.
- Great for deep-space objects (galaxies, nebulae, and star clusters).
- Not as good as refractors for planets and double stars due to diffraction caused by the secondary mirror assembly and spider (vanes that hold the secondary).

- Can use active cooling for primary mirror.
- Dew not as big a problem as with refractors and catadioptric designs.
- Fast focal ratios (< f/6–7) have very noticeable coma.
- Equatorial mounts may be heavy for large-diameter primary mirrors.
- Not usable close to the equator or poles.
- Schmidt-Newtonians and Maksutov-Newtonians will require dew management on corrector plates in high humidity.

Newtonians: Alt-Azimuth Mounts

- Lowest costs per inch of aperture than other designs—can get large aperture telescopes inexpensively.
- Bulkier to handle than small refractors and Cassegrains.
- Eyepiece usually in a good viewing location when slewing around.
- Great for deep-space objects.
- Not as good as refractors for planets and double stars due to diffraction caused by secondary and spider.
- Can use active cooling for primary mirror.
- Dew is not as big a problem as with refractors and catadioptric designs.
- Fast focal ratios (< f/6–7) have very noticeable coma.
- Must stand or use ladder when viewing near zenith and kneel or sit on a chair or ground when viewing near horizon for large Dobsonians.
- Hard to find objects in Dobson's hole (above 75° altitude).
- Large models may be very heavy to move around and transport.

Cassegrains

- Compact design.
- Long focal lengths/high magnifications.
- Easy to access eyepiece (except when eyepiece is between arms on fork mount).
- Narrow fields of view.
- Suffer from coma (Classical Cassegrains).
- Can use active cooling for primary mirror.
- Shorter focal ratio designs suffer from field curvature.
- Excellent for deep-space objects.

Schmidt-Cassegrains

- Compact design.
- Long focal lengths/high magnifications.
- Easy to access eyepiece (except when eyepiece is between arms on fork mount).
- Narrow fields of view.
- Image shift when primary mirror moves for focusing—collimation issues.
- Suffer from coma (except coma-corrected models which are more expensive).
- Long cool-down times due to enclosed OTA.
- Can use active cooling for primary mirror.
- Schmidt-Cassegrains will require dew management in locations with high humidity.

Maksutov-Newtonians and Schmidt-Newtonians

- Tube has to be rotated to get eyepiece to good viewing location when slewing around.
- Great for deep-space objects (galaxies, nebulae, and star clusters).
- As good as refractors for planets and double stars.
- Can use active cooling for primary mirror.
- Heavier than same mirror-size classical Newtonians.
- More expensive per objective size than other reflector designs.
- Will require dew management in locations with high humidity.

2

Astrophotography

Not only astrophotography but almost all photography today is done with digital cameras. An example is pictured in Image 2.1. Digital cameras use one of two types of imaging sensors: a CCD and CMOS (Image 2.2). CCD is an abbreviation for **c**harged **c**oupled **d**evice, whereas CMOS stands for **c**harged **m**etal **o**xide **s**emiconductor. Both CCD and CMOS chips have rows and columns of metal oxide semiconductors, each of which is referred to as a pixel. When light strikes these pixels, an electric charge builds up whose strength is proportional to the amount of light absorbed. The amount of charge on each pixel can then be read and converted into a digital value.

The main differences between a CCD and CMOS sensor are how the pixels are exposed to light and how the pixels are read. The details are beyond the scope of this book. CCD sensors tend to have lower thermal noise and a greater dynamic range. However, CCD sensors consume up to 100 times more power than the equivalent CMOS sensors and are more expensive to make. There is no consensus as to which are better CCD or CMOS sensors. Both are found widely produced by various camera manufacturers.

The simplest astrophotography can be performed with a cell phone camera, a point-and-shoot camera, or a digital single-lens reflex (DSLR) camera. Most cell phones have decent cameras. But the apertures are small and the focal lengths are short. Point-and-shoot cameras typically have larger objectives and longer focal lengths. Some point-and-shoot cameras have sight-through-the-camera viewfinders, while others display the image on a screen before and after exposing an image. The control of exposure and shutter speed is very limited in cell phones and point-and-shoot cameras.

© The Author(s), under exclusive license to Springer Nature Switzerland AG 2024
J. Dire, *Exploring the Universe*, The Patrick Moore Practical Astronomy Series,
https://doi.org/10.1007/978-3-031-65346-9_2

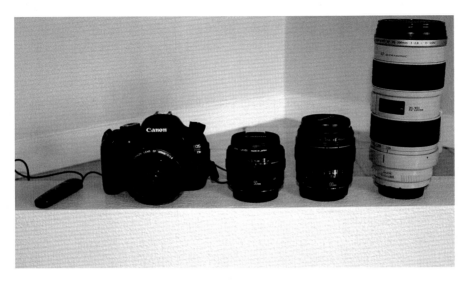

Image 2.1 DSLR camera with cable release remote, along with 50 mm f/1.4, 100 mm f/2, and 70–200 mm (a.k.a. zoom) f/2.8 lenses

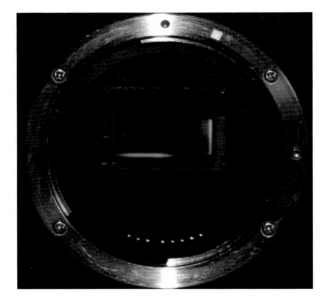

Image 2.2 During an exposure with a DSLR camera, the mirror and prism assembly flips up and out of the way and the shutter opens. This view shows the 18-megapixel CMOS chip

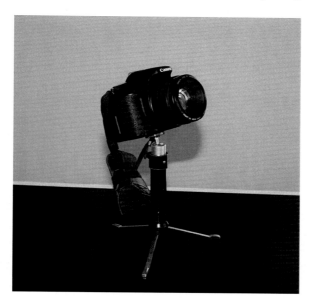

Image 2.3 Camera tripods do not have to be large or expensive for use in astrophotography. This tabletop model works well on picnic tables or on the roof of an automobile

Single-lens reflex cameras typically use a mirror and prism system to view objects to be imaged through the lens. The mirror pops up out of the way when an image is taken so that the light passing through the lens reaches the imaging sensor. DSLR cameras offer the best control of the shutter speeds and aperture size, and most of these cameras allow interchanging of lenses with different focal lengths.

Many celestial objects can be photographed with the above cameras without the use of a telescope. For extremely short exposure times, such as when a full moon is exposed, the camera can be held by hand. However, a tripod (Image 2.3) is often needed to keep the camera from moving to prevent blurring the image. The act of touching the camera to initiate an exposure can also vibrate or move the camera resulting in a blurred image. In those cases, a shutter release cable is used. Images 2.4, 2.5, 2.6, 2.7, 2.8, 2.9, and 2.10 were taken with cameras on tripods.

DSLR cameras allow shutter speeds as fast as 0.001 s to as long as 30 s. For longer exposures, the cameras typically have a bulb (B) setting where the shutter can remain open any length of time as long as the shutter release button remains depressed.

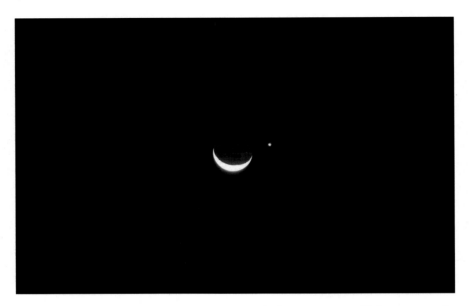

Image 2.4 The Moon and Venus were captured before morning twilight on December 7, 2015, from Kauai using a 70–200 mm zoom lens with a DSLR camera on a tripod

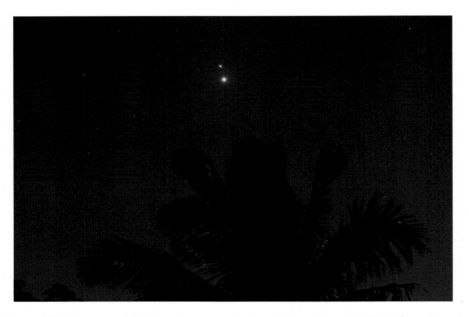

Image 2.5 Venus and Jupiter above a palm tree. Taken June 29, 2015, from Kauai using a 70–200 mm zoom lens with a DSLR camera on a tripod

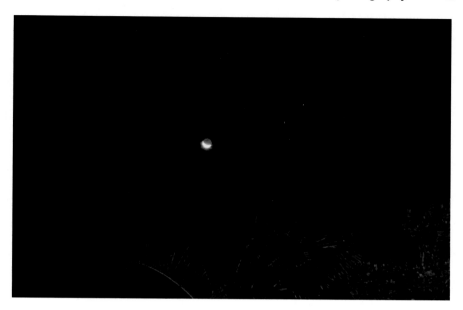

Image 2.6 The Moon, Jupiter, and Mars taken January 11, 2018, from Kauai using a 50-mm zoom lens with a DSLR camera on a tripod

Objects often shot with the abovementioned types of cameras include the Moon, the Sun, comets, and the planets when grouped with each other or the Moon. Depending on how large the field of view of the lens is, using stunning foreground objects in the image can enhance the beauty of the composition.

For exposures more than a few seconds long, stars will be elongated or show trails when shot with a camera on a tripod. This is due to the rotation of the Earth causing the stars to move from east to west in the sky. Short focal length lenses will allow longer exposures without trails than longer focal length lenses. To prevent star trails, a camera should be on a polar aligned and tracking equatorial mount.

Many companies sell star trackers for use with cameras and lenses. These can be polar aligned and can drive a light payload in right ascension to track a celestial object during an exposure. The polar alignment does not have to be perfect if the lens has a short focal length and if the exposures are not too long.

Another popular method is to attach a camera piggyback on top of a telescope, like displayed in Images 2.11 and 2.12. If the telescope is permanently installed in an observatory, it should already be polar aligned. Long-exposure imaging with a camera and lens system can capture some great wide-field images. When using a portable telescope, the polar alignment need not be perfect for wide-field images if the exposures are relatively short, i.e., a few minutes.

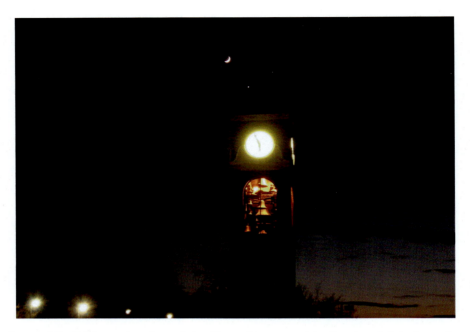

Image 2.7 Triple conjunction of the Moon, Venus, and Jupiter (on right) above the clock tower at Gardner-Webb University on December 1, 2008, at 5:55 p.m

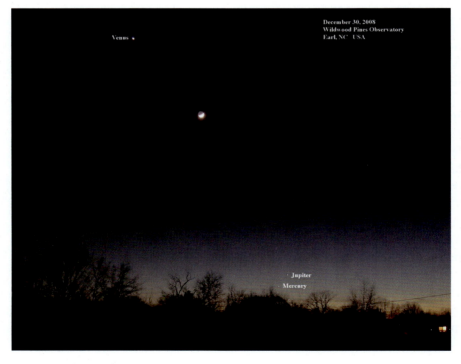

Image 2.8 Venus, the Moon, Jupiter, and Mercury are all captured in a single image with a camera on a tripod using an 18-mm wide-angle lens

2 Astrophotography 29

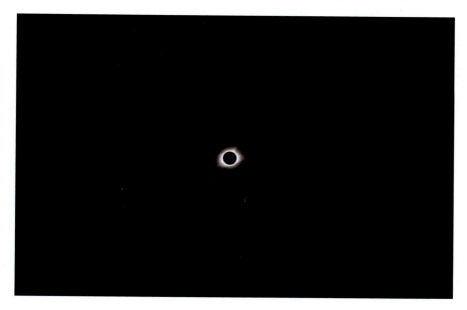

Image 2.9 The total solar eclipse of August 21, 2017, taken with a 70-mm lens at f/2.8 with a DSLR camera on a tripod. The photo was taken from where the centerline of the path of totality crossed US Highway 50, east of Jefferson City, Missouri

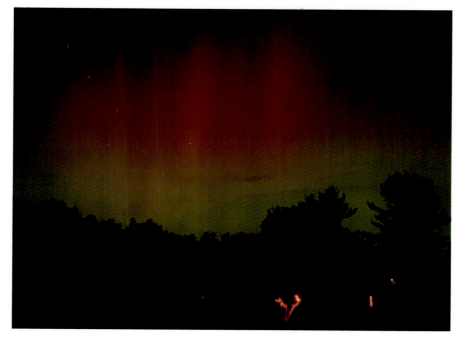

Image 2.10 The Aurora Borealis or Northern Lights captured with a few-second exposure with a DSLR camera on a tripod from Connecticut in 2002

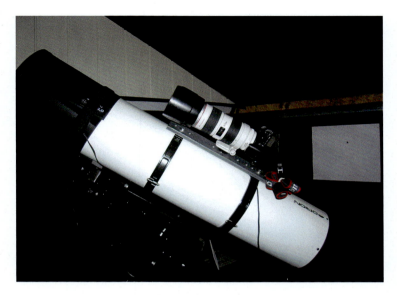

Image 2.11 A DSLR camera with a 70–200 mm f/2.8 zoom lens atop a telescope in an observatory

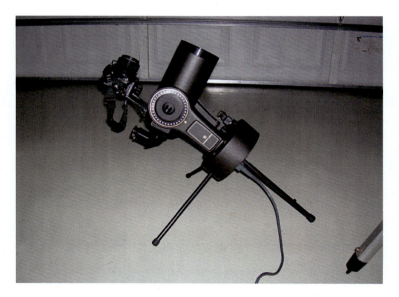

Image 2.12 This camera is piggybacked on a 4-inch Schmitt-Cassegrain telescope with a fork equatorial mount. The rightmost leg on the mount telescopes in and out to polar align the mount. The mount has a right ascension motor to track objects

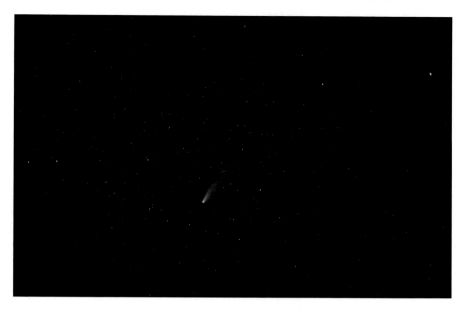

Image 2.13 Comet C2020 F3 NEOWISE shot with a 50-mm f/1.4 lens with a DSLR camera. The exposure was 30 s

Images 2.13, 2.14, and 2.15 were all taken with SLR cameras riding piggyback on telescopes with equatorial mounts. The exposures were increasing in length: first 30 s, then 5 min, and finally 2 h. The limit to the length of an exposure depends on the accuracy of the mount's polar alignment, the focal length of the lens, and the darkness of the location. In a city or suburb where there is significant light pollution, images such as these would be difficult to capture.

It is possible to take photos with a cell phone camera, point-and-shoot camera, or DSLR camera by holding the camera in front of a telescope eyepiece. This approach works quite well for taking images of the Moon or bright planets. The keys to success include centering the camera over the center of the eyepiece, holding the camera steady so as not to blur the image, and operating the shutter button without giggling the camera and blurring the image. Care must also be taken not to touch or vibrate the telescope while taking the image. If the camera has a connection for a shutter release cable, by all means use one. If not, but the camera has a shutter timer, the timer can be used to take the photo. During the 10 or so seconds, the timer ticks off; any vibration imparted to the telescope or camera will dampen out before the shutter opens to take the picture!

Image 2.14 The Leonid Meteor Shower peaks every 33 years. This 5-min exposure with a 50-mm camera lens captured two Leonid streaks during the shower's peak on November 17, 2001

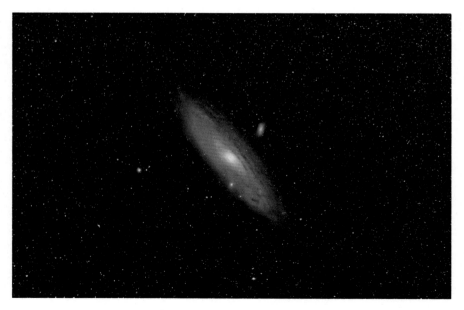

Image 2.15 The Andromeda Galaxy taken with the camera and lens shown in Image 2.9. The zoom lens was set at 200-mm f/2.8. The exposure was 120 min. This image was taken with the same equipment as Image 2.4. A comparison of the two images reveals that the Andromeda Galaxy is much larger in our sky than the Moon

2 Astrophotography 33

Image 2.16 One of myriad types of adapters to hold a small camera that has a 1/4–20 tripod screw, onto a telescope. Similar models have brackets for holding mobile phones. This one clamps around an eyepiece with two adjustments to center the camera lens in front of the eyepiece

Several companies manufacture devices that will hold a mobile phone or camera in front of a telescope eyepiece with adjustment controls to center the camera lens to the perfect spot (Image 2.16). If the camera is too heavy for one of these devices, the camera can be placed on a tripod and positioned in front of the telescope (Image 2.17). Pictures taken with one of these methods appear in Images 2.18, and 2.19.

To take long exposures of fainter celestial objects or high magnification images of the Moon, Sun, or planets, the camera must be attached to the telescope. For cameras that can be operated by such devices, the shutter should be actuated either with a cable release or using computer software.

When attaching a camera to a telescope, usually no eyepiece or camera lens is needed. The telescope essentially becomes the lens. The focal length of the telescope and its f/# are the lens settings for the images captured. Image 2.20 shows the hardware required to use with the camera. In the left picture are the camera with the lens removed, a T-ring, and two T-adapters (sometimes called noseplugs). The T-ring is specific to the bayonet mount of the camera model on one side and has standard female T-threads (42-mm diameter, 0.75-mm thread pitch) on the other side. The noseplug has male T-threads and a barrel of one of two standard eyepiece diameters: 1.25 or 2 inches. Noseplugs of

Image 2.17 Placing a camera on a tripod and positioning it in front of a telescope's eyepiece makes it possible to take short exposures of the Moon, the Sun, or bright planets. There should always be a safe solar filter over the end of the telescope tube if photographing the sun

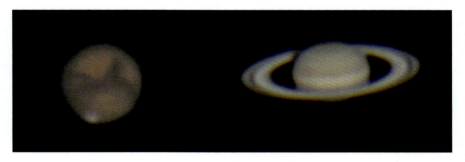

Image 2.18 Mars and Saturn each taken with a point-and-shoot camera using the device in Image 2.16 held in front of a 10-mm eyepiece on a 20-inch f/8 Ritchey–Chrétien telescope

each diameter are shown in Image 2.20. The right picture in Image 2.20 shows everything assembled. The noseplug is then inserted into the telescope's focuser in place of an eyepiece. This setup is called "prime focus" photography.

2 Astrophotography 35

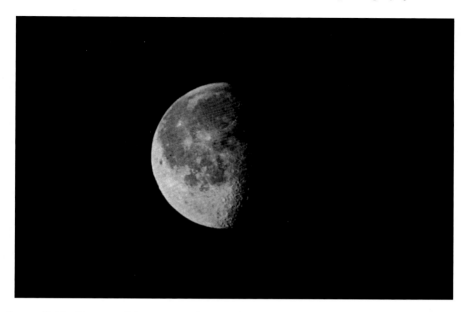

Image 2.19 Picture of the Moon taken with the setup in Image 2.17

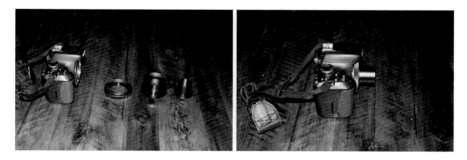

Image 2.20 Hardware for attaching a DSLR camera to a telescope

To achieve much higher magnifications for imaging planets or lunar craters, an eyepiece can be used. Image 2.21 shows how to assemble such equipment. In addition to a T-ring and T-adapter, an additional barrel is required to hold an eyepiece. This barrel has male T-threads on one side, a female T-thread on the other, and a setscrew to lock the eyepiece in place. The eyepiece must be small enough to fit inside of the barrel. The barrel fits in between the T-ring and T-adapter as shown on the right side of Image 2.21.

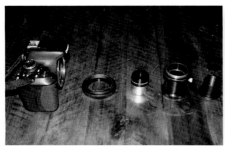

Image 2.21 Equipment for eyepiece projection

To calculate the new effective focal length, use the formula:

$$\text{Effective FL} = \frac{(\text{Depchip} - \text{FLep})}{\text{FLep}} \times \text{FLtel}$$

where

Depchip is the distance from the eyepiece to the imaging sensor in mm,
FLep is the focal length of the eyepiece in mm, and,
FLtel is the focal length of the telescope.

The new focal ratio is the new effective focal length divided by the telescope's objective diameter. For example, consider a 120-mm f/7 telescope (840 mm FL) with a 9-mm eyepiece, which is 40 mm from the digital sensor. The effective focal length is:

$$\frac{(40 \text{ mm} - 9 \text{ mm})}{9 \text{ mm}} \times 840 \text{ mm} = 2893 \text{ mm}$$

Most astrophotographers use CCD or CMOS cameras specifically designed for astroimaging. These cameras have many advantages over DSLR cameras. They can easily be computer controlled. Most have thermoelectric cooling to lower the temperature of the imaging sensor to help minimize thermal noise collected during the exposure. They can be used with narrowband filters. Some use color sensors like in DSLR cameras. Others have monochromatic sensors. Images must be taken through red, green, and blue filters to produce color pictures. These cameras, such as those pictured in Image 2.22, are superb for imaging deep-space objects.

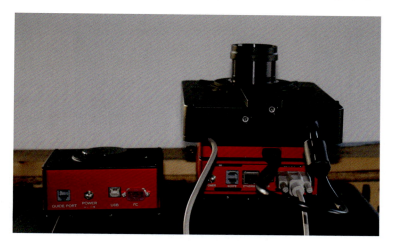

Image 2.22 Two CCD cameras with 8.3 megapixel CCD sensors, both with 2-inch noseplugs. The camera on the left has a color sensor. The camera on the right has a monochromatic sensor, thus the large filter wheel assembly on top. The filter wheel contains broadband red, green, blue, and clear filters and narrowband hydrogen alpha (656.3 nm), oxygen III (501 nm), and sulfur II (673 nm) filters

Cameras at any temperature radiate infrared energy. This infrared radiation appears as dark current (a.k.a. thermal noise) on the imaging sensors. For long exposures of faint, deep-space objects, the dark current can overwhelm the light current on an image. The colder the sensor is, the less dark current that is recorded along with the current produced by visible light from the target object. Most astronomical cameras can cool their sensors tens of degrees below ambient temperature, drastically reducing the thermal noise. The thermal electric coolers that lower the sensor temperature have heat sinks, which remove the heat from the camera with a fan.

DSLR cameras can also be used for deep-space imaging. Since they do not employ sensor cooling, they are best used in winter months when outdoor temperatures are lower. Some newer models have very low thermal noise and can be used year round. Many can be controlled with a computer using the proper cable or wirelessly.

Like most refractors and many other telescope designs, the telescopes in Images 2.23 and 2.24 suffer from field curvature, also known as Petzval field curvature (Fig. 2.1). This optical problem causes stars to appear sharp only in the center of a telescope image. Moving outward from the center of the field of view, the stars are elongated in the direction away from the center. This effect increases for stars further from the center. This is because the focusing surface is actually spherical while the imaging sensor is flat. Each camera in Image 2.23 has a field flattener set of optics between the camera and noseplug to remove this aberration. The effect of field curvature decreases with increasing focal ratios.

Image 2.23 Santa Barbara Instruments Group (SBIG) models ST-2000XCM (top) and STF-8300C (bottom) color CCD cameras. The top camera has a second chip installed for self-guiding. Note the fans on the back of each camera to remove heat from within each unit

Image 2.24 Typical astrophotography setup with an 8-inch Ritchey–Chrétien telescope with an upgraded motorized focuser and a cooled CCD camera on a permanently installed and polar aligned, high-end German equatorial mount

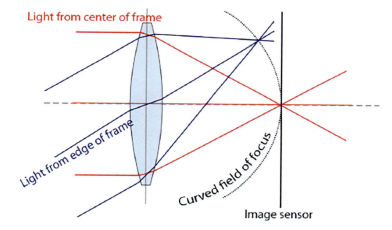

Fig. 2.1 Schematic showing the cause of field curvature in certain telescope designs

If the focal ratio of a telescope is large enough, a field flattener may not be needed. When needed, it is important to use one that is designed for the specific telescope model. The manufacturer's recommendation for the spacing between the field flattener and the imaging sensor should be maintained with appropriate spacers for the field flattener to remove all the field curvature.

There are essentially four requirements for successful long-exposure, deep-space astrophotography: a telescope with a good-quality focuser, a good sturdy equatorial mount (preferably with autoguider capabilities), a CCD or CMOS digital camera (preferably cooled to reduce thermal noise), and an autoguider. Telescopes and mounts were covered in the first chapter of this book. Cameras were covered above in this chapter. That just leaves autoguiders to be covered below.

But first, a few comments are warranted on the first two requirements. A telescope's focuser must be of sufficient quality and resolution to allow for fine focusing with the camera. Although almost any telescope can be used for astrophotography, many do not come with focusers that are conducive for photography. For this reason, many astroimagers have upgraded from stock focusers supplied with production telescopes. Some even add motorized focusers that can be controlled by a computer to adjust the focus during the course of an imaging session as the optical tube assembly responds to ambient temperature changes.

For mounts, not enough can be said to have a mount that is robust and can easily handle the payload of the telescope and camera equipment. It is not unusual to have a mount that is much more expensive than the optical tube

assembly (OTA). It is important that the mount is balanced around both axes. However, for equatorial mounts with worm gears driving the right ascension axis, the east side of the mount, whether it is the counterweight side or the OTA side, should be slightly heavier. This ensures that the worm gears stay engaged by lifting the heavier side as the mount drives the axis from east to west. This will prevent minor east-west wobbling as the gears turn which could cause stars on the image to have east-west elongation or the autoguider to have difficulties making right ascension corrections.

Guiding a long-exposure image is the act of ensuring all objects in the field of view are captured on the same pixels during the exposure without drifting. Guiding is performed to mitigate periodic errors in the right ascension drive, to prevent drift from minor polar alignment errors or orthogonal errors (i.e., the telescope and two axes are not perfectly orthogonal to each other), to prevent drift from imperfect motor tracking speed, and to prevent drift from minor telescope balance issues.

Guiding for astrophotography throughout the nineteenth and most of the twentieth centuries was performed with a second parallel telescope attached to the same mount as the imaging telescope. The astronomer would view through the guide scope with an eyepiece that had crosshairs. A star was centered on the crosshairs. Using a hand controller with buttons or a joystick, the astronomer could make minor real-time corrections to the right ascension and declination motors to keep the guide star centered on the crosshairs during the exposure. This tedious and painful method was replaced by the use of autoguiders at the end of the twentieth century.

To autoguide, a second digital sensor captures images of the star field every few seconds to track for any drift. A single star is required to look for drift, although multistar guiding can also be performed. If any drift is detected, the autoguider can send corrections to the mount through a cable connecting the two, which adjusts the mount's motors to counter the drift. An autoguider should be able to keep the guide star on the same camera pixel throughout a long exposure.

The camera in Image 2.24 has two digital sensors, both pictured in Image 2.25. The main sensor is for imaging and is found in the middle of the focal plane. The smaller sensor is used for guiding. The gray cable in Image 2.24 running from the camera to the mount allows the guiding sensor to send commands to the mount's motors. A USB cable connects the camera to a computer, which controls both digital sensors as if they were two separate cameras.

Image 2.25 The imaging and guiding digital sensors in the camera from Image 2.24 are shown on the right

Color cameras work well with a built-in guide chip. However, monochromatic cameras using narrow band filters may not have bright enough stars visible on the guide chip to perform autoguiding.

Another method for autoguiding is to use a guide scope on the mount with the imaging telescope. The camera on the guide scope need only be monochromatic with a small inexpensive sensor. Differential flexing between the two telescopes during a long exposure series could result in tracking errors. The setup would look similar to that seen in Image 2.23.

The most popular method for guiding is the use of an off-axis guider like those shown in Image 2.26. The off-axis guider has a prism that deflects some of the telescope's field of view onto a second, smaller camera for guiding. The prism does not block the part of the field of view incident on the imaging camera. Filters used for the imaging camera do not affect the guide camera. The biggest advantage of an off-axis guider is that only one telescope is required, reducing the setup cost and mount payload weight.

There is an abundance of literature on the electronics and mechanics of digital cameras, calculating proper total exposure times and subframe exposure times for various celestial objects and the processing of digital astronomical images. Readers should refer to those sources for detailed information on image data collection and processing. However, this text will outline some basic information that readers should understand before consulting more detailed documents.

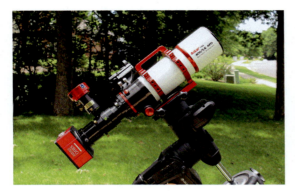

Image 2.26 Off-axis guider assembly attached to a small refractor. The inside of the off-axis guider assemble is shown on the right

Typically for digital astrophotography, four types of images are used to create a fully processed celestial image. The images are called light frames, dark frames, flat frames, and bias frames. Each type is discussed individually below.

Light frames are the images of the celestial object. The total exposure time depends on the brightness and extent of the celestial objects, the focal ratio of the telescope, and the density of the sensor's pixels. Typically, the total exposure time is divided into subframes, which are combined during the processing stages. The number and exposure length of the subframes vary according the object type, the mount's tracking accuracy, camera characteristics and operating temperature, and finally the sky darkness or amount of light pollution present.

Long exposures are at risk of being bad due to the saturation of bright stars, too much sky glow, or satellites, meteors, or airplanes passing through the frame. Combining shorter subframes allows bad frames to be tossed without losing too much time collecting images. However, too many short exposures would result in too many files to process. Moreover, each subframe might not have a sufficient signal-to-noise ratio. Most of the astroimages contained in this text used 5–10-min subframes with a minimum of six to ten subframes through each filter, or overall when a color sensor was used (Image 2.27).

Dithering light frames is beneficial. Dithering means randomly moving the camera's field of view by a few pixels between each subframe. In this way, if there are bad pixels on the imaging sensor (all seem to have some), each star falls on a different pixel for each subframe so that when they are aligned and combined, the effect of the bad pixels does not affect the final product.

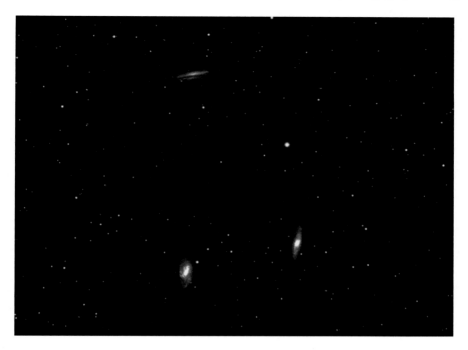

Image 2.27 One 10-min, unprocessed light frame of galaxies M67, M66, and NGC3628 taken though a 130-mm f/7 apochromatic refractor with an 8.3 megapixel CCD camera at -35 °C

Dark frames are images taken for the same length of time and at the same temperature as light frames, but with the shutter closed and telescope covered so that no light reaches the sensor. Any dark current appearing in on the dark frame (Image 2.28) is solely due to thermal noise (neglecting cosmic ray strikes). Dark frames are subtracted from light frames pixel by pixel to remove thermal noise from the light frames. A series of multiple dark frames should be taken and averaged to obtain a statistically better image of the real thermal noise before applying it to all the light frames. A library of dark frames at various exposure times and camera temperatures can be created for each digital camera for use in dark frame subtractions.

Flat frames are images of a uniformly illuminated screen or gray sky to adjust the light frames for nonuniformity in the image caused by the optics and obstructions in the optical path. Flat frames can be taken by pointing the telescope at the gray sky after sunset or before sunrise on a clear night or by pointing the telescope at a white screen that is uniformly illuminated. For small telescopes, a flat frame can be obtained using a light box placed on top

Image 2.28 A typical dark frame from a CCD camera. The speckle pattern is the thermal noise picked up by the sensor

of the telescope when pointed straight up. A large iPad with a white screen application works well for 3–5-inch refractors.

Flat frame exposures tend to be short, 0.1 s to a couple of seconds. A typical flat frame is shown in Image 2.29. The amount of signal should be close to 50% of the maximum possible pixel count for the digital sensor (for a 16 bit pixel, the maximum count is 65,535). Dark frames at the same temperature and exposure time as the flat frames must be subtracted from the flat frames before they can be used. Flat frames do not have to be taken at the same time or temperature as the image frames. A series of multiple flat frames should be taken and averaged to obtain a statistically better image for use in correcting the light frames. Flat frames need to be taken through each filter used for light frames. Image-processing software uses flat frame images to adjust all the pixel counts on the light frames to compensate for irregularities in the optical system.

Bias frames are used to account for the fact that some pixels will measure a small, random electron count (albeit a small number) before the light frame exposure starts. So to zero out all of the pixels on the chip, a bias frame is

Image 2.29 Typical flat field image. The contrast has been exaggerated. Note that the lower left side is brighter than the other regions. This is due to the OTA optics and field flattener. The large and small donuts are caused by dust particles either on the CCD camera's glass window or the filter that sits on top of the imaging sensor

taken. Bias frames are taken with the shortest possible exposure the camera can take (for the cameras pictured in Image 2.23, this is 0.001 s) with the shutter closed and the cover on the telescope, so no light falls on the chip. Bias frames should be taken at the same temperature as the light frames. The bias frame is subtracted from the light frame.

With four types of images taken with astronomical cameras, the progression for processing the images is performed in the following order:

Monochromatic Sensors

1. Subtract bias frames from light frames.
2. Perform dark frame subtraction for each light frame.
3. Perform flat field adjustment for each light frame making sure to use the proper flat taken through the same filter as each light frame (if shooting through color filters).

4. Register all images (make sure all the stars are lined up on each image before combining them).
5. Combine all the images taken through similar filters.
6. Combine all color channels to create a color image.
7. Use digital darkroom techniques to process an image to make the best picture.

Color Sensors

1. Subtract bias frames from light frames.
2. Perform dark frame subtraction for each light frame.
3. Perform flat field adjustment for each light frame.
4. Debayer all calibrated images (i.e., convert images to color).
5. Register all images (make sure all the stars are lined up on each image before combining them).
6. Combine all images to obtain a single image.
7. Use digital darkroom techniques to process images to make the best picture.

Image 2.30 shows a final processed image of galaxies M65, M66, and NGC3628. The unprocessed subframe was shown in Image 2.27. The final processed image used 12 subframes where bias, darks, and flats were applied. These images were registered and then combined using a straight average. Myriad imaging process techniques were used to produce the final image.

It is not unusual to take more time processing a deep-space image than the amount of time taken to collect all of the subframes. Digital image processing is as much an art as it is a science. It takes years to master. Raw image frames (lights, darks, flats, and bias) should be stored unprocessed. In this way as image-processing skills improve, it is possible to go back to archived raw images and try to improve on the final product!

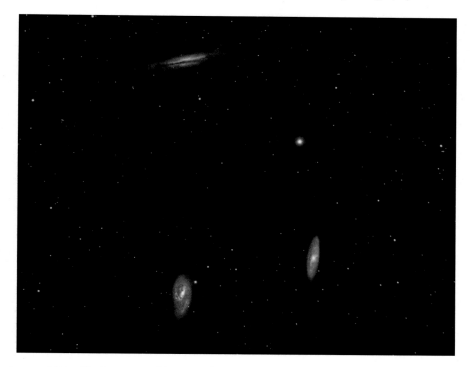

Image 2.30 Final processed image of galaxies from Image 2.25 from twelve 10-min exposures using a color CCD camera

3

Star Atlases, Constellations, and Celestial Nomenclature

The first star maps were cave drawings dated between 10,000 and 30,000 years ago. These drawings were probably used in storytelling or were purely artistic in nature. Throughout history on every inhabited continent, the stars were used in stories and mythology. Stars were also used for direction and navigation on land and in the seas. The earliest known paper atlases date back to ancient Egypt 3500 years ago.

Hipparchus, a second-century BC Greek astronomer, devised a star magnitude scale. He called the brightest stars magnitude 1. The second brightest group has a magnitude of 2, and the faintest stars visible have a magnitude of 6. From that time on, stars were denoted on charts by magnitude with the first magnitude stars drawn with the largest circles and the sixth magnitude stars with the smallest circles.

This stellar magnitude system is essentially still in effect today. Modern measurements have shown that magnitude 1 stars are 100 times brighter than magnitude 6 stars. Therefore, if five magnitudes span a brightness difference of 100, one magnitude difference is the fifth root of 100, or approximately a difference of 2.51. With the invention of telescopes and photography, we know that there are stars much dimmer than magnitude 6. Therefore, each decrease in brightness by a factor of 100 still spans five magnitudes. Magnitude 6 stars are 100 times brighter than magnitude 11 stars, and magnitude 11 stars are 100 brighter than magnitude 16 stars, with each successive magnitude group differing by a brightness factor of 2.51. It is important to remember that the smaller the magnitude number is, the brighter the object. This might seem backward, but that is the way it has been for more than 2000 years.

© The Author(s), under exclusive license to Springer Nature Switzerland AG 2024
J. Dire, *Exploring the Universe*, The Patrick Moore Practical Astronomy Series,
https://doi.org/10.1007/978-3-031-65346-9_3

50 J. Dire

There are some stars today that are brighter than the first magnitude stars, so are planets like Venus, Jupiter, and Mars, as well as the Moon and Sun. Keeping with the rule that every five magnitudes span a difference in brightness of 100, negative numbers are used to denote the magnitude of the brightest of objects in our skies. The magnitude of Sirius, the brightest star in the night sky, is −1.46.

Interested readers should consult the history of astronomy literature to discover how star atlases have evolved between Hipparchus and modern times. This text will only discuss star atlases that are still available today in print or electronic formats. However, first, a general discussion of star atlases is in order.

Surely everyone has seen a globe of the Earth. On it are the oceans and continents, usually labeled with the names of oceans, continents, countries, cities, and perhaps more detailed political divisions. At the top of the globe is the North Pole and at the bottom is the South Pole. In this orientation looking anywhere on the globe, east is to the right and west is to the left. The Earth rotates from west to east around the axis that passes through the two poles.

When looking at a globe, only half can be viewed at once. To see the other half, the globe must be rotated 180°. Most globes allow rotation around the pole-to-pole axis to simulate the Earth's rotation.

There is an east-west line surrounding the globe that divides the globe into a northern hemisphere and a southern hemisphere. This line is called the equator. Lines parallel to the equator are called latitude lines. A globe might show them every 10°. The poles are 90° from the equator so latitude lines run from 0° (the equator) to 90° north and 90° south. Degrees of latitude are divided into 60 min, of which each minute of latitude is divided into 60 s.

There are also other lines on a globe that are perpendicular to lines of latitude. These are called longitude lines. All longitude lines intersect at the North and South Poles, so they are not parallel to each other. Longitude lines are sometimes called meridians. They are labeled in degrees east or west of a reference line called the prime meridian. Sir George Airy (1801–1892), an English astronomer, first established the prime meridian in the year 1851. It passes through the Royal Observatory, Greenwich, in London, England. Meridian lines extend from 0° to 180° west or from 0° to 180° east. The meridians at 180°W and 180°E are the same line. This meridian is on the opposite side of the globe as the prime meridian. Longitude degrees are also divided into 60 min, of which each minute of longitude is divided into 60 s.

A road map, say of a US State or a European county, is a small piece of the globe. The piece is usually small enough where it can be drawn on a flat sheet and the curvature of the Earth is neglected. Latitude lines still run east-west

3 Star Atlases, Constellations, and Celestial Nomenclature

and longitude lines north-south. However, longitude lines on maps of small regions far from the poles appear to be parallel, when they really are not parallel.

The *celestial sphere* is like a globe that surrounds the Earth. Just like a globe, only half of the celestial sphere is visible at any one time. Unlike a globe of the Earth which is viewed from above, the celestial sphere is viewed from below. Therefore, east and west are reversed. Like on a globe, objects in the celestial sphere each have two coordinates to designate their positions. All of the objects in the celestial sphere are at varying distances. Since we cannot perceive those distances, we think of all of the objects as residing on this imaginary celestial sphere.

The celestial sphere (Image 3.1) also has north and south poles. These poles are located immediately above the Earth's North and South Poles, respectively. Like the globe, the celestial sphere has a line splitting it into Northern and Southern Hemispheres. This line is called the *celestial equator*. Lines on the celestial sphere parallel to the celestial equator are called *declination* (dec.) lines. They are measured by the distance in degrees from the celestial equator

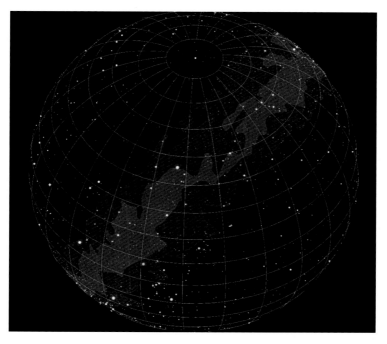

Image 3.1 The celestial sphere showing the North Celestial Pole, right ascension lines, declination lines, bright stars, and the outline of the inner and outer Milky Way. This view is centered on the constellations Auriga, Taurus, and Perseus

and range from +90° (the North Celestial Pole) to -90° (the South Celestial Pole). Declination degrees are divided into 60 arcminutes, of which each arcminute of declination is divided into 60 arcseconds. Declination is to the celestial sphere what latitude is to the globe.

The celestial sphere also has lines perpendicular to declination lines, analogous to longitude lines on the globe. These lines are called *right ascension* (r.a.). Unlike longitude, which is measured both east and west of a reference line, right ascension is only measured eastward along the celestial equator from a reference point. The reference point is where the Sun crosses the celestial equator passing from south to north on the vernal equinox (the first day of Northern Hemisphere spring). That point on the celestial equator is called the *Point of Aries*. Right ascension is measured in hours, minutes, and seconds. There are 24 h of right ascension along the entire circumference of the celestial equator. The 24-h line is the same as the 0-h line. Lines of right ascension run from the North Celestial Pole to the South Celestial Pole and like lines of longitude on the globe are not parallel.

Just as maps depict a portion of a globe, celestial charts or star atlas plates contain regions of the celestial sphere. Celestial charts or atlases usually contain coordinate lines (r.a. and dec.), the ecliptic (the Sun's path across the celestial sphere), the galactic equator, the celestial poles and equator, ecliptic poles and galactic poles, and possibly the outline of the Milky Way. The following are usually plotted on these charts (monochromatic charts with white backgrounds):

- Stars: Denoted with solid black dots whose size depends on the brightness of the stars. The larger the dot is, the brighter the star ● ● •.
- Multiple stars: Two or more stars located close to each other in space. Each is denoted by a black dot with a line through or next to it -●- or -●.
- Variable stars: Stars that vary in brightness. Each is denoted by a solid black dot with a concentric circle around it. The circle represents the brightest a star gets, while the dot represents the dimmest it gets ◉.
- Galaxies: Denoted by ovals ⬭.
- Open star clusters: A loose cluster of stars like the Pleiades. Each is denoted by a dotted, dashed, or solid unfilled circle ⬡.
- Globular clusters: Compact high-density spherical clusters of stars. Each is denoted by a circle with a cross in it ⊕.
- Nebulae (plural of nebula): Interstellar clouds of gas and dust. Each is denoted by lines showing their boundaries or by squares ⬭ or □.

3 Star Atlases, Constellations, and Celestial Nomenclature

Image 3.2 The 19th Edition of Norton's Star Atlas

- Planetary nebulae: Approximately circular regions of hot expanding gas expelled by old stars. Each is denoted by a circle covering a cross ⊕.

One of the oldest celestial charts still in print today is Norton's Star Atlas (Image 3.2). The atlas was created by Arthur Phillips Norton (1876–1955) of Great Britain and was first published in 1910. Norton published 17 editions of the atlas. Ian Ridpath (1947–), an English science writer and space enthusiast, has drawn subsequent editions up to the current 20th edition.

Norton's handbook contains 16 charts covering the entire celestial sphere. Maps 1 and 2 cover the regions around the North Celestial Pole, while maps 15 and 16 cover the regions around the South Celestial Pole. The other maps cover all the other regions.

One chart from Norton's Star Atlas is shown below in Image 3.3. On each chart, other than the previously mentioned polar regions, north is up and east is to the left. Celestial objects are depicted in black with a white background. The only color used is green to denote the Milky Way. All celestial object positions are for epoch 2000.0 (i.e., their positions at the beginning of the year 2000). Stars are plotted down to magnitude 6, thus showing all naked-eye

54 J. Dire

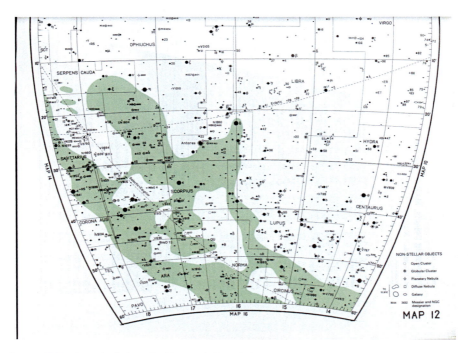

Image 3.3 A typical chart in Norton's Star Atlas

stars visible from a dark site. Galaxies, nebulae, and star clusters are plotted to magnitude 10. Right ascension lines are visible for each hour, and declination lines are visible for every 10°. In the image above, the labeled dashed lines show the ecliptic and the galactic equator. Solid lines depict the boundaries of the constellations, with each constellation labeled with uppercase letters. Note the large population of double stars on the chart. More than half of all stars are binary stars. Our Sun in is the minority!

Now would be a good point to discuss nomenclature for celestial objects as myriad objects are labeled in the image above. Starting with stars, approximately 550 of the brightest stars have common names. Examples include Sirius, Canopus, Polaris, Vega, Arcturus, Altair, and Spica. Furthermore, in each constellation, the brightest star is named Alpha followed by the possessive Latin form of the constellation name. The second brightest is Beta, followed by Delta, and so on, until the Greek alphabet is exhausted. In this system, Sirius is Alpha Canis Majoris, Vega is Alpha Lyrae, and Polaris is Alpha Ursae Minoris. The second brightest star in Ursa Minor is Kochab or Beta Ursae Minoris.

3 Star Atlases, Constellations, and Celestial Nomenclature 55

German astronomer Johann Bayer (1572–1625) first implemented the Greek naming system in 1603, before modern instruments could differentiate the brightness of two stars very close in light output. Currently, there are a few constellations in which the "Beta" star is slightly brighter than the "Alpha" star. Additionally, over time, some stars have increased or decreased in brightness making them out of order with the Greek alphabet. Finally, some stars have moved into neighboring constellations due to procession of the Earth's spin axis. However, for the most part, we can assume that Alpha is the brightest star in each constellation, followed by Beta and onward.

Another naming system for stars is that in each constellation the visible stars are numbered in order of increasing right ascension. The westernmost star in a constellation is given the number 1, next 2, then 3, etc. These are called Flamsteed numbers after John Flamsteed (1646–1719), the British Astronomer Royal appointed in 1675 by King Charles II. Flamsteed's star catalog was published posthumously in 1725. It contained 2925 stars. The catalog was converted into star charts in 1729.

The brightest star in the constellation Scorpius (found just to the left of the center in Image 3.3) is Antares. Antares is also known as Alpha Scorpii. Note the Greek letter "α" below the star in the chart. Using its Flamsteed number, it is also known as 21 Scorpii. According to the symbols on the chart, Antares is both a binary star and a variable star. Antares has two components, one with magnitude of 1.1 and the other with magnitude 5.5. Known as α Scorpii A and α Scorpii B, they are separated by 2.5 arcseconds. The brighter component varies from magnitude 0.6 to 1.6.

Stars that are too faint to have a Greek letter or Flamsteed number may still be listed in a catalog somewhere. Two popular are the Henry Draper (HD) catalog and the Smithsonian Astrophysical Observatory (SAO) catalog. The HD catalog was published between 1918 and 1924 and was named after the American astronomer and physician Henry Draper (1837–1882). Draper was one of the first astrophotographers and took the first stellar spectra. The original HD catalog contained 225,300 stars down to eighth magnitude. A total of 133,783 additional, fainter stars have been added to the HD catalog over the years since it was originally published. The SAO star catalog was first published in 1966 and contains more than a quarter million stars. The star Antares is cataloged as SAO184415 and HD148478. The SAO catalog numbers stars from north to south while the HD catalog numbers them with increasing right ascension. These numbers do not appear on star charts.

Variable stars are given letter designations in the order that the stars are discovered (or suspected) to be variable. The first variable star discovered in a constellation was designated by the letter R. Then comes S, T, U, V, W, X, Y,

and Z. This accounts for nine names. The tenth and higher variable stars in a constellation are given double letters starting with RR. Next comes RS, RT, … RZ, then SS … SZ, TT … TZ, up to ZZ. This amounts to 54 variable star names. Then it continues AA, AB … AZ except the letter J is never used. After AZ is BB, BC, … BZ, etc. until we get back to QQ (remembering J is never used). This accounts for the possibility of 334 named variable stars per constellation. These variable stars have a wide range of maximum brightness. Therefore, most of these names are not found on a star chart that only goes down to sixth, eighth, or eleventh magnitude.

It is curious why variable star designations started with the letter R and why J is not used. The answer goes back to really old star charts using both uppercase and lowercase Latin letters as star names. However, they only went up to Q. Thus, variable stars started with R. The letter J was never used since the Latin alphabet did not have a J. Latin letters are no longer used for star charts anymore, except for Norton's Star Atlas which still shows some of them.

Some constellations have more than 334 variable stars. After 334, the next variable star is just called V335, followed by V336, etc. Why we could not have just started with V1, V2, etc., is beyond me. Variable stars that have a Bayer designation, such as α Scorpii, are not given a separate variable star name.

There are multiple naming systems for deep-sky objects (star clusters, nebulae, and galaxies) too. The most popular objects were cataloged by the French comet hunter Charles Messier (1730–1817). Messier used a three-inch refractor to search for comets. He cataloged objects that might be confused with comets in his then-modern telescope. Messier's catalog contains more than 100 deep-sky objects numbered M1, M2, M3, etc. Note that in Image 3.3, M4 is a globular star cluster slightly west of Antares.

The next most common deep-sky designations come from the New General Catalog (NGC). Danish astronomer Johan Ludwig Emil Dreyer (1852–1926) published this catalog in 1888. The New General Catalog contains 7840 entries organized by right ascension. On Norton's Star Atlas, any one- to four-digit number next to a galaxy, nebula, or star cluster is its NGC number.

In 1895 and 1908, supplements were published to the NGC catalog. They are called the Index Catalogs. Objects in these catalogs are given IC numbers starting with IC1 and ending with IC5386. On Norton's Star Atlas, any one- to four-digit number, preceded by the letters IC, is an Index Catalog deep-sky object.

Sky Publishing Corporation, the parent company of *Sky and Telescope* magazine, published a complete star atlas (Image 3.4) in the 1950s. This atlas consisted of sixteen 18-inch by 12-inch plates covering the entire celestial sphere. Objects were plotted for epoch 1950.0.

3 Star Atlases, Constellations, and Celestial Nomenclature

Image 3.4 Atlas of the Heavens by Sky Publishing Corporation. This edition was printed in 1958

The atlas was composed at the Skalnaté Pleso Observatory in Slovakia and was first published by the Czechoslovak Astronomical Society in 1948. Later that year, Sky Publishing Corporation obtained the copyright and published the atlas in the United States.

Stars are plotted on the charts down to magnitude 7.75, all obtainable with binoculars from a dark site. Each plate has a legend showing magnitude bin symbols for various astronomical objects (Image 3.5). Only stars with Bayer Greek letters are labeled on the charts, with the exception of variable stars that reach a maximum brightness greater than magnitude 7.75. NGC objects are labeled with just a number. Those that have Messier numbers have NGC and Messier labels. Index Catalog objects have a number preceded by an "I.", although the period is hard to see and the "I" looks like the number one. Only NGC and IC objects brighter than magnitude 12 are labeled. Those fainter than magnitude 12 appear only with an object symbol.

The 1950 epoch is no longer in print, but Sky Publishing Corporation updated it to epoch 2000.0 and expanded it to 26 plates (Image 3.6) in 1981 with the assistance of Dutch stellar cartographer Wil Tirion (1943–). Expanding the atlas from 16 to 26 plates allowed three plates to cover each polar region and more stars, down to eighth magnitude, were plotted on each plate.

58　J. Dire

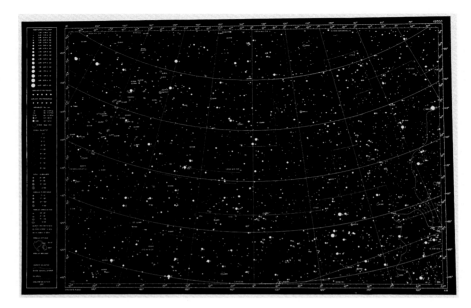

Image 3.5 Plate number III from the Skalnaté Pleso Atlas of the Heavens

Image 3.6 SkyAtlas 2000.0 provided more current positions of celestial objects replacing Sky Publishing Company's epoch 1950.0 atlas

3 Star Atlases, Constellations, and Celestial Nomenclature

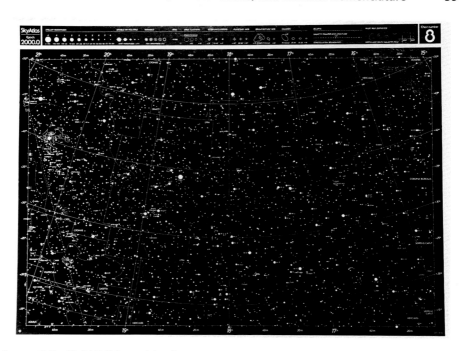

Image 3.7 Field Edition with white stars on a black background

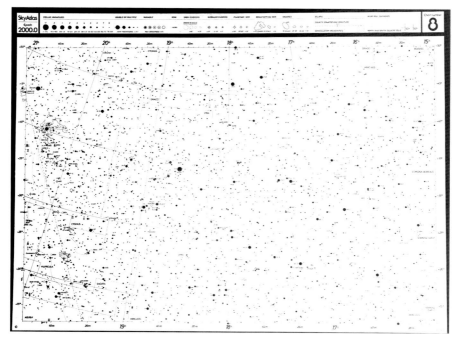

Image 3.8 Desk Edition with black stars on a white background

Image 3.9 The Cambridge Double Star Atlas

SkyAtlas 2000.0 is available in multiple versions. The Field and Desk Editions (Images 3.7 and 3.8) each have 26 loose plates measuring approximately 18 inches by 13 inches in size. A Deluxe Edition is spiral bound with each plate laminated and folded in half. The Deluxe Edition plates are colored with a white background. Stars are black, star clusters are yellow, nebulae are green, and the Milky Way is blue.

On StarAtlas 2000.0, stars are plotted to magnitude 8 with ten dot sizes ranging from magnitude -1 to 8. All Bayer Greek letters and Flamsteed numbers are printed for stars that use them. All NGC and IC objects are plotted with their numbers labeled. IC numbers are preceded with the letter "I". Like the Epoch 1950.0 publication, declination lines appear every 10° and right ascension lines appear every hour. The ecliptic and galactic equators are both drawn, the latter with galactic longitude labels.

After producing SkyAtlas 2000.0, Wil Tirion went on to produce Uranometria 2000.0 a 220 chart, all-sky atlas with stars down to magnitude 9.75 and more than 30,000 nonstellar objects. The name Uranometria was used by Johan Bayer as the title of his star atlas published in 1603. The word comes from the Greek and means "measuring the heavens."

3 Star Atlases, Constellations, and Celestial Nomenclature

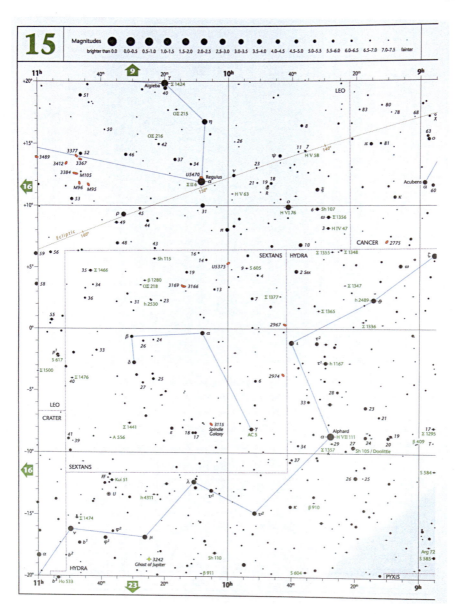

Image 3.10 The left side of chart 15 in the Cambridge Double Star Atlas. Stars below magnitude 7.5 and all NGC and IC objects are plotted on 30 opposing-page plates

Image 3.11 The Millennium Star Atlas comprises three hardbound volumes each covering 8 h of right ascension from pole to pole

Wil Tirion also produced the Cambridge Star Atlas 2000.0. The atlas has been revised into several versions including one of my favorites, the Cambridge Double Star Atlas (Image 3.9). The Cambridge Double Star Atlas was a collaboration between Tirion and James Mullaney (1940–) and was first published in 2009 by Cambridge University Press.

The Cambridge Double Star Atlas is an excellent composition containing all that is needed to explore double stars. The atlas contains 30 plates 8.5 by 11 inches in size covering the entire celestial sphere. Nearly 2400 double and multiple stars are plotted on the plates, each labeled with the discoverer, catalog, and/or observatory index number. The double stars plotted have a limiting combined visual magnitude of 7.5 with no double stars identified with components fainter than tenth magnitude. Pairs separated by more than 3 arcminutes are plotted as separate stars. The data corresponding to all plotted double stars are contained in one of the appendices within the atlas.

3 Star Atlases, Constellations, and Celestial Nomenclature

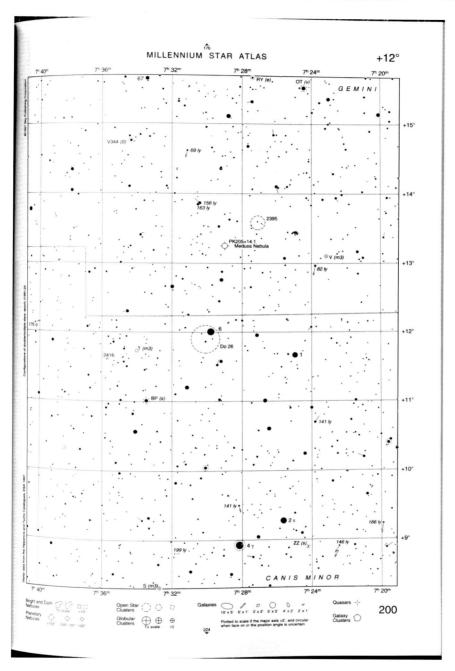

Image 3.12 A typical page from the millennium star atlas. This is Chart 200 of 1548

64 J. Dire

Each plate covers between 1200 and 1400 square degrees of the sky. The background is white with solid black circles for stars; as is typical, the larger circles indicate brighter stars (Image 3.10). Double and multiple stars have a horizontal line through the circle, while variable stars have a concentric ring around a solid circle. Star clusters are yellow, nebulae are yellow-green, and galaxies are red. The Milky Way is indicated by two shades of purple, and the darker shade denotes the inner Milky Way. A legend appears at the top of every page to help identify object classes and estimate the brightness of all the plotted stars to within a half magnitude.

The look of the Cambridge Double Star Atlas is very similar to the Deluxe Edition of Sky Atlas 2000.0. Both are spiral bound with laminated pages to resist dew. In both, all celestial objects are labeled in black, except for the Double Star Atlas which has additional labels for all double stars plotted in green. The Double Star Atlas is a great all around star atlas.

The most detailed paper star atlas ever published is called the Millennium Star Atlas (Images 3.11 and 3.12). Roger W. Sinnott (194?–) and Michael A.C. Perryman (1954–) produced magnificent work. It was published jointly by Sky Publishing Corporation and the European Space Agency in the year 1997.

The Millennium Star Atlas contains a whopping 1548 charts, each containing a portion of the sky that might be visible in an average set of binoculars. There are more than 1 million stars plotted brighter than magnitude 12. As you might guess by its name, objects are plotted for epic 2000.0. The sizes of the star dots on the charts are mathematically related to their visual magnitudes with no binning, except for all stars magnitude 2 or brighter which are plotted as if they were magnitude 2. Otherwise, the brightest star dots would be too large to see stars near them. All stars with proper motion (i.e., their motion with respect to more distant objects) greater than 0.2 arcseconds per year have an arrow from their dot extending in the direction of their motion whose length displays their motion in 1000 years.

Stars closer than 200 light years have their distance labeled on the charts. Variable stars have a code in parenthesis next to their names indicating the classification of the variable. On every chart, declination lines are drawn for every degree. Right ascension lines are spaced every 4 min near the celestial equator, tapering off to every hour around the poles. Both the ecliptic and galactic equators are drawn with labeled ticks showing each degree of longitude. The outline of the Milky Way appears on each appropriate chart.

In the Millennium Star Atlas, double stars are denoted by dots with a line drawn on one side of the dot in the direction of the secondary star from the primary (brighter) component. The length of the line is proportional to the

3 Star Atlases, Constellations, and Celestial Nomenclature 65

components' separation. Double stars separated by more than 30 arcseconds have both stars plotted with separate and possibly overlapping dots.

All NGC and IC objects are plotted, as are all galaxies magnitude 13.5 and brighter. Overall, more than 8000 galaxies are plotted. NGC objects have numbers next to their symbols while IC objects have their number preceded by the letters "IC." Pentagons denote galaxy clusters. The size of each pentagon is proportional to the size of the respective galaxy cluster. Finally, quasars brighter than magnitude 16 appear in the atlas and are denoted with a + sign. Quasars are highly energetic galaxy cores of extremely distant galaxies. They appear like stars when viewed.

As paper star atlases have gone increasingly in magnitude, the number of missing stars has increased. Atlases down to magnitude 6 have probably captured all naked-eye stars accurately. Going fainter relies on accurate catalogs but human error creeps in. The Millennium Star Atlas is based on the Tycho Catalog which was produced using images from the European Space Agency's Hipparcos satellite. They estimate that they captured 99.9% of all stars with visual magnitudes greater than 10, and 90% of all stars with visual magnitude greater than 10.5. The inclusion rate decreases considerably for fainter objects, but no estimation was made as to what percentage of stars magnitude 10.5–12 is included in the atlas. There is likely to be no future paper atlases with stars down to or dimmer than magnitude 12 as electronic atlases are beginning to replace paper atlases. Nevertheless, the atlases mentioned above and other star field guides in print today will continue to be useful for decades to come.

Planetarium programs for commercial use have roots back to the 1980s when personal computers were beginning to find their way into many households. Today, there are myriad versions from which to choose. Several are open source. Commercial products seem to be more robust than open source products and offer many pricing options. In this chapter, I will only discuss four products, which I find to be exceptional. While they are known as desktop planetarium programs, they are essentially digital star atlases with an abundance of features for study and productivity.

Voyager by Carina Software is the only desktop planetarium originally developed for Macintosh computers. Version 1 was released in 1988. The software was shipped on a 3.5-inch floppy disk and offered a monochromatic map of the celestial sphere as seen from any location on Earth for any date and time. It included stars, solar system objects, and deep-sky objects.

Version 2 was released in 1995 on eight floppy disks or one floppy disk and a CD ROM. The entire SAO catalog of stars was included giving stars down to magnitude 10. Multiple choices were available for the epoch, the default being epoch 2000.0. The software could be set to the computer's date to use

the current epoch. Color was added to the program with user control over the colors used for various reference lines, gridlines, and object symbols. The Hubble Guide Star Catalog 1.1 was included allowing nearly 19 million objects (15 million stars) down to 16th magnitude to be plotted. The chart could be displayed with a white background or a black background. Comet or artificial satellite orbits could be added. Ephemeri (tables showing the coordinates for objects at regular intervals throughout a time period) could be generated for any object in the solar system, and sky charts could be generated for viewing from anywhere in the solar system! The CD contained 800 pictures of celestial objects.

In 2001, Voyager 3 added myriad more features including a multitude of comets, asteroids, satellites, and spacecraft that could be plotted. The Tycho and Hipparcos star catalogs were added. The charts could be drawn with different projections (orthographic, azimuthal, equal area, or sinusoidal). The charts could also be drawn with equatorial, altitude-azimuth, solar system, or galactic coordinates. More labeling options were also added. The software only came on a CD-ROM, but a second CD could be purchased with a telescope control program called Voyager SkyPilot. With a cable attached between the computer and a telescope mount (typically a serial port connection), the software could drive up to 20 different models of telescopes to any object on the chart with the click of a mouse. The SkyPilot software included a night vision mode that could turn the computer screen one of three darkness levels of red for this software or any other software on the computer. This was useful for maintaining dark adaption when using the software on a laptop in the field.

Voyager 4 was released a few years later and incorporated the SkyPilot software into the main planetarium program. It added many more commercial telescopes to choose from for driving with the software, a more realistic sky chart view, a translucent horizon, more projection options, a natural sky option, and the ability to import comet and asteroid files, among countless other new features. Voyager 4 included the Hubble Guide Star Catalog 2.3, which contains 155 million stars brighter than magnitude 18. The software was also released for Windows platforms in this version.

The last release of Voyager was version 4.5.7 (Images 3.13, 3.14, 3.15, and 3.16) in May 2010. No future releases are expected although the software can still be purchased. Unfortunately, the Macintosh version will not run on any MacOS after 10.14. However, the Windows version still works fine under the current Windows operating system. Although the software is not current, it will still drive most of the amateur telescopes sold on the market today.

Another planetarium program called Starry Night (Simulation Curriculum, Inc.) was developed for Windows operating systems around the same time

3 Star Atlases, Constellations, and Celestial Nomenclature

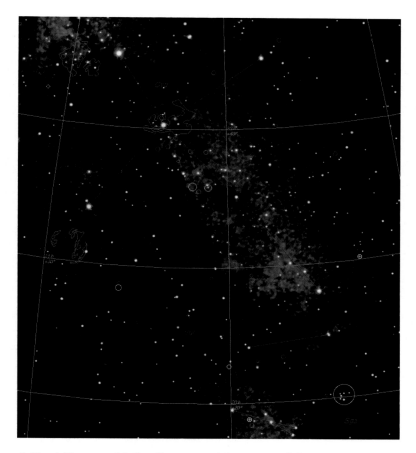

Image 3.13 A Voyager 4.5 Sky Chart containing parts of the Constellations Cygnus, Vulpecula, and Sagitta. Right ascension and declination lines are shown. Basic constellation figures are turned on. Typical symbols are shown for various celestial objects and are sized according to the actually dimensions. Star colors are shown as well as a photorealistic Milky Way

Voyager was produced for Macintosh computers. Through new releases, Starry Night added features similar to Voyager (Images 3.17 and 3.18). The current version runs on Macintosh and Windows operating systems. Starting with Version 8.0, the software will not run on operating systems older than Windows 10. The Macintosh version will not run on operating systems older than 10.12.

Starry Night contains the complete Tycho/Hipparcos catalog and the Hubble Guide Star Catalog which contain nearly 19 million objects. Of course, all NGC and IC objects were included. The charts in Starry Night do

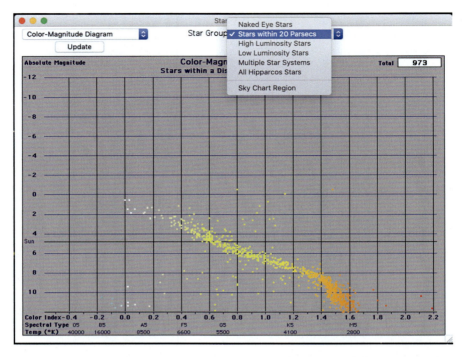

Image 3.14 Voyager 4.5 can generate many types of reports and charts. Shown here is a Hertzsprung-Russell (H-R) diagram, a plot of luminosity versus star temperature, for stars in the Sun's neighborhood

not resemble traditional star atlases in that there are no symbols drawn for star clusters, planetary nebula, galaxies, etc. Those deep-space objects are not apparent in wide field views. They can be found through the search engine or by turning on labels for various object types. The charts display a more realistic sky and zooming in will provide realistic views of the various deep-sky objects.

The Pro and Pro Plus versions of Starry Night are able to plot stars from the USNO-A2 database, which contains 500 million stars down to magnitude 21. This database is too large to fit on a DVD. The software can download portions of the database for use in plotting detailed charts.

Starry Night doubles as an educational tool. Educator versions are available for all grade levels and colleges. Simulations can be created such as transits of Jupiter's Galilean moons and their shadows. These can be exported to MPEG video formats.

Installing Starry Night Pro also installs ASCOM software for telescope control. This allows the software to control just about any commercially made

3 Star Atlases, Constellations, and Celestial Nomenclature

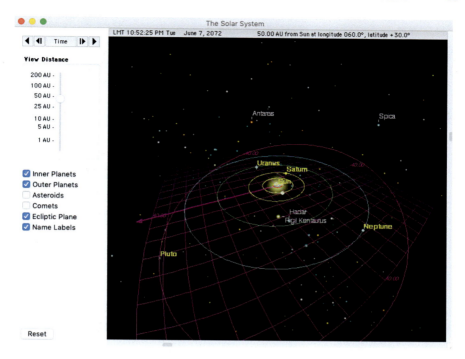

Image 3.15 Voyager has an orrery, which can step solar system orbits through time

telescope mount. The software also connects to Live Sky allowing access to Digital Sky Survey data and images.

I found it impressive when I first installed and launched Starry Night Pro Plus in that satellites were shown crossing the sky. Their motion was exactly how they appear under the real nighttime sky. The software contains information on Earth orbiting satellites and space missions. All of the program's databases are upgradable with an Internet connection.

One of the most popular planetarium programs of all time is The Sky. Software Bisque released The Sky in 1992. Like the other programs above, it has evolved considerably since then. The largest changes to The Sky came in Version 10 released around 2015. The software was completely rebuilt with extraordinary features. With this change, the software was renamed TheSkyX (Images 3.19 and 3.20). It is available for Windows, Macintosh, and Linux operating systems.

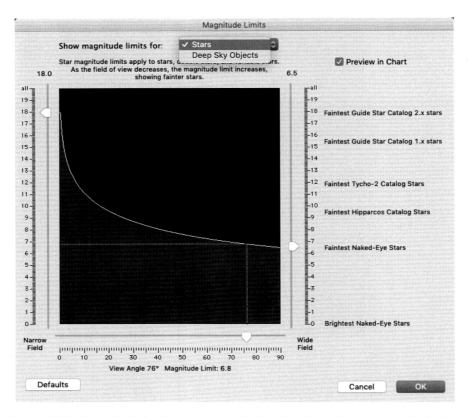

Image 3.16 Magnitude limits are easily adjusted for star and deep-sky objects. The two sliders set the minimum star brightness displayed and how quickly dimmer stars appear as the field of view is decreased

The biggest difference between The Sky and other planetarium software is The Sky has evolved into a comprehensive observatory control system. Besides digital sky charts, the software can control telescope mounts, cameras (still, video, and guider), focusers, and even domes or roll-off-roof enclosures. Many of these features require the professional version plus add-ons. One such add-on is called TPoint. TPoint can produce a mount model with an unlimited number of reference stars for exact pointing of a telescope onto an object. This software can also check a telescope's polar alignment and help a user zero in on a perfect alignment.

Short of a perfect mount model TheSkyX has this nifty feature called a "closed loop slew" for users conducting astroimaging. When selecting an object to image, the software will slew a telescope to the object, take an exposure with the connected camera, evaluate the image, and then move the telescope to perfectly center the selected object.

3 Star Atlases, Constellations, and Celestial Nomenclature

Image 3.17 A Chart from Starry Night Pro showing various constellations around Cygnus. The yellow lines are right ascension and declination with the celestial equator in green. Bright stars are plotted in this wide field view as well as constellation stick figures. The sky glows simulating light pollution near the horizon on the left is an adjustable feature

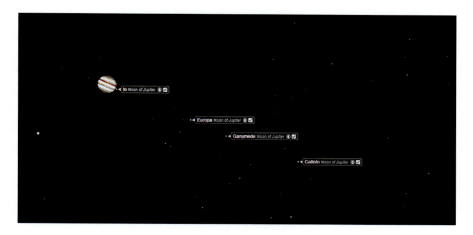

Image 3.18 Starry Night zoomed in of Jupiter showing the Galilean moons

Like previously discussed planetarium programs, The Sky has tens of millions of celestial objects in its database and the ability to import more. The default symbols for various celestial objects are not the same as those in paper star atlases. For instance, the galaxy symbol looks like a miniature hurricane. The good news is, unlike the other programs discussed herein, TheSkyX has a symbol editor allowing users to create simple symbols akin to paper star atlases.

72 J. Dire

Image 3.19 A chart view from TheSky6 centered on Virgo galaxies. TheSky6 was one of the most popular Windows planetarium programs of its time

Image 3.20 TheSkyX centered on globular cluster NGC5053. Each planetarium program displays object information in side or overlay windows and all contain extensive information on celestial objects

3 Star Atlases, Constellations, and Celestial Nomenclature 73

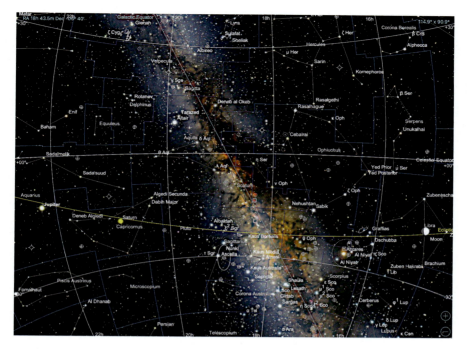

Image 3.21 A Sky Safari Pro chart centered on the summer Milky Way

TheSkyX also contains a horizon editor. This is useful for users with obstructions in one or more directions to avoid slewing a telescope to look at buildings or trees. Like Starry Night, the software will allow user input of various equipment (telescopes, eyepieces, and cameras) and can project a rectangle (for a selected camera) or circle (for a selected eyepiece) onto a sky chart showing the field of view. This is useful for finding faint objects in the eyepiece or framing photographs.

Many planetarium applications have been developed for smartphones and tablets (e.g., iPads) mainly targeting those running iOS (iPhones) or Android operating systems. These programs offer a real time view of the skies with stars, constellations, planets, the Moon, and in some cases deep-sky objects. With the accelerometers contained in many smartphones and tablets, these programs can sense the position a device is being held and the direction the backside is pointed to display a sky chart on the screen duplicating the sky behind the device. These applications have enabled novices to learn their way around the nighttime celestial sphere.

Herein, I will only describe one of these products due to its comprehensive robust features and the fact that it is also available for computers. This application is called Sky Safari. Image 3.21 shows a typical chart from Sky Safari Pro. The sky chart looks similar to that of Voyager, which is not surprising

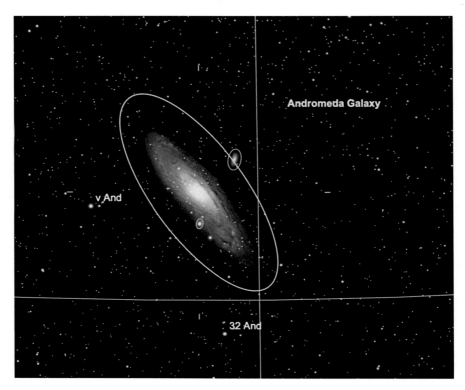

Image 3.22 Sky Safari Pro view of the Andromeda Galaxy, M31, and its satellite galaxies M32 and NGC M110. The oval galaxy symbols enlarge when zooming in, maintaining the orientation and relative size of galaxies. Eventually, a photo of a galaxy appears, which also increases in size and detail upon further zooming

since Sky Safari was cofounded by one of the programmers for Voyager 4 and 4.5. Simulation Curriculum, the same company that produces Starry Night, now sells the product.

In Image 3.21, bright star labels are displayed along with constellation stick figures, constellation boundaries, an equatorial grid, the ecliptic, and the galactic equator. The usual star atlas symbols are drawn for open star clusters, globular star clusters, nebulae, and planetary nebulae. The chart is not zoomed in enough to show any galaxies, except the Sagittarius Dwarf Galaxy (below the yellow ecliptic line near the center), a satellite galaxy of the Milky Way that is so large in the sky and faint that most people do not realize it is part of the Milky Way.

Image 3.22 shows Sky Safari zoomed in on the Andromeda Galaxy. Galaxies are shown by white, user-defined, ovals. When zoomed in sufficiently, some objects display a realistic photo. Other features of Sky Safari are shown in Images 3.23 and 3.24.

Image 3.23 In Sky Safari Pro, charts can display the rise and set times of objects with the sunrise, sunset, moonrise, and moonset times for reference. The green vertical line with a time above it slides left and right to display chart times. The graph also displays the altitude of each object as a function of time

Image 3.24 Image of Sky Safari Pro on an iPhone with telescope control on. Touching an object on the screen and selecting GoTo drives the telescope to the object. Manual slewing is accomplished by using the arrows on the left and right sides of the screen, which move the telescope in right ascension and declination, respectively. There are four slewing rates to choose with 1 being the slowest and 4 the fastest

Table 3.1 Features of various Sky Safari versions

Version	Number of stars	Deep-sky objects	Solar system objects	Telescope control
Basic	120,000	222	>200	No
Plus	2,500,000	32,000	7000	Yes
Pro	100,000,000	3,000,000	750,000	Yes

Like many of the above software packages, there are three versions of Sky Safari. The differences are summarized in Table 3.1.

All of the planetarium programs mentioned above have at one time or another been packaged with astronomy books or commercial telescopes. These packages are typically basic versions for supplementing a book or providing basic sky information for new telescope owners.

Planetarium programs, including but not limited to those presented herein, can create sky charts with stars much fainter than any paper star atlas. However, like any paper star atlas that goes deeper than magnitude 8, all of the electronic planetarium programs do not capture 100% of all possible stars at any faint magnitude. No estimates are available as to what percentage of stars is plotted for each magnitude. I have photographed star fields below 18th magnitude and often find stars on my images that are not on any or all of these planetarium programs. Regardless, the amount of information they contain is phenomenal.

As depicted on star atlases, the heavens have always been broken up into star groupings which we know as constellations. Originally, these groupings were related to storytelling and mythology. Some were created to honor a character, exploration, or scientific instrument. These groupings form a perceived outline or pattern that has and still does help individuals remember the locations of the various stars and deep-sky objects.

Many of our current constellations have been known for thousands of years as their names are found in ancient literature. Stellar cartographers created other constellations as they plotted stars. Some of these new constellations have survived, while others have not. For instance, there was once a constellation Argo Navis (the ship Argo) from Greek mythology. The constellation covered 28% of the sky and was unwieldy in size. In the year 1755, stellar cartographer Nicolas Louis de Lacaille (1713–1762) divided it into three fairly equal-sized constellations: Carina (the hull), Puppis (the poop deck), and Vela (the sails).

To formalize a consistent set of constellations, the International Astronomical Union accepted a modern list of 88 constellations in the year 1922. Six years later, they officially adopted fixed boundaries for all of the constellations, which together cover the entire celestial sphere. Table 3.2 contains an alphabetical list of all 88 constellations with basic information about their size, bright stars, and naked-eye stars. Finally, Table 3.3 provides guidance on the pronunciation of constellation names and their genitive cases.

3 Star Atlases, Constellations, and Celestial Nomenclature

Table 3.2 The 88 modern constellations

Latin name	English name	Abbreviation	Area (square degrees)	No. of stars brighter than mag. 6	No. of stars brighter than mag. 3
Andromeda	Andromeda	And	722	151	4
Antlia	Pump	Ant	239	43	0
Apus	Bird of Paradise	Aps	206	35	0
Aquarius	Water Bearer	Aqr	980	148	1
Aquila	Eagle	Aql	652	110	6
Ara	Altar	Ara	237	59	4
Aries	Ram	Ari	441	82	2
Auriga	Charioteer	Aur	657	148	6
Bootes	Herdsman	Boo	907	164	5
Caelum	Chisel	Cae	125	18	0
Camelopardalis	Giraffe	Cam	757	142	0
Cancer	Crab	Cnc	506	129	2
Canes Venatici	Hound Dogs	CVn	465	62	1
Canis Major	Great Dog	CMa	380	137	8
Canis Minor	Little Dog	CMi	183	36	2
Capricornus	Goat	Cap	414	100	3
Carina	Keel	Car	1083	198	11
Cassiopeia	Cassiopeia	Cas	598	145	6
Centaurus	Centaurus	Cen	1060	289	14
Cepheus	Cepheus	Cep	588	140	5
Cetus	Sea-monster	Cet	1231	173	5
Chamaeleon	Chameleon	Cha	132	24	0
Circinus	Compass	Cir	93	33	1
Columba	Dove	Col	270	69	3
Coma Berenices	Berenice's Hair	Com	386	67	0
Corona Austrina	Southern Crown	CrA	128	46	0
Corona Borealis	Northern Crown	CrB	179	35	1
Corvus	Crow	Crv	184	27	4
Crater	Goblet	Crt	282	45	0
Crux	Southern Cross	Cru	68	46	5
Cygnus	Swan	Cyg	804	267	6
Delphinus	Dolphin	Del	189	49	0
Dorado	Gold Fish	Dor	179	29	1
Draco	Dragon	Dra	494	210	6
Equules	Little Horse	Eqe	72	20	2
Eridanus	Eridanus	Eri	1138	193	4
Fornax	Furnace	For	398	55	0
Gemini	Twins	Gem	514	119	7
Grus	Crane	Gru	366	61	4
Hercules	Hercules	Her	1225	245	6

(*continued*)

78 J. Dire

Table 3.2 (continued)

Latin name	English name	Abbreviation	Area (square degrees)	No. of stars brighter than mag. 6	No. of stars brighter than mag. 3
Horologium	Clock	Hor	249	33	0
Hydra	Sea Snake	Hya	1303	206	4
Hydrus	Lesser Snake	Hyi	243	29	3
Indus	Indian	Ind	294	39	1
Lacerta	Lizard	Lac	201	62	0
Leo	Lion	Leo	947	133	7
Leo Minor	Little Lion	LMi	232	36	0
Lepus	Hare	Lep	290	67	4
Libra	Balance	Lib	538	96	3
Lupus	Wolf	Lup	334	115	7
Lynx	Wildcat	Lyn	545	89	1
Lyra	Lyre	Lyr	286	71	3
Mensa	Mesa	Men	153	21	0
Microscopium	Microscope	Mic	210	36	0
Monoceros	Unicorn	Mon	482	135	0
Musca	Fly	Mus	138	52	2
Norma	Scale	Nor	165	41	0
Octans	Octant	Oct	291	56	0
Ophiuchus	Serpent Holder	Oph	948	165	7
Orion	Orion, Hunter	Ori	594	202	11
Pavo	Peacock	Pav	378	73	1
Pegasus	Winged Horse	Peg	1121	204	8
Perseus	Perseus	Per	615	152	7
Phoenix	Phoenix	Phe	469	67	3
Pictor	Painter's Easel	Pic	247	55	2
Pisces	Fishes	Psc	889	106	0
Piscis Austrinus	Southern Fish	PsA	245	41	1
Puppis	Stern,Poop deck	Pup	673	233	7
Pyxis	Compass	Pyx	221	45	0
Reticulum	Reticle	Ret	114	23	1
Sagitta	Arrow	Sge	80	28	1
Sagittarius	Archer	Sgr	867	194	10
Scorpius	Scorpion	Sco	497	183	17
Sculptor	Sculptor's Studio	Scl	475	51	0
Scutum	Shield	Sct	109	37	0
Serpens(Caput)	Serpent(head)	Ser	428	57	1
Serpens(Cauda)	Serpent(tail)	Ser	208	18	1
Sextans	Sextant	Sex	314	24	0
Taurus	Bull	Tau	797	217	6
Telescopium	Telescope	Tel	252	51	1

(*continued*)

3 Star Atlases, Constellations, and Celestial Nomenclature 79

Table 3.2 (continued)

Latin name	English name	Abbreviation	Area (square degrees)	No. of stars brighter than mag. 6	No. of stars brighter than mag. 3
Triangulum	Triangle	Tri	132	24	2
Triangulum Austrinus	Southern Triangle	TrA	110	33	3
Tucana	Toucan	Tuc	295	44	1
Ursa Major	Big Bear	UMa	1280	199	14
Ursa Minor	Little Bear	UMi	256	39	3
Vela	Sail	Vel	500	211	6
Virgo	Virgin	Vir	1294	136	5
Volans	Flying Fish	Vol	141	28	0
Vulpecula	Little Fox	Vul	268	33	6

80 J. Dire

Table 3.3 Pronunciation guide to the constellations

Name	Pronunciation	Genitive form	Pronunciation
Andromeda	an draw' meh duh	Andromedae	an drom' uh die
Antlia	ant' lee ah	Antliae	ant' lee eye
Apus	ape' us	Apodis	ap' oh diss
Aquarius	uh qwayr' ee us	Aquarii	ah kwar' ee ee
Aquila	ak' will uh	Aquilae	ak' will eye
Ara	air' uh	Arae	air' eye
Aries	air eeze	Arietis	air ee' ay tiss
Auriga	or eye' guh	Aurigae	or eye' guy
Boötes	bow owe' teez	Boötis	bow owe' tiss
Caelum	see' lum	Caeli	see' lee
Camelopardalis	kam uh low par' dah liss	Camelopardalis	kam uh low par' dah liss
Cancer	kan' sir	Cancri	kan' kree
Canes Venatici	kay' neez yen ah tee' see	Canum Venaticorum	kay' num yen at ih kor' urn
Canis Major	kay' niss may' jor	Canis Majoris	kay' niss muh jor' iss
Canis Minor	kay' niss my' nor	Canis Minoris	kay' niss muh nor' iss
Capricornus	kap nh kor' nus	Capricorni	kap nh corn' ee
Carina	kuh ree' nuh	Carinae	kar ee' nye
Cassiopeia	kass ee oh pee' uh	Cassiopeiae	kass ee oh pee' eye
Centaurus	sen tor' us	Centauri	sen tor' ee
Cepheus	see' fee us	Cephei	see' fee ee
Cetus	see' tus	Ceti	set' ee
Chamaeleon	kuh meel' ee un	Chamaeleontis	kuh meel ee on' tiss
Circinus	sir sin us	Circini	sir sin' ee
Columba	kol um' buh	Columbae	kol um' bye
Coma Berenices	koe' muh bear uh nye' seez	Comae Berenices	koe' my ber uh nye' seez
Corona Australis	kor oh' nuh os tral' iss	Coronae Australis	kor oh' nye os tral' iss
Corona Borealis	kor oh' nuh boar ee al' iss	Coronae Borealis	kor oh' nye bor ee al' iss
Corvus	kor' vus	Corvi	kor' vee
Crater	kray' ter	Crateris	kray' ter iss
Crux	kruks	Crucis	kroo' siss
Cygnus	sig' nus	Cygni	sig' nee
Deiphinus	dell fee' nus	Delphini	del fee' nee
Dorado	dor ah' doe	Doradus	dor ah' dus
Draco	dray' koe	Draconis	druh koe' niss
Equuleus	ek woo oo' lee us	Equulei	ek woo oo' lay ee
Eridanus	air uh day' nus	Eridani	air uh day' nec
Fornax	for' nax	Fornacis	for nay' siss
Gemini	gem' in eye	Geminorum	jem uh nor' um
Grus	groose	Gruis	groo' eese
Hercules	her' cue leez	Herculis	her' kyoo liss
Horologium	hor uh low' gee um	Horologii	hor owe low' gee ee
Hydra	hi' druh	Hydrae	hide' rye
Hydrus	hi' druss	Hydri	hide' ree

(*continued*)

3 Star Atlases, Constellations, and Celestial Nomenclature 81

Table 3.3 (continued)

Name	Pronunciation	Genitive form	Pronunciation
Indus	in' dus	Indi	in' dee
Lacerta	luh sir' tuh	Lacertae	luh sir' tie
Leo	lee' owe	Leonis	lee owe' niss
Leo Minor	lee' owe my' nor	Leonis Minoris	lee owe' niss my nor 'iss
Lepus	lee' pus	Leporis	lee por' iss
Libra	lye' bruh	Librae	lye' bry
Lupus	loo' pus	Lupi	loo' pee
Lynx	links	Lyncis	lin' siss
Lyra	lie' ruh	Lyrae	lie' rye
Mensa	men' suh	Mensae	men~ sigh
Microscopium	my krow scop' ee um	Microscopii	my krow skow' pee ee
Monoceros	mon oss' sir us	Monocerotis	mon awe sir awe' tiss
Musca	mus' kuh	Muscae	mus' kye
Norma	nor' muh	Normae	nor' mye
Octans	ok' tans	Octantis	ok tan' tiss
Ophiuchus	off ee oo' kus	Ophiuchi	off ee oo' key
Orion	or eye' on	Orionis	or ee oh' niss
Pavo	pah' voe	Pavonis	puh voe' niss
Pegasus	peg' ah sus	Pegasi	peg' uh see
Perseus	pur' see us	Persei	per' see ee
Phoenix	fee' niks	Phoenicis	fen ee' siss
Pictor	pik' tor	Pictoris	pik tor' iss
Pisces	pie' seez	Piscium	pish' ee um
Piscis Austrinus	pie' siss os try' nus	Piscis Austrini	pie' sis os tree' nee
Puppis	pup' iss	Puppis	pup' iss
Pyxis	pik' siss	Pyxidis	pik' si diss
Reticulum	reh tik' yoo lum	Reticuli	reh tik' yoo lee
Sagitta	suh gee' tuh	Sagittae	suh jeet' eye
Sagittarius	sa ji tare' ee us	Sagittarii	sa jit air' ee ee
Scorpius	skor' pee us	Scorpii	skor' pee ee
Sculptor	skulp' tor	Sculptoris	skulp tor' iss
Scutum	skoo' tum	Scuti	skoo' tee
Serpens	sir' pens	Serpentis	sir pen' tiss
Sextans	sex' tans	Sextantis	sex tan' tiss
Taurus	tor' us	Tauri	tor' ee
Telescopium	tel es koe' pee um	Telescopii	tel es koe' pee ee
Triangulum	try ang' yoo lum	Trianguli	try ang' yoo lee
Triangulum Australe	try ang' yoo lum os trail'	Trianguli Australis	try ang' yoo lee os tral' iss
Tucana	too kan' uh	Tucanae	too kan' eye
Ursa Major	er' suh may' jor	Ursae Majoris	er' sigh muh jor' iss
Ursa Minor	er' suh my' nor	Ursae Minoris	er' sigh muh nor' iss
Vela	vay' luh	Velorum	vee lor' um
Virgo	ver' go	Virginis	ver' jin iss
Volans	voe' lans	Volantis	voe lan' tiss
Vulpecula	vul pek' yoo la	Vulpeculae	vul pek' yoo lye

4

Light, Color, Filters, Seeing, and Transparency

Except for rocks returned from the Moon, meteorites that have landed on Earth, and small samples returned to Earth by remote spacecraft, everything we know about the universe comes to us by analyzing light from distant places. Some spacecraft have landed on or flown past myriad solar system objects. However, all of the information they have gathered have been beamed to Earth using radio waves, which are a longer wavelength than the visible light we observe. Another form of light had to be used to convey that information to Earth. To fully appreciate the beauty and science associated with celestial observations, a general understanding of light is essential.

All light is composed of traveling electromagnetic waves. Sometimes this is called electromagnetic radiation. The term "*light*" is commonly associated with visible light, which has wavelengths between 400 and 700 nm (nanometers = one billionth of a meter). However, there are many types of electromagnetic radiation that differ from visible light by their wavelengths. These wavelengths are outside our ability to see; yet we can detect them in other ways. These types of light include radio waves, microwaves, infrared, ultraviolet, X-rays, and gamma rays.

As shown in Fig. 4.1, radio waves are the longest wavelength form of electromagnetic waves. At the other end of the spectrum, x-rays and gamma rays are the shortest wavelengths followed by ultraviolet radiation. Our atmosphere blocks most of those wavelengths from reaching the ground, so Earth- or Sun-orbiting observatories are used to observe the universe in those wavelengths.

© The Author(s), under exclusive license to Springer Nature Switzerland AG 2024
J. Dire, *Exploring the Universe*, The Patrick Moore Practical Astronomy Series,
https://doi.org/10.1007/978-3-031-65346-9_4

83

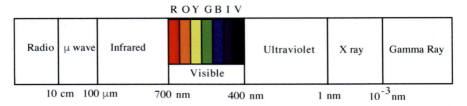

Fig. 4.1 Electromagnetic waves with cutoff wavelengths

The visible forms of light can be seen in various colors which we call red, orange, yellow, green, blue, indigo, and violet. Red light has the longest wavelength while violet has the shortest.

All electromagnetic radiation, regardless of the type or wavelength, travel at the same speed in a vacuum. This speed is known as the *speed of light*. In equations, the speed of light in a vacuum is usually represented by the lowercase letter c. The value of c is 299,790,000 meters per second (m/s). This speed is written as 2.9979×10^8 m/s in scientific notation.

Light travels at slower speeds in other mediums. The ratio of the speed of light in a vacuum to its speed in another medium is called the *index of refraction*. The index of refraction is a number greater than or equal to one. The index of refraction of pure water is 1.33. For common clear glass, the index of refraction is 1.52. The greater the number is, the slower light travels in the medium. By these numbers, we can deduce that light travels faster in water than in clear glass!

The bending of light as it passes from one medium to another is known as *refraction*. Immersing half of a pencil in a glass of water allows this effect to be seen. Looking down into the glass, the apparent bending of the pencil at the water-air interface is caused by light reflecting off the pencil in the water, bending as it leaves the water on its path to the eye. Refraction is what makes refractor telescopes possible. Light can also bend around an obstruction. This bending is known as *diffraction*. Diffraction causes the spikes on the stars in Image 4.1.

Sometimes instead of wavelength, light is characterized by *frequency*. Frequency is the number of waves passing a fixed point per unit time. Frequency (f) is related to wavelength by the equation

$$v = \lambda f$$

where v is the velocity of the light (in a vacuum v = c) and the Greek letter lambda (λ) is the wavelength of the light. Frequency has the unit 1/s or s^{-1},

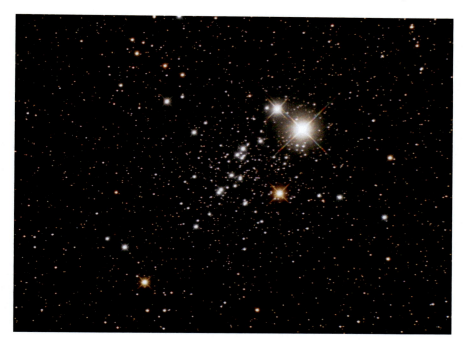

Image 4.1 NGC457 taken using an 8-inch f/8 Ritchey–Chrétien Cassegrain (with a Televue 0.8× focal reducer/field flattener yielding f/6.4) with a SBIG ST-2000XCM CCD camera. The exposure time was 60 min. The spikes coming off of the brighter stars are caused by diffraction of light on the vanes that hold the secondary mirror assembly (see Image 1.8)

which is called Hertz (Hz). The energy carried by electromagnetic waves is directly proportional to the frequency. Long wavelengths, like radio waves, have small frequencies and do not carry as much energy as gamma rays, which have short wavelengths, but high frequencies.

The *intensity* of light is a measure of the amount of electromagnetic radiation present. We perceive stars that emit high intensity of visible light as brighter than stars at the same distance that emit lower intensity of light. *Opacity* is the extent to which materials block light. In our atmosphere, clouds block light to some extent. Denser and taller clouds have greater opacity, which causes them to appear dark gray instead of white. In outer space, gas, and dust, along with molecular clouds, hinder light from reaching us. Two stars of the same intensity and distance but different directions to our line of sight may have different apparent brightnesses due to different amounts of opacity between the stars and Earth.

All objects at temperatures above absolute zero emit a continuous distribution of electromagnetic radiation. A plot of this distribution (intensity as a function of frequency) is called a black body curve (Fig. 4.2). Black body curves are an ideal situation, but real objects' light curves follow similar trends.

German physicist Wilhelm Wien (1864–1928) discovered that the higher the temperature of an object, the greater is the frequency (smaller the wavelength) of the peak emission on a black body radiation curve. Another German physicist, Max Planck (1858–1947) expanded upon this idea and discovered that the higher the temperature of an object, the greater the total energy it radiates.

Physicists and astronomers typically use Kelvin (K) to denote absolute temperature. A temperature in Kelvin is the temperature in degrees Celsius plus 273. When a room temperature is 22 °C, the absolute temperature is 295 K. Celsius is related to Fahrenheit by the equation:

$$T_C = (T_F - 32)/1.8$$

The degree symbol "°" is used for Fahrenheit and Celsius, but not for Kelvin.

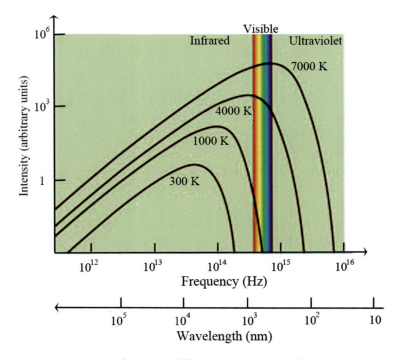

Fig. 4.2 Black body curves for three different temperature objects

4 Light, Color, Filters, Seeing, and Transparency 87

Consider the blackbody curves below (Fig. 4.2) for four different temperature objects: one at 300 K, one at 1000 K, one at 4000 K, and one at 7000 K. The objects at 300 K and 1000 K radiate most of their energy in the infrared and longer wavelengths (shorter frequencies). The peak of each curve is an infrared wavelength. There is negligible radiation from the 300 K object in visible light, so it could not be detected with the human eye. However, it could be imaged with an infrared telescope.

The object at 1000 K does radiate some light at longer visible wavelengths and the light appears red to the eye. The object at 4000 K radiates in the infrared, visible, and ultraviolet regions. The peak radiation occurs in the near-infrared region. The object would also appear red, but at a higher intensity than the 1000 K object. The object at 7000 K radiates most strongly across visible wavelengths and is yellow in color. Hotter stars would peak in the ultraviolet region and would have white or blue overall color to the human eye. Thus, a star's temperature determines its color. Unlike red hot and blue cold water faucets, blue stars are hotter than red stars.

Another interesting property of light, or in general any wave, is called the *Doppler shift.*

Consider the top half of Fig. 4.3 where there exists a stationary light source and a stationary observer. The observer would see light at the same wavelength the source emits. However, if a source is moving relatively toward or away from an observer, as illustrated in the bottom half of Fig. 4.3, the light is not seen at the same wavelength the source emits.

When a source is moving relatively toward an observer, the observer sees the light at a shorter wavelength. This shift is called a blueshift, not because the light is blue but because blue signifies the shorter wavelength of visible light. If the source is moving relatively away from an observer, the observer sees the light at a longer wavelength. This shift is called a redshift, not because the light is red but because red signifies the longer wavelength visible light.

The light from celestial objects with radial (line of sight) motion away from Earth is redshifted. This means that the light we observe has longer wavelengths than that emitted. The light from celestial objects with radial (line of sight) motion toward Earth is blue shifted. This means the light we see has shorter wavelengths than that emitted. The amount of redshift or blueshift increases with increasing radial velocity between the source and the observer according to the equation:

$$\frac{\lambda_{observed}}{\lambda_{emitted}} = 1 + \frac{V}{C}$$

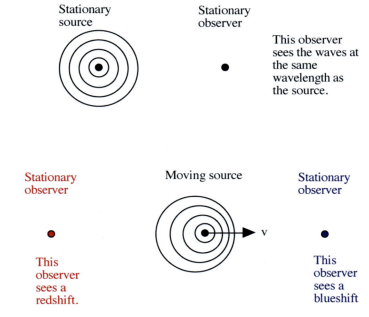

Fig. 4.3 A Doppler shift can result in an observer seeing light at longer or shorter wavelengths than a light source emits

where v is the relative radial velocity between the source and the observer and c is the speed of light.

It is possible for light emitted in visible wavelengths to be redshifted into the infrared or blueshifted into the ultraviolet if the relative source and observer line of sight velocity is sufficiently high. Likewise, infrared light can be blueshifted into visible wavelengths or ultraviolet light red shifted into visible wavelengths. However, for most celestial objects, the relative velocities are not great enough to shift visible light wavelengths much.

Most stars and other celestial objects are far enough to be considered point sources. The energy radiated from these sources travels away from the source along spherical wave fronts. Since the surface area of a sphere is proportional to the square of its radius, when a wave front has doubled its distance from the source, the surface area is quadrupled. Therefore, the intensity of unobstructed light twice as far from the source is only one quarter the strength. This relationship is known as the inverse square law.

The inverse square law also works for sound waves. If you are sitting at a concert and the music is too loud, doubling your distance from the sound source will make the sound volume one fourth of what it was. Hopefully, this will alleviate the ear discomfort.

Hot gases are usually where light originates from in celestial objects. Gases are composed of atoms or molecules. Likewise, atoms and molecules can absorb light. The study of the interactions between light and matter is called *spectroscopy*. A brief discussion of spectroscopy is provided here to fully understand what we are seeing in the celestial sphere.

Atoms and molecules have discrete energy levels, the lowest of which is called the *ground state*. When an atom or molecule absorbs or emits light, the energy state of the atom or molecule increases or decreases, respectively. The amount of light absorbed or emitted must correspond exactly to the energy difference between two discrete energy states in the atom or molecule. The packets of light (electromagnetic energy), which carry these specific amounts of energy, are called *photons*.

The energy of a photon is directly proportional to the frequency of the light. This is given by the equation:

$$E = h\ f$$

where $E \equiv$ energy, $h =$ Planck's constant, and $f =$ frequency. Max Planck is credited for discovering this property. It follows from the equation that gamma rays, which are the highest frequency form of electromagnetic radiation, have the highest energy photons, while radio waves have the lowest.

In the early days of spectroscopy, experiments revealed that there were three main types of spectra. Figure 4.4 shows three types of spectra commonly observed from celestial objects. In a *continuous spectrum*, the radiation is distributed across all frequencies. In an *emission spectrum*, only a pattern of bright spectral lines at specific frequencies emitted by a radiating material is seen. The lines are at specific frequencies related to specific atoms or molecules emitting the light. Finally, an *absorption spectrum* contains dark lines in an otherwise continuous spectrum. The dark lines are caused by the absorption of light at specific frequencies by specific atoms or molecules along the line of sight.

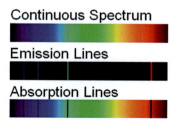

Fig. 4.4 Three types of spectra and how they might be seen in visible light

A description of how these different spectra are created (illustrated in Fig. 4.5) was provided by Gustav Kirchhoff's (1824–1871) in three laws of spectroscopy:

1. A luminous solid, liquid, or sufficiently dense gas emits light of all wavelengths and produces a continuous spectrum.
2. A low-density, hot gas seen against a cooler background radiates an emission spectrum.
3. A low-density, cool gas in front of a hotter source of a continuous spectrum creates an absorption spectrum.

The wavelengths of the spectral lines in the emission or absorption spectra are used to determine the elements that emit or absorb light. This is how astronomers determine the elemental composition of celestial objects. Molecules, which are composed of one or more elements, also have discrete energy levels associated with vibration or rotation. The photons associated with molecular energy level transitions are not as energetic as those associated with atomic energy transitions. Therefore, these photons are typically in infrared, microwave, or radio wavelengths. Astronomers use instruments at various wavelengths to determine the molecular composition in of celestial objects.

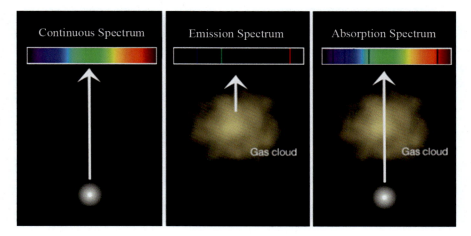

Fig. 4.5 An illustration of Kirchhoff's three laws of spectroscopy

Filters are often used in astronomy instruments to help gather information about objects emitting light. As mentioned in Chap. 2, imagers using monochromatic sensors must capture images through color filters to combine them into color images. Typical transmission curves for these filters are similar to those in Fig. 4.6. The width of a filter's spectral transmission is sometimes expressed as the full width at half maximum (FWHM). The FWHM is the width of the spectral curve in nanometers (nm) or ångström (10 ångström = 1 nm) at a transmission level one half the maximum level. The FWHM is illustrated in Fig. 4.7. Sometimes this is called the bandwidth of the filter. For the RGB filters in Fig. 4.6, the FWHM for the red and green filters is approximately 130 nm, while for the blue filter, the FWHM is approximately 170 nm.

For narrow band astronomical imaging using hydrogen alpha, oxygen III, hydrogen beta, or sulfur II filters, a typical FWHM is 12 nm centered on the emission frequency of those atomic transitions. Table 4.1 shows the central wavelength of these narrow band filters as well as some less commonly used filters.

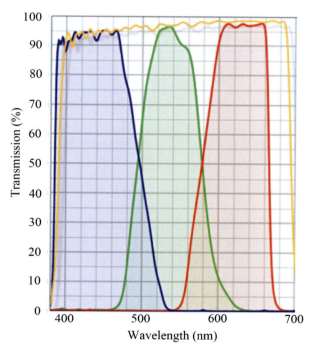

Fig. 4.6 Spectral curves for luminance (yellow), red, green, and blue (RGB) filters

Fig. 4.7 Illustration showing the full-width half-maximum for a typical curve

Table 4.1 Sampling of narrow band filters used for astronomical imaging

Filter type	Central wavelength
Hydrogen alpha	656 nm
Hydrogen beta	486 nm
Oxygen III	496 and 501 nm
Sulfur II	672 nm
Helium II	468 nm
Helium I	587 nm
Oxygen I	630 nm
Argon III	713 nm
Calcium II, CA-K/CA-H	393 and 396 nm

The magnitudes of celestial objects, such as stars, are a measurement of how bright they appear in visible light. For a star whose radiation does not peak in visible light (see Fig. 4.2), the *bolometric magnitude* is a better measure of the star's output. Bolometric magnitudes include emissions across all wavelengths. Astronomers also measure the magnitude of stars in specific wavelength bands. Figure 4.8 shows the five standard wavelength regions used. They are ultraviolet, blue, visual, red, and infrared. The visual filter has its peak transmission in green wavelengths, matching the highest sensitivity of the human eye.

4 Light, Color, Filters, Seeing, and Transparency

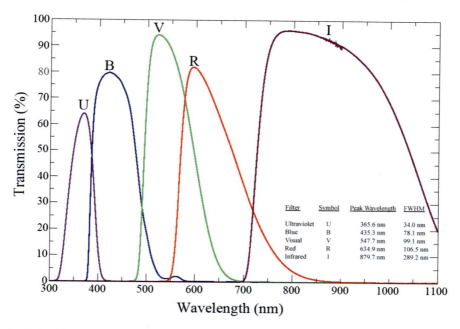

Fig. 4.8 Johnson-Cousins UBVRI filters for photometric measurements

A common way to classify the color of a star is to measure its magnitude through B and V filters. Looking at the various temperature curves in Fig. 4.9, it is apparent that knowing the intensity of a star in two color bands determines what temperature curve corresponds to a star's temperature and therefore its color. The *color index* of a star is related to the V magnitude subtracted from the B magnitude.

$$\text{Color Index} = B - V$$

The color index value could be positive or negative. Take, for example, the four stars in the Constellation Orion: Bellatrix, Betelgeuse, Rigel, and Saiph. The color index, temperature, and color for all four stars appear in the table below Table 4.2.

The table shows that the hotter a star is, the smaller (or more negative) its B–V color index and the bluer the star appears. The cooler a star is, the greater its color index and the redder the star appears.

Earth's atmosphere can affect the light from celestial objects and limit what can be seen from the ground. Astronomers use the two terms *seeing* and *transparency* to describe atmospheric conditions affecting light passing through the atmosphere to the ground.

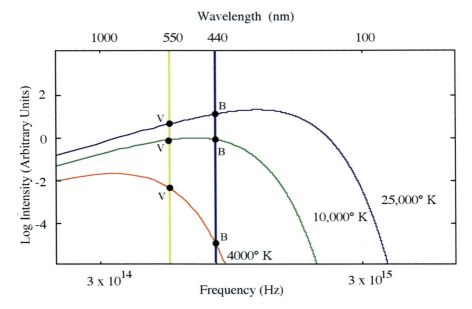

Fig. 4.9 Measuring the intensity (i.e., visual magnitude) of stars at two wavelengths, such as through B and V filters, specifies the temperatures of the stars and consequently their colors

Fig. 4.10 Seeing disk example

Table 4.2 Color index (B–V) and color for four stars in Orion

Star	B–V	Temperature	Color
Betegeuse	1.74	3100 K	Orange
Bellatrix	−0.14	16,400 K	Blue-white
Rigel	0.02	9800 K	White
Saiph	−0.11	14,600 K	Blue-white

4 Light, Color, Filters, Seeing, and Transparency

Seeing is related to the twinkling of stars. When there is turbulence in the atmosphere, stars twinkle. On calm nights, they do not twinkle much at all. When a star twinkles, it randomly moves around a disk-shaped region in the sky.

As illustrated in Fig. 4.10, twinkling causes a star to move around randomly within a certain diameter region in the sky. The greater the twinkling is, the larger the diameter of the disk. The disk is called a *seeing disk*. The diameter of the disk is measured in arcseconds. Recall that an arcsecond is 1/3600 of a degree of declination. Therefore, astronomers measure seeing in arcseconds. On an average night in the central part of North America, the seeing might be 2–3 arcseconds. On a bad night, it might be 6 or more arcseconds. An exceptional night would be one arcsecond or better, what we call subarcsecond seeing.

Certain parts of the globe experience very smooth laminar flow of air where the seeing is often better than average. Often these locations are on the tops of mountains. Thus, most major observatories are located atop high peaks.

Transparency is the opposite of opacity. When the skies are opaque, the transparency is very poor. On exceptionally clear nights, the transparency of the atmosphere is excellent. Clouds, dust, air pollution, and water vapor typically hinder the transparency of the atmosphere above an observer. The better the transparency is, the less the reflection of city lights drown out the night skies. Transparency is typically much better at higher elevations where there is less air above an observer, another reason major observatories are atop mountains. Clouds and water vapor are less prevalent in deserts, making the skies more transparent. However, if surface winds are strong, dust can limit transparency in deserts. The deeper blue the sky appears during the day, the better the atmospheric transparency. The more gray the clear sky appears during the day, the poorer the atmospheric transparency.

The above discussion of transparency only applies to visible light. In general, our atmosphere blocks most ultraviolet light, X-rays, and gamma rays. This is actually a good thing for life to survive on the surface of the Earth. There are also longer-wavelength regions that are absorbed by our atmosphere. For this reason, observatories are launched into spaces to conduct astronomical research in many nonvisible wavelength regions.

5

Stars

Parallax is a way to calculate the distance to nearby stars. Parallax is the shift in an object's position with respect to more distant objects when the viewing angle has shifted. Hold a finger out at arm length and look at it with one eye. Note the position of the finger with respect to the background. Shifting to the other eye shows that the finger's position moves with respect to the background objects. That is parallax.

Nearby stars are far enough that a very long baseline is needed to observe any parallax. Fortunately, Earth orbits the Sun. Every 6 months, half of the orbit is completed, and the diameter of Earth's orbit can be used as a baseline for parallax measurements.

Consider the parallax depicted in Fig. 5.1. Earth's orbit is depicted with the Sun at the center. The Earth-Sun separation is one astronomical unit (1 AU), which is 92,955,807 miles (149,597,871 km). From one side of Earth's orbit to another, the star is seen to shift by an angle of 2θ with respect to the background. The Greek letter theta (θ) is the parallax angle. From trigonometry for the right triangle with sides r and 1 AU, we know the following:

$$\tan \theta = \frac{1 \text{ AU}}{r}$$

Thus,

$$r = \frac{1 \text{ AU}}{\tan \theta}$$

© The Author(s), under exclusive license to Springer Nature Switzerland AG 2024
J. Dire, *Exploring the Universe*, The Patrick Moore Practical Astronomy Series,
https://doi.org/10.1007/978-3-031-65346-9_5

Fig. 5.1 Parallax of a star a distance r from the Sun

Parallax angles are very small, on the order of fractions of an arcsecond. If a star had a parallax of one arcsecond (1/3600 degree = 2.777×10^{-4} degree), its distance would be:

$$r = \frac{1 \text{ AU}}{\tan(2.777 \times 10^{-4} \text{ deg})} = 206{,}265 \text{ AU}$$

Astronomers define the distance 206,625 AU as one parsec. All close stars have parallax angles smaller than one arcsecond. Some astronomers like to use parsecs for distance. The parallax equation simplifies to:

$$\text{Distance (parsecs)} = \frac{1}{\text{Parallax } (arcsec)}$$

The distance r used in the above formula is the distance of a star from the Sun. Since stellar distances are so great compared to the Sun-Earth separation (1 AU), distances calculated by parallax are also the distances away from Earth. A parsec is approximately 3.26 light years (ly) where a light year is the distance that light travels in 1 year. A light year is 5.88 trillion miles (9.46 trillion km). The closest star to Earth is 4.2 ly.

Consider the star Vega shown in Image 5.1. Vega is the sixth brightest star visible from Earth. Vega has a parallax of 0.129 arcseconds. Its distance is therefore 1/0.129 = 7.75 parsecs. This is equivalent to 25.3 ly.

Consider the star Deneb shown in Image 5.2. Deneb is the 20th brightest star in our skies. Yet it has no measureable parallax with ground-based telescopes. Ground-based telescopes can measure the parallax of stars out to ~100 ly. The Hipparchus satellite was able to measure parallax for stars out to ~1000 ly. It too could not detect parallax for Deneb. Thus, Deneb is much farther than 1000 ly. For stars too far away to detect any parallax, distances must be measured using indirect methods.

The apparent brightness of any star depends on its luminosity (L) and its distance (r) according to the following relationship:

$$\text{Apparent brightness} \propto \frac{L}{r^2}$$

This is called an inverse square relationship since doubling the distance means a star is one fourth as bright.

Image 5.1 The constellation Lyra taken with a Canon 600D camera set at ISO 800 with a 100 mm lens set at f/3.5. The exposure was 640 s. The bright blue-white star is Vega (Alpha Lyrae)

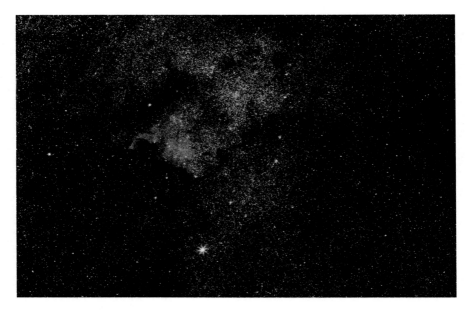

Image 5.2 The bright blue-white star Deneb (Alpha Cygni) resides near the North America Nebula (NGC7000). The image was taken with a Canon 30D camera set at ISO400 with a 100 mm lens set at f/4. The exposure was 30 min

The luminosity of a star can be determined using theoretical models. Once a star's luminosity is known, its brightness is given by something known as *absolute magnitude* (M). The absolute magnitude is the magnitude a star would have if it were located 10 parsecs away. This is different than the *apparent magnitude* (m) of a star, which is how bright a star appears in nighttime sky. Once M and m are known for a star, its distance can be determined using the following relationship:

$$m - M = 5 \log r - 5$$

where "log" stands for the base 10 logarithm and r is the distance in parsec.

The star Deneb has an apparent magnitude of 1.33 and an absolute magnitude of −8.65. The above formula gives Deneb's distance to be 990 parsec (3229 ly). If Deneb were as close as Vega, it would have an apparent magnitude of −9.33 and be the brightest object in the sky after the Sun and the Moon. It would be visible during the day! Although Deneb and Vega have the same color and nearly the same temperature, Deneb has a luminosity of 251,000 suns while Vega has a luminosity of 51 suns. Deneb has a radius 221 times that of the Sun, while Vega has a radius 2.51 times that of the Sun.

This leads us to explore how a star's luminosity depends on its temperature and radius. The luminosity (L) of a star is proportional to the product of its surface area and its effective temperature (T) raised to the fourth power. Mathematically, this is expressed as follows:

$$L = 4\pi R^2 \sigma T^4$$

Assuming that stars are roughly spherical, $4\pi R^2$ is the surface area of a star of radius R. Sigma (σ) is the constant of proportionality. This relationship was deduced by Josef Stefan (1835–1893) in 1879 and derived theoretically by Ludwig Boltzmann (1844–1906) in 1884. Thus, the equation is known as the Stefan-Boltzmann equation and σ is called the Stefan-Boltzmann constant.

Spectroscopy and photometry can be used to deduce the luminosity and temperature of stars. Their radii can be deduced using the Stefan-Boltzmann equation.

Before modern understanding of spectroscopy, stars were classified by the strength of their hydrogen spectral features. It was thought that the stronger a star's hydrogen spectral features, the greater percentage of hydrogen the star contained. The classifications in the order of decreasing hydrogen abundance were called A,B,C,D,.....P. Today, we know that the elemental abundance of most stars does not vary that much. Stellar surface temperature mostly gives stars their distinguishing spectra. Instead of redefining the stellar classifications, the existing types were reordered according to temperature. Only the seven classifications in Table 5.1 were necessary to account for the range of surface temperatures.

Each spectral class is subdivided into ten divisions numbered 0 to 9. The hottest subdivision is numbered 0 and the coolest is numbered 9. Figure 5.2 demonstrates how these divisions and subdivisions are arranged by stellar temperature.

Table 5.1 Star spectral classes

Spectral class	Temperature (K)
O	30,000
B	20,000
A	10,000
F	7000
G	6000
K	4000
M	3000

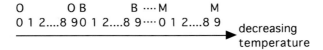

Fig. 5.2 Stellar classes and subclasses by temperature

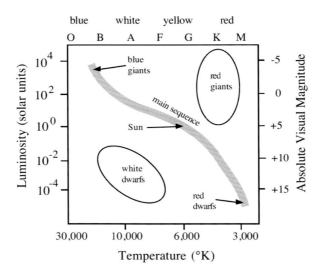

Fig. 5.3 Hertzsprung-Russell diagram

The first astronomers to explore the relationship between temperature and luminosity of stars were the American astronomer, Henry Norris Russell (1877–1957), and the Danish astronomer, Edjar Hertzsprung (1873–1967). Today, plots of luminosity versus temperature are known as Hertzsprung-Russell diagrams, or H-R diagrams for short (Fig. 5.3).

When all stars were plotted on H-R diagrams, 90% of the stars fell on a band corresponding to the *main sequence*. On the top end of the main sequence, the stars are hot and luminous. They appear blue in color and are approximately ten times the diameter of the Sun. These stars are called *blue giants*. On the bottom of the main sequence, the stars are very faint and cool. They appear red in color and are approximately 0.1 times the diameter of the Sun. These stars are called *red dwarfs*. The Sun is an average yellow dwarf star that falls in the middle of the main sequence.

Approximately 9% of stars are hot A-type stars that are not very luminous. These stars are called *white dwarfs* and are found below and to the left of the main sequence. Finally, 1% of all stars are cool but very large and luminous. These are the *red giants* and are found above and to the right of the main sequence.

Stars are called dwarfs if they have diameters less than ten times that of the Sun. Thus, the Sun (spectral class G5) and Vega (A0) are dwarf stars. Giant stars are those with diameters 10–100 times greater than that of the Sun. Stars greater than 100 times the diameter of the Sun are called supergiants. Deneb (spectral class A2) is a supergiant!

For stars on the main sequence, determining their spectral type specifies their luminosity and thus their absolute brightness. Once their absolute and apparent magnitudes are determined, their distance is easily determined. This procedure assumes that no dust and gas lie between a star and the Sun, which might dim its apparent magnitude beyond what distance alone would. This assumption is incorrect so often that astronomers are always trying to estimate the dimming effect of interstellar gas and dust, to correct distance estimates.

Many stars appear to be *double stars*. Double stars could just be line-of-sight doubles that appear to be close together in the sky, but one is actually much closer and the other much farther. In most cases, double stars are stars that are gravitationally bound to each other. We call these *binary stars*. Some stars are in gravitationally bound stellar systems containing three or more stars. Astronomers have no accurate estimate of the percentage of stars in binary systems. Some estimate that 50% of sun-like stars are binary (the Sun is a single-star system) and that 70% of O stars are in binary or larger star systems. However, it is thought that a majority of red dwarf stars, perhaps 75% or more, are single-star systems. Since red dwarfs are the most common stars in the galaxy, and possibly in the universe, perhaps binaries make up a minority of all star systems.

Astronomers have special names for many types of binary stars. *Visual binaries* are stars that can be optically resolved into their components. The orbits of the stars can be determined by tracking their relative position over time. Once the orbits are known, the masses of the two components can be determined.

Binary stars that cannot be resolved but whose spectra show characteristics of two stellar types are called *spectroscopic binaries*. Spectroscopic binaries might have orbits that cause the stars to sometimes be moving toward us and other times moving away from use. This would result in Doppler shifts of their spectral lines. When one component's spectral lines are redshifted, the others would be blueshifted and vice versa. So unresolved binaries are spectroscopic binaries if their spectral lines show spectra of two different stellar types, alternating red and blue shifts of the spectral lines, or both.

Some unresolved binary stars vary in brightness as the stars mutually eclipse one another from our line of sight. These are known as *eclipsing binaries*. A typical light curve for an eclipsing binary system is shown in Fig. 5.4.

When a star wobbles periodically and it moves through a field of view with more distant background stars, there may be an unresolved component. These stars are called *astrometric binaries*.

The orbits of two binary stars of unequal masses are shown in Fig. 5.5. Both stars are in elliptical orbits around a common center of mass. The center of mass is at one of the focus points for each ellipse. Star A is more massive than Star B. Therefore, Star A orbits the center of mass in a smaller ellipse than does Star B.

As shown in Image 5.3, the star Epsilon Lyrae is a visual binary star when viewed through binoculars or small telescopes at low magnification. The two components are called Epsilon Lyrae 1 and Epsilon Lyrae 2. However, when longer focal length telescopes are used at higher magnifications and the seeing is better than two arcseconds, Epsilon Lyrae 1 and Epsilon Lyrae 2 can be resolved as visual binaries themselves.

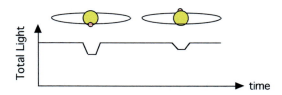

Fig. 5.4 A typical light curve from an eclipsing binary star where one star is more luminous than the other

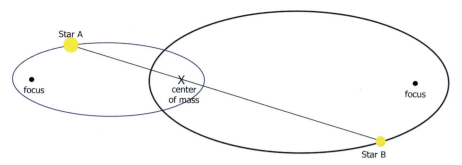

Fig. 5.5 The orbits for a set of binary stars of unequal mass. Each star has an elliptical orbit. All ellipses have two foci. The center of mass of the two stars is always at the focus point that is common to both eclipses

Image 5.3 The visual double star named Epsilon Lyrae near Vega on nights of good seeing with sufficient magnification can be split into four stars. Thus, Epsilon Lyrae is also known as the Double-Double Star

Image 5.4 Photograph or Mizar (left) and Alcor (right) taken with a 70-mm f/6 telescope. Note the elongated bump on Mizar showing it is a binary star

The middle star in the handle of the Big Dipper (Image 5.4) is a visual binary that can be seen with the naked eye. The brighter star is named Mizar and the dimmer star is Alcor. Telescopic views of Mizar and Alcor show that Mizar itself is a visual binary. The two components of Mizar are named Mizar A and Mizar B.

Image 5.5 The star cluster NGC884 has many colorful stars ranging from red to blue. The different colors are due to the different surface temperatures of the stars. The bright red star in the lower left corner is spectral class M2. The bright yellow-white star near the top center is spectral class A1, while the slightly less bright star of the same color to its left is A4. The brightest stars in the center of the cluster (not counting the red star) are mostly spectral class B. Many of these stars are binary stars that can be resolved with telescopes or that show the spectra of two different stellar types

Spectroscopic studies of Mizar A, Mizar B, and Alcor show that all three are spectroscopic binaries. Thus, the Mizar-Alcor system contains six stars!

Star clusters, such as NGC884 in Image 5.5, typically contain a plethora of double and binary stars. NGC884 also contains stars across all spectral types.

Table 5.2 lists the 20 brightest stars. Table 5.3 lists the 20 nearest stars. Note, only the Sun, Sirius, Procyon and Alpha Centauri appear on both lists. The remaining nearest stars are all faint K or M dwarf stars.

108 J. Dire

Table 5.2 The brightest stars

Name	Star	Distance (pc)	Apparent magnitude A	Apparent magnitude B	Absolute magnitude A	Absolute magnitude B	Proper motion (arcsec/year)
Sun			-26.72		+4.85		
Sirius	αCMa	2.70	-1.46	+8.7	+1.40	+11.6	1.33
Canopus	αCar	30	-0.72		-3.1		0.02
Alpha Centauri	αCen	1.30	-0.01	+1.3	+4.40	+5.7	3.68
Arcturus	α Boo	11	-0.06		-0.3		2.28
Vega	αLyr	8.00	+0.04		+0.50		0.34
Capella	αAur	14	+0.05	+10.2	-0.7	+9.5	0.44
Rigel	βOri	250	+0.14	+6.6	-6.8	-0.4	0.00
Procyon	αCMi	3.50	+0.37	+10.7	+2.60	+13.0	1.25
Betelgeuse	αOri	150	+0.41		-5.5		0.03
Achernar	αEri	20	+0.50	+1.0	-1.0		0.10
Hadar	βCen	90	+0.63	+4.0	-4.1	-0.8	0.04
Altair	αAql	5.10	+0.77		+2.2		0.66
Acrux	aCru	120	+1.39	+1.9	-4.0	-3.5	0.04
Aldebaran	αTau	16	+0.86	+13.0	-0.2	+12.00	0.20
Spica	αVir	80	+0.91		-3.6		0.05
Antares	αSco	120	+0.92	+5.1	-4.5	-0.3	0.03
Pollux	βGem	12	+1.16		+0.8		0.62
Formaihaut	αPsA	7.00	+1.19	+6.5	+2.0	+7.30	0.37
Deneb	αCyg	430	+1.26		-6.9		0.003
Mimosa	βCru	150	+1.28		-4.6		0.05

A and B refer to the two components of a binary pair

Table 5.3 The nearest stars

| Name | Distance | Apparent visual magnitude | | Absolute visual magnitude | | Proper motion |
	(pc)	A	B	A	B	(arcsec/year)
Sun		-26.72		+4.85		
Proxima Centauri	1.30	+11.05		+15.50		3.86
Alpha Centauri	1.33	-0.01	+1.33	+4.40	+5.70	3.68
Barnard's star	1.83	+9.54		+13.20		10.34
Wolf 359	2.38	+13.53		+16.70		4.70
Lalande 21,185	2.52	+7.50		+10.50		4.78
UV Ceti	2.58	+12.52	+13.02	+15.50	+16.00	3.36
Sirius	2.65	-1.46	+8.30	+1.40	+11.20	1.33
Ross 154	2.90	+10.45		+13.30		0.72
Ross 248	3.18	+12.29		+14.80		1.58
ε Eridani	3.30	+3.73		+6.10		0.98
Ross 128	3.36	+11.10		+13.50		1.37
61 Cygni	3.40	+5.22	+6.03	+7.60	+8.40	5.22
ε Indi	3.44	+4.68		+7.00		4.69
Grm 34	3.45	+8.08	+11.06	+10.40	+13.40	2.89
Luyten 789-6	3.45	+12.18		+14.60		3.26
Procyon	3.51	+0.37	+10.70	+2.60	+13.00	1.25
Σ 2398	3.55	+8.90	+9.69	+11.20	+11.90	2.28
Lacaille 9352	3.58	+7.35		+9.60		6.90
G51–15	3.60	+14.81		+17.00		1.26

A and B refer to the two components of a binary pair

6

The Moon

The Moon (Image 6.1) is our closest celestial neighbor. Since the Moon has a diameter 27% of the Earth's diameter, from a distance, the Earth and Moon might appear as a binary planet. However, the mass of the Moon is a mere 1.23% of the Earth's mass. Thus, the Moon orbits the Earth and is a satellite.

The Moon orbits the Earth every 27.3 days in an elliptical orbit with a *semi-major* axis of 238,900 miles (384,400 km). Referring to Fig. 6.1, the *semi-major* axis is denoted by the letter "a." The letter "b" denotes the *semi-minor axis*. For an ellipse, the *eccentricity* (e) is the ratio of the distance from the center of the ellipse to a focus point (ea) to the semi-major axis (a) of the ellipse. Eccentricity tells us how elongated the ellipse is. For a perfectly circular orbit, the eccentricity would be zero. Since the Moon eccentricity is 0.0549, its distance from the Earth varies by approximately 10%. At *perigee*, i.e., the Moon's closest point to the Earth in its orbit [a(1 − e) in Fig. 6.1], it is 225,700 miles (363,300 km) away. At *apogee*, the Moon's farthest point away from the Earth [(a + ea) in Fig. 6.1], its distance is 252,000 miles (405,500 km). Therefore, a full Moon occurring at perigee would be brighter than a full Moon at apogee.

As the Moon orbits the Earth, it goes through phases (Image 6.2). These are illustrated in Fig. 6.2. When it is closest to the Sun in the sky and passes through the same right ascension as the Sun, it is called a new Moon. We cannot see the Moon at this phase. Occasionally, it passes in front of the Sun causing a solar eclipse. The age of the Moon is given as the number of days past the new Moon.

© The Author(s), under exclusive license to Springer Nature Switzerland AG 2024
J. Dire, *Exploring the Universe*, The Patrick Moore Practical Astronomy Series,
https://doi.org/10.1007/978-3-031-65346-9_6

Image 6.1 The Moon 1 day past full. The image was taken with a William Optics 132 mm f/6 apochromatic refractor using a Canon 600D camera. The exposure was 0.001 s at ISO 200

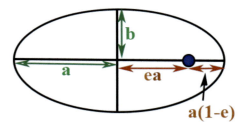

Fig. 6.1 The Moon's orbit around Earth is elliptical (exaggerated in the figure). The Earth is the blue dot at one focus point of the ellipse. The long axis of the ellipse is called the major axis, while the short axis is the minor axis

Approximately 7 days past the new Moon, the Moon is in the first quarter. During first quarter, half of the side of the Moon facing the Earth is in sunlight. Thus, we see one quarter of the Moon's surface illuminated.

The southern half of the first quarter Moon appears in Image 6.3. The region where the sunlight side of the Moon meets the nighttime side is called the *terminator*. Near the terminator, shadows are observed around mountains and crater rims. In the terminator region, the Sun is rising as seen from the surface of the Moon.

Image 6.2 Four-day-old moon (waxing crescent) taken on July 26, 2017, using a William Optics 61 mm f/5.6 refractor. The crescent was overexposed to bring out the night side of the Moon illuminated by Earthshine. Image cropped

When the Moon is between first quarter and full, it is called a waxing gibbous Moon. Waxing is used because more of the side facing the Earth is illuminated by the Sun than on the previous day. Between full and last quarter, it is called a waning gibbous Moon (Image 6.4). Waning is used since the lunar surface facing the Earth is less illuminated than that on the previous day.

The full Moon occurs on day 14 or 15 of the lunar cycle. The Moon appears nearly full the day before or the day after a full Moon and is virtually indistinguishable from perfectly full (Image 6.1). The full Moon shines at magnitude −12.7 and is 12 times brighter than the first quarter Moon.

The last quarter (also called third quarter) Moon occurs approximately 21 days after the new Moon. During last quarter, the eastern half of the side of the Moon facing Earth is illuminated. The terminator is in approximately the same location as during First Quarter except that the shadows are now on the opposite sides of the mountains and craters. Points on the surface of the Moon at the terminator would be observing sunset.

The Moon orbits the Earth in the same direction the Earth orbits the Sun. During the lunar cycle, the Earth travels more than one twelfth of the way around the Sun. Thus, the Moon has to travel past one full orbit to reach the same right ascension as the Sun. Although the period of the Moon's orbit is

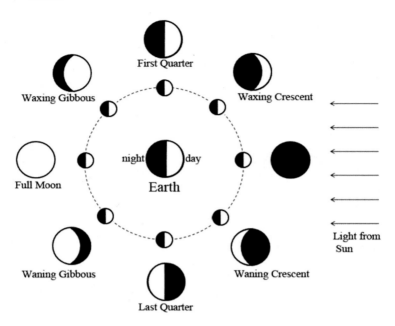

Fig. 6.2 The phases of the Moon

27.3 days, the time between new Moons, called the synodic period, is 29.5 days. This is the same length of a solar day on the Moon!

The same side of the Moon always faces the Earth. It is common in a binary system like the Earth-Moon or Pluto-Charon for tidal forces to decelerate the components, so they orbit at the same rate at which they revolve. This is known as tidal lock. Pluto and its moon, Charon, form a binary planet where the same side of Pluto always faces Charon and the same side of Charon always faces Pluto. They orbit a common center of mass every 6.4 days, and each sees the other at the same position in the sky from the sides facing each other.

In the Earth-Moon system, insufficient time has passed for the Earth to slow down so the same side always faces the Moon. The Earth's rotational rate is slowing due to tidal forces from the Moon. As the Earth rotates more slowly, the Earth-Moon separation increases to conserve angular momentum. Ultimately, the Earth will slow down such that the length of the terrestrial day will equal the length of the lunar month. The same side of the Earth will always face the Moon and the Moon will always be in the same point in the sky on the side of the Earth facing the Moon and vice versa. Astronomers estimate that this might take tens of billions of years. Long before then our Sun will become a red giant star and that may engulf the Earth and Moon!

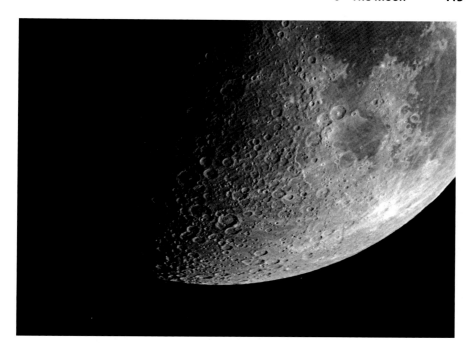

Image 6.3 First quarter Moon taken with a Discovery 10-inch f/6 Newtonian outfitted with a Paracorr II Coma corrector. The image was taken with a SBIG ST-2000XCM CCD camera and the exposure was 0.01 s

The Moon is the most studied celestial body in the heavens. Many spacecraft have landed on the Moon and studied it from orbit. Twelve Apollo astronauts walked on the Moon and brought back samples of its surface rocks and soil.

The Moon's surface consists of highlands and maria. The highlands are light-colored regions that include mountain ranges. The maria are darker regions at lower elevations. They compose 17% of the lunar surface and are mostly located on the side facing the Earth. Of course, the Moon is heavily cratered. It has no atmosphere or surface liquid to erode away impact features. Astronomers estimate that the Moon has more than 30,000 craters greater than 1 km in diameter.

The Moon is composed of silicate rocks and does not have an iron core like the Earth. This is why the Moon's density is so much lower than the Earth's density. With no iron core, the Moon also does not have a magnetic field.

All surfaces on the Moon are covered with small fragmented rock and dust. Most of the rocks and dust were created by the heavy bombardment early in the history of the solar system responsible for most of the craters we see today.

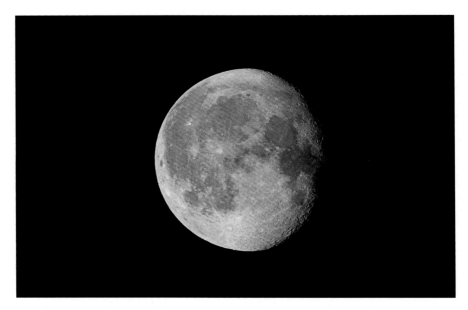

Image 6.4 A waning gibbous Moon taken with Stellavue 70-mm f/6 apochromatic refractor with a Canon 600D camera. The exposure was 1/160 s. This image was cropped

The layer of rocks and dust is called the regolith. It varies in depth from tens of meters in the maria to hundreds of meters in the highlands. The lunar soil also contains large quantities of small glass spheres. They are dark in color and about a millimeter in diameter. The glass spheres were formed when the silicates were heated up during meteoric impacts.

Volcanism occurred on the Moon between 3.3 and 3.8 billion years ago. The volcanic basalts filled the lower elevations forming the maria. Lava flowed from large fissures, not large volcanoes as on the Earth. The maria are thought to be about 3 miles (5 km) deep, created by multiple individual lava flows. Lava rivers also carved many canyons on the Moon.

Many craters on the Moon have rays emanating from them. These can be seen in the image above as well as other lunar photographs in this chapter. An example is shown in Images 6.5. The crater just to the right of the terminator, one third of the way from the top to the bottom, is the crater Copernicus (also shown in Image 6.6). The rays were formed when a large meteor hit the lunar surface in a highland region. The ejecta from the impact explosion send the light highland material radially outward. When the lighter material settled over maria or other darker regions, the difference in contrast became the rays we see today.

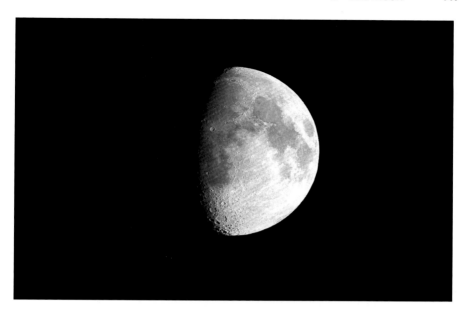

Image 6.5 Nine-day-old moon taken with an Explore Scientific AR152 6-inch f/6.5 achromatic refractor using a hydrogen beta filter. The image was taken with a Canon 600D camera

The craters on the Moon are circular shaped depressions. Most have rims that rise above the surface as much as the depth of the depressions. Some craters have a central peak in the middle of the depression.

As stated above, a crater is formed when a meteor strikes the Moon. The kinetic energy of the impactor is mostly converted to heat at the instant of contact, superheating and vaporizing the meteor and surrounding material. The superheated material expands in a massive explosion creating the craters and spreading ejecta outward from the crater. A crater can be up to ten times the size of the meteor that formed it. Since it is the explosion that creates the crater, not the impact itself, craters are round regardless of the angle of the strike. Secondary craters formed by ejecta are not formed by an explosion but by falling material. Therefore, they can be elongated in shape. The central peak is formed by material rebounding from the explosive compression.

Many phases of the Moon are visible during the day (Image 6.7). Phases around new and full (Image 6.8) cannot be seen during the day.

The Moon is one of seven large moons in the solar system. Jupiter has four large moons (Io, Europa, Ganymede, and Callisto), Saturn has one (Titan), and Neptune has one (Triton). All six of these large moons orbit in their

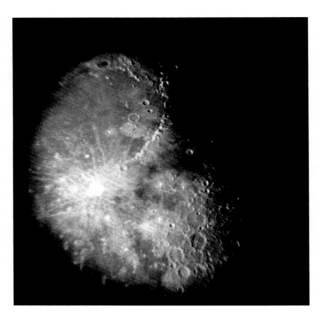

Image 6.6 Close-up of the crater Copernicus and the surrounding ray pattern. Taken with the 8-inch f/12 Alvin Clark refractor at the US Naval Academy using eyepiece projection with a 30-mm eyepiece around the third quarter phase

planet's equatorial plane. However, the Moon does not orbit in the Earth's equatorial plane.

The lunar orbit is in a plane tilted 5° to the ecliptic plane (the plane of the solar system). Because Earth's equatorial plane is tilted 23.5° to the ecliptic, the Moon reaches declinations from 28.5° north to 28.5° south. Image 2.8 shows how the planets and the Moon tend to lie close to the ecliptic plane.

Because the Moon's orbit is so close to the ecliptic, occasionally it passes near or in front of one of our solar system's planets. Additionally, the Moon will on a rare occasion pass in front of the Sun or through the Earth's shadow (see Chap. 8 on lunar and solar eclipses).

The Moon is often striking when it is in conjunction with or occulting a bright star or planet (Images 2.4, 2.6, 2.7, and 2.8). Sometimes the Moon just grazes a star as it moves eastward through the celestial sphere and the star can be seen passing through lunar valleys on its northern or southern edges! Almost every lunar month, there are great reasons to go outdoors and catch a glimpse of our closest celestial neighbor (Images 6.9 and 6.10).

6 The Moon 119

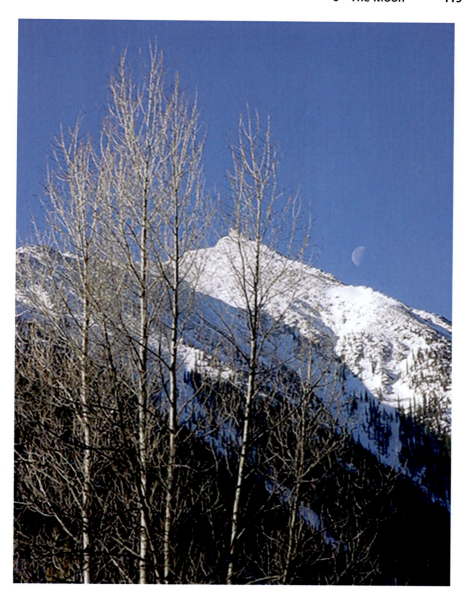

Image 6.7 The Moon can be viewed for as many hours during the day as at night. Using a telescope during the daytime will bring out nice detail near the terminator. This photo was taken with a Canon 600D camera with a 70–200 mm f/2.8 lens in the Colorado Rocky Mountains

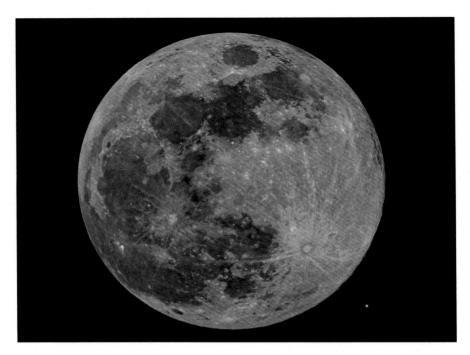

Image 6.8 On December 7, 2022, the full Moon passed very close to Mars as seen from Gray, Louisiana. This image was taken with a 102-mm f/7 apochromatic refractor with a Canon 60D camera. The image was cropped. Mars is the red dot to the lower right of the Moon. Although Mars was at its closest point to Earth for the year and was therefore a very bright celestial object, it is dwarfed in apparent size and brightness next to the full Moon

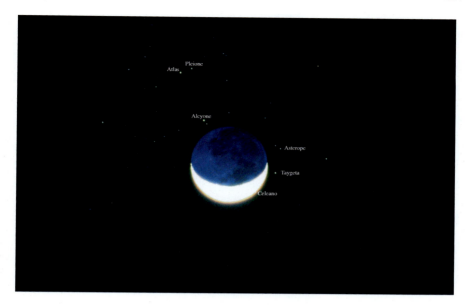

Image 6.9 A four-day-old Moon passing over the Pleaides star cluster. The image was captured through a Celestron 5-inch f/10 Schmidt Cassegrain telescope with a 10-second exposure using a Minolta X-570 camera with Ektachrome 100 slide film

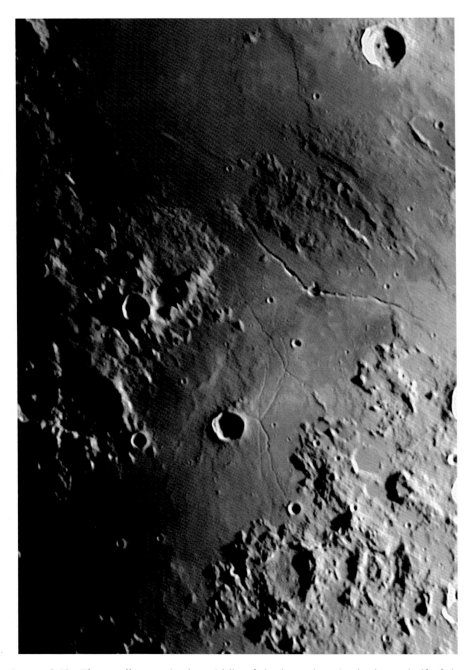

Image 6.10 The small crater in the middle of the lava plane in the lower half of the image is named Triednecker. The long crack or valley running from upper left to the lower right on the north side of the lava plane (with a crater in the middle of it) is known as Rima Hyginus. The image was taken with a ZWO ASI120MC camera on a 10-inch f/12 Cassegrain. The image was created by stacking 820 video frames

7

The Sun

The Sun is an average yellow dwarf star. It is the lone star, centered in a solar system in the Milky Way Galaxy, that we know provides light to a planet that contains life (Images 7.1 and 7.2)! It is our sun; therefore, we compare all other stars to it. We define the masses and diameters of all other stars in terms of our Sun's mass and diameter. Sometimes, we compare the Sun's parameters to Earth to get the scale with our home world.

Some of the properties of the Sun are listed in Table 7.1. As can be seen in the table, the Sun is 109 times larger in diameter than the Earth and 332,000 times as massive. Yet its overall density is only a quarter of Earth's density. That is because the Sun is made up of gases. While the Sun does not have a solid surface to land on, we can determine the surface gravity of the visual surface of the Sun (called the photosphere). This surface gravity is 28 times that on Earth. But that surface is at 5780 K (9944 °F), so not only would the gravity be oppressive, but so would the temperature.

The Sun rotates approximately once a month. But not being solid, the Sun rotates faster at its equator than near its poles. This differential rotation is also seen on Jupiter and Saturn, enormous planets that, like the Sun, are made up of gases.

Table 7.2 shows the elemental composition of the Sun. Like most stars (and the gas-giant planets), the Sun mostly contains the elements hydrogen and helium. Unlike the gas-giant planets, the Sun is too hot for atoms to combine into molecules.

© The Author(s), under exclusive license to Springer Nature Switzerland AG 2024
J. Dire, *Exploring the Universe*, The Patrick Moore Practical Astronomy Series,
https://doi.org/10.1007/978-3-031-65346-9_7

Image 7.1 The Sun rises over the Pacific Ocean as viewed from the island of Kauai

Image 7.2 The late afternoon Sun as seen from the slopes of Mauna Kea on Hawaii's Big Island

7 The Sun 125

Table 7.1 Properties of the Sun

Property	Value for sun	Comparison
Mass	1.989×10^{30} kg	332,000 m_{Earth}
Mean diameter (d)	1.3927×10^{6} km	109 d_{Earth}
Mean density (D)	1.41 g/cm^3	0.255 D_{Earth}
Surface gravity(g)	274 m/s^2	28.0 g_{Earth}
Sidereal rotation period	25.4 days mean rotation	
	25.1 days at equator	
	34.4 days at poles	
Axial tilt	7.25°	(relative to ecliptic)
Surface temperature	5780 K	
Luminosity	3.85×10^{26} W	1375 W/$_m^2$ incident on earth

Table 7.2 Elemental composition of the Sun

Element	% fraction by number of atoms	% fraction by mass
Hydrogen	91.2	71
Helium	8.7	27.1
Oxygen	0.078	0.97
Carbon	0.043	0.4
Nitrogen	0.0088	0.096
Silicon	0.0045	0.099
Magnesium	0.0038	0.076
Neon	0.0035	0.058
Iron	0.003	0.14
Sulfur	0.0015	0.04

The Sun has five main layers called the *core*, the *radiation zone*, the *convection zone*, the *photosphere*, and the *chromosphere*. These are shown roughly to scale in Fig. 7.1.

The core of the Sun is where nuclear fusion occurs providing the Sun with all of its energy. This fusion process combines atoms of hydrogen to form helium releasing an enormous amount of energy. The core temperature is ~15,000,000 K and the density is 150 $^g/_{cm}{}^3$. The Sun has enough hydrogen in the core to burn for another ~5 billion years.

The region surrounding the core is the radiation zone. This layer is 300,000 km thick and has a mean temperature of 7,000,000 K. Energy is transported through this layer via energetic photons. No photon created in the core makes it through this region. Photons are continuously emitted and absorbed as energy radiates upward.

The next outward layer is the convection zone. This region has a mean temperature of 2,000,000 K. Energy is transported from the interior upward via convection heat transfer. Heat is transported upward by successive cells as

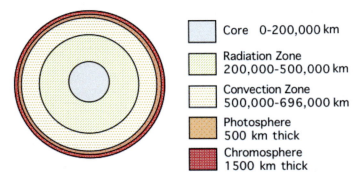

Fig. 7.1 The layers of the Sun

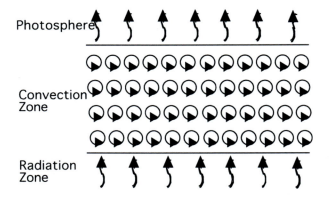

Fig. 7.2 The convection zone in the Sun

shown in Fig. 7.2. The largest convection cells are thought to be tens of thousands of kilometers in diameter.

The visual surface of the Sun is called the photosphere (Image 7.3). The photosphere is 500 km thick and has a mean temperature of 5780 K. The light incident on Earth originates from the photosphere.

Sunspots are large regions in the photosphere that appear darker than their surroundings (Image 7.4). High-resolution images show sunspots have a dark central region called the umbra (4500 K) surrounded by a gray region called the penumbra (5500 K). These regions only appear darker than the surrounding regions because they are colder and therefore less luminous. Sunspots are created by abnormally strong regions of magnetism that block the convective flow of hot gases. Each sunspot is a magnetic north or south pole and has a close-by companion sunspot of opposite polarity. The magnetic pairs are often vastly different in size. In the northern hemisphere, the leading sunspots in all the sunspot pairs have the same polarity. The leading sunspots in the southern

7 The Sun 127

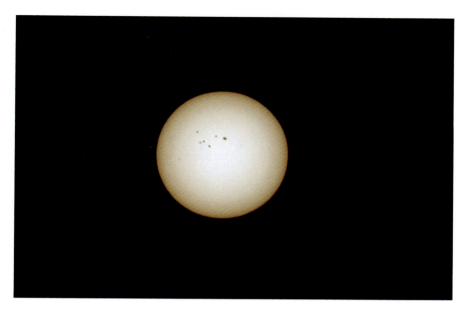

Image 7.3 The photosphere of the Sun in white light taken in 2014. Note the myriad sunspots

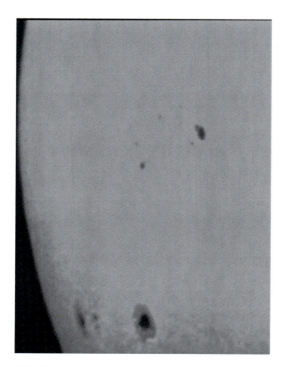

Image 7.4 White light image of the Sun captured with a Celestron 14-inch Schmidt-Cassegrain telescope showing sunspot pairs. The details on the large sunspots near the bottom clearly show the darker umbra regions surrounded by the lighter penumbra regions

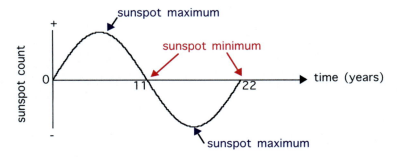

Fig. 7.3 The sunspot cycle

hemisphere all have the opposite polarity of their northern hemisphere counterparts. Sunspot pairs tend to drift toward the equator as the Sun rotates. However, they never cross the solar equator.

As depicted in Fig. 7.3, the number of sunspots present on the Sun varies with cycle that averages 22 years in length. Every 11 years, a maximum occurs with the polarities reversed. The next sunspot maximum is expected in July 2025.

High-resolution photography of the photosphere shows regions of bright and dark gas called granules. The granules are the tops of convection cells. Doppler shifts in spectra show that the light areas are rising and the dark areas are subsiding.

Image 7.5 shows the Sun in hydrogen alpha light, a.k.a. light emitted from hydrogen atoms at a wavelength of 636.5 nm. Hydrogen alpha filters are perfect for viewing *solar prominences* and *solar flares* (Images 7.6, 7.7, and 7.8). Solar prominences are violent eruptions in the photosphere resulting in large loops or sheets of glowing gas ejected from the photosphere into the solar corona. Prominences can last for days to weeks. Solar flares are another type of violent eruption resulting in hot gas released from the photosphere into the corona. Flares last minutes to hours and can release as much energy as solar prominence. Both phenomena can affect the Earth causing an increase in aurora activity, damage to satellite electronics, and outages in terrestrial power and communications grids.

The chromosphere is the lower atmosphere of the Sun. This layer lies above the photosphere and is ~1500 km thick. The chromosphere is cooler (4500°K) and not as bright as the photosphere. It is only visible during solar eclipses. It appears as a thin red layer surrounding the photosphere.

7 The Sun 129

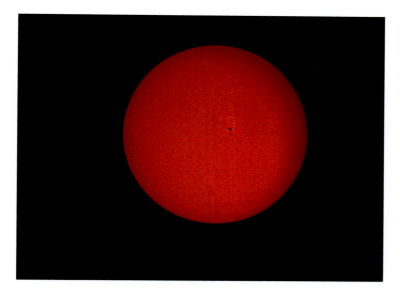

Image 7.5 The Sun shot with a small refractor and a hydrogen alpha filter (636.5 nm). This wavelength readily shows the solar granulations as well as an Earth-sized sunspot

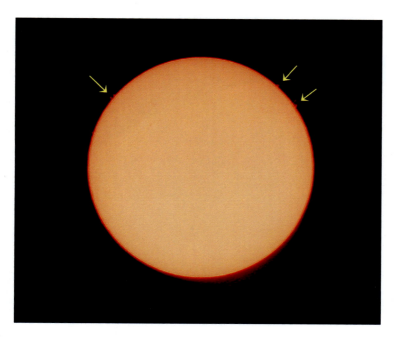

Image 7.6 This full-Sun image was slightly overexposed to bring out solar prominences at the 1, 2, and 10 o'clock positions. This prime focus image was taken with a Stellarvue 102-mm f/7.9 apochromatic refractor using a Canon 30D camera. A Coronado 40-mm hydrogen alpha filter was employed. The exposure was 1/20 s

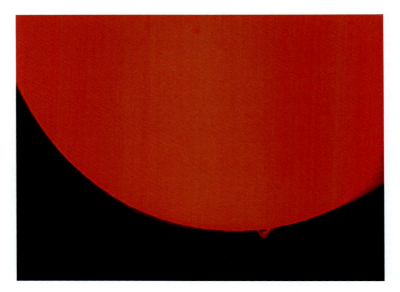

Image 7.7 This image of the Sun is zoomed in to see more detail of a solar prominence. Taken with Stellarvue 80-mm f/6 achromatic refractor with a 2× Barlow and a SBIG ST-2000XCM CCD camera. The exposure was 1/20 s with the same H-alpha filter as Image 7.6

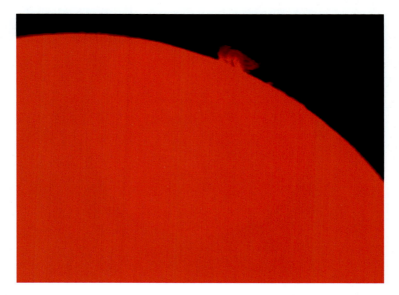

Image 7.8 A larger solar prominence taken with the same equipment and the same exposure as Image 7.7. Both images overexposed the photosphere drowning out the granulations. This was necessary to bring out detail in the prominences

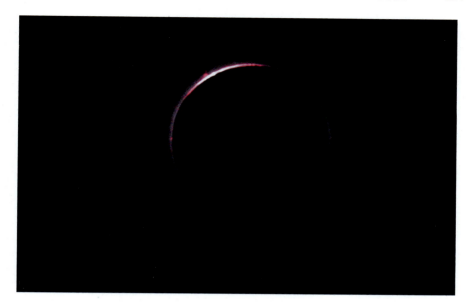

Image 7.9 Image of a solar eclipse showing the reddish-pink chromosphere

Image 7.9 was taken during a solar eclipse when the Moon had not quite covered all of the photosphere at the 11 o'clock position. Furthermore, at the 10 and 12 o'clock positions, the photosphere is covered by the Moon, but the chromosphere is still uncovered. The chromosphere is the red region on the Sun's circumference. This image was taken with a 4-inch f/10 Schmidt-Cassegrain telescope.

Everything above the Sun's chromosphere is called the corona. The corona (Image 7.10) is essentially the upper atmosphere of the Sun. Coronal temperatures reach 1,000,000 K. The cause of the temperature increase is probably due to magnetic heating of ions in the coronal atmosphere. The corona does not have an upper boundary and essentially dissipates into the solar wind.

The solar wind is a steady stream of particles moving away from the Sun in all directions. The Sun is essentially evaporating. The total mass lost during the lifetime of the Sun is less than 0.1% of its present mass. The solar wind interacts with Earth's magnetic field and is responsible for the aurora seen at polar latitudes (Image 7.11).

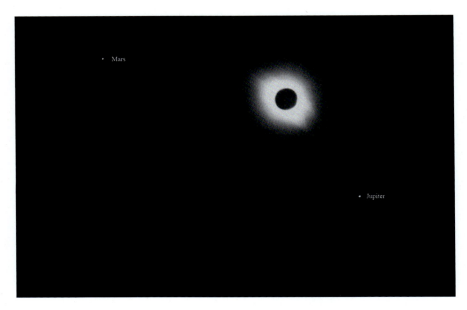

Image 7.10 The solar corona can be seen during a total solar eclipse. This wide-field image also captured the planets Jupiter (lower right) and Mars (upper left), which were located on the far side of the Sun at the time of this eclipse

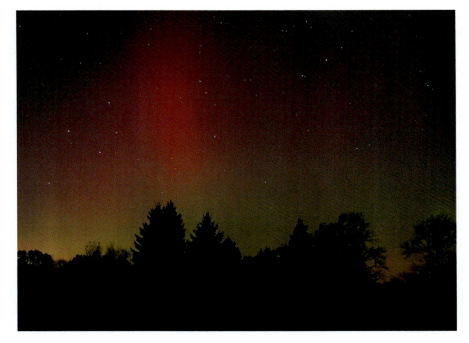

Image 7.11 Taken from Stonington, Connecticut, red, green, and blue emissions are captured in this image of the aurora borealis. The aurora is caused when particles from the solar wind collide with air molecules high in our atmosphere

8

Eclipses

Eclipses come in two flavors: solar eclipses and lunar eclipses. These occur when the Sun, the Moon, and the Earth are all along a line. When the alignment has the Moon in the middle it is called a *solar eclipse*. On Earth, we see the Moon pass in front of the Sun. When the Earth is in the middle, the Moon passes through the Earth's shadow. This is called a *lunar eclipse*. Solar eclipses occur when the Moon is new, while lunar eclipses occur when the Moon is full. Both are equally probable and fantastic to watch.

The Moon circles the Earth about once every month. The reason we do not have eclipses every month is related to the geometry of the Moon's orbit. Before addressing the geometry, a lesson in shadows is in order.

A light source that has a finite width, shining on an object, has various regions as illustrated in Fig. 8.1. The *umbra* is the dark part of the shadow. If the eye is in the umbra looking back at the source, none of the sources can be seen. The source is entirely blocked, or covered if you would, by the obstructing object.

Outside of the umbra is the second region, called the *penumbra*. If the eye is in the penumbra looking back at the source, the object is only partially obstructing the source. Part of the object is seen silhouetted in front of the source.

The last part of a shadow is called the *antiumbra*. When the eye is in the antiumbra looking back at the source, the object is so far away that it is too small to block or cover the entire source. The entire object is seen in silhouette in front of the source with a ring of light visible around it.

For eclipses, the Sun is always the light source. For lunar eclipses, the Earth is the obstructing object in Fig. 8.1. The Moon orbits very close to the Earth

© The Author(s), under exclusive license to Springer Nature Switzerland AG 2024
J. Dire, *Exploring the Universe*, The Patrick Moore Practical Astronomy Series,
https://doi.org/10.1007/978-3-031-65346-9_8

133

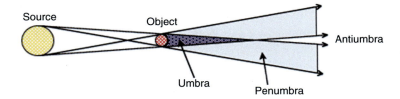

Fig. 8.1 Shadows have various parts

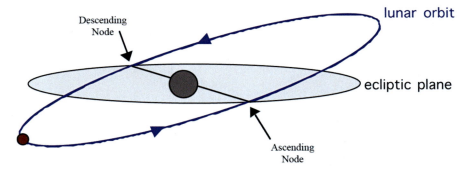

Fig. 8.2 The Moon's orbital plane is inclined to the ecliptic plane

compared to the distance from the Sun to the Earth. Therefore, the Moon will never be far enough away to pass through the Earth's antiumbra. It either passes through just the penumbra (called a *penumbral lunar eclipse*), partially into the Earth's umbra (called a *partial lunar eclipse*), or completely through the umbra (called a *total lunar eclipse*).

During a solar eclipse, the Moon is the object blocking the source as shown in Fig. 8.1. The Moon's umbral shadow is much smaller in length and diameter than the Earth's shadow. Add to this is the fact that the Moon's distance to the Earth varies in its orbit and the Earth's distance from the Sun varies in its orbit (orbits tend to be elliptical, not circular). Therefore, sometimes, only the Moon's penumbra touches the surface of the Earth (called a *partial solar eclipse*), sometimes only the antiumbra touches the surface of the Earth (called an annular solar eclipse), and rarely is the Moon's umbra cast on the Earth (called a *total solar eclipse*).

Now, we return to why eclipses do not occur every month. The Earth orbits the Sun in a plane we call the ecliptic. However, the Moon's orbit around the Earth is not in the ecliptic plane. Its orbital plane is tilted approximately 5° to the ecliptic. The tilt is exaggerated in Fig. 8.2.

The Moon passes through the ecliptic twice in its orbit around the Earth. We call those points in the lunar orbit *nodes*. The *ascending node* is where the

Moon passes through the ecliptic plane from south to north. The *descending node* is where it passes through the ecliptic from north to south. The line connecting the two nodes is called the *line of nodes*.

If the Moon is new or full, and at the same time it passes close to one of the nodes in its orbit around the Earth, an eclipse will occur. In other words, when the line of nodes points toward the Sun when the Moon is at or near a node, we have an eclipse. If at this time, the Moon is between the Earth and the Sun, a solar eclipse occurs. The shadow of the Moon falls upon the surface of the Earth. If at this time, the Earth is between the Moon and the Sun, a lunar eclipse occurs. The Moon passes through the Earth's shadow. Lunar eclipse pictures are found in Images 8.1, 8.2, 8.3, 8.4, 8.5, 8.6, and 8.7.

The line of nodes pictured in Fig. 8.2 remains approximately fixed in space as the Earth orbits the Sun. Every 6 months this line points toward the Sun. There is a ~ 38-day period centered on this time which is called an eclipse season. When a full or new moon occurs during an eclipse season, an eclipse occurs. Most years (70%) have two eclipse seasons. But occasionally, a

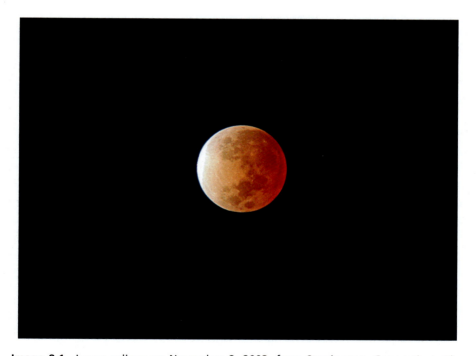

Image 8.1 Lunar eclipse on November 8, 2003, from Stonington, Connecticut. The image was taken with a Nikon Coolpix 4600 digital point-and-shoot camera using the device pictured in Image 2.16 attached to the eyepiece of a Celestron C5 Schmidt-Cassegrain telescope. The exposure was 5 s

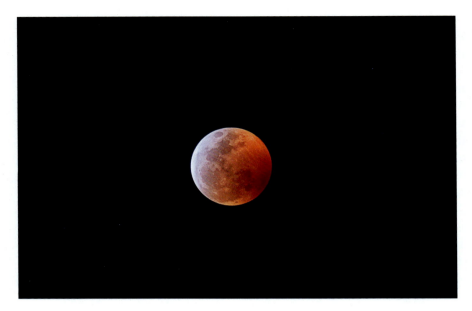

Image 8.2 Total lunar eclipse on January 21, 2019, from Dunlap, Illinois. The image was taken with a Canon 30D camera attached to a Stellarvue 70-mm f/6 triplet refractor. The exposure was 4 s at ISO800

calendar year can have three eclipse seasons: one in January, one in December, and one in between.

Since the synodic period (time between full Moons) of the Moon is approximately 29.5 days and an eclipse season lasts approximately 38 days, there are usually two eclipses in an eclipse season (one solar and one lunar). Occasionally, there are three eclipses in an eclipse season (two solar and one lunar or two lunar and one solar). The maximum possible number of solar and lunar eclipses in 1 year is seven. The average number is 4.5. Most of these are not *total* eclipses. The fact that total solar and lunar eclipses are so rare makes them that much more special to see.

The Earth's umbra is 1,384,000 km long, whereas the Moon's mean distance from the Earth is 385,000 km. The Moon's orbit is well inside the extent of the umbra. Therefore, the Moon can easily fit entirely within the Earth's umbra. This is illustrated in Fig. 8.3.

Keep in mind that lunar eclipses occur when the Moon is full. As the Moon enters the penumbra, it is receiving less sunlight and will dim slightly. When the Moon enters the umbra, it begins to get very dark. The Moon is darkest when entirely within the umbra. However, it is not totally dark. It looks red as illustrated in the total lunar eclipse images in this chapter.

8 Eclipses

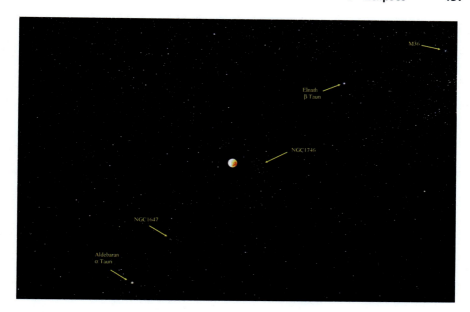

Image 8.3 Normally a starry field is impossible to see around the full Moon. But when the Moon is in the Earth's umbra, many stars are visible from a dark observing site. Taken on December 11, 2011, from Barking Sands, Hawaii, with a Canon 30D using a 50-mm lens set at f/2 riding piggyback on a tracking telescope. The exposure was 3 seconds

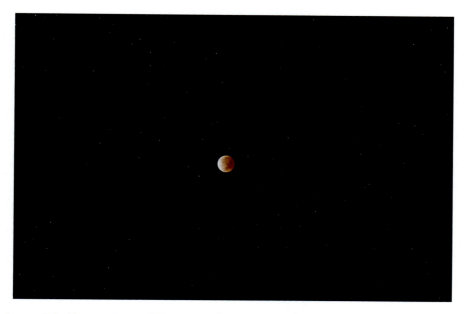

Image 8.4 Same as Image 8.3 except using a 100-mm lens at f/4 for 2 seconds

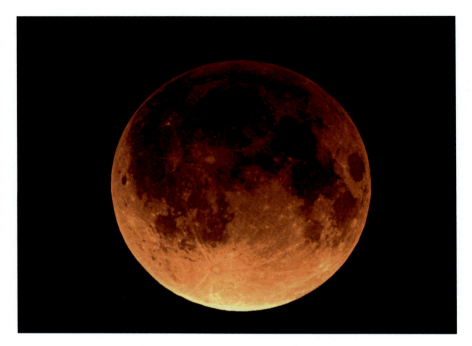

Image 8.5 Same eclipse and location as the previous two images. This image was taken with a Stellarvue 102 mm f/7.9 apochromatic refractor using a SBIG ST-2000XCM CCD camera. The exposure was 1 s

To understand why the Moon appears faintly red when it is entirely in the Earth's umbra, imagine you are on the Moon facing the Earth. Looking back at the Earth, you see that the Earth is entirely blocking the Sun. However, the layer of atmosphere around the Earth has a red glow similar to what we see in the west sky immediately after sunset on a clear day. This faint red glow provides the red illumination on the Moon's surface. Someday someone will take a picture from the Moon of what the Earth looks like during a total lunar eclipse. The photograph will be awesome!

The maximum duration of a lunar eclipse occurs when the center of the Moon passes through the center of the umbra. The Moon will take 6 h to transit from one side of the penumbra to the other. It will take 4 h to pass through the umbra, of which it will be entirely in the umbra for 1.5 h.

The three types of solar eclipses are illustrated in Fig. 8.4 and pictured in Images 8.8, 8.9, 8.10, 8.11, 8.12, 8.13, 8.14, 8.15, and 8.16. Total solar eclipses are only possible by a celestial coincidence. The Sun is approximately 400 times larger than the Moon. However, the Sun is approximately 400 times farther from the Earth than the Moon. Therefore, they appear to be the same size in the sky.

8 Eclipses 139

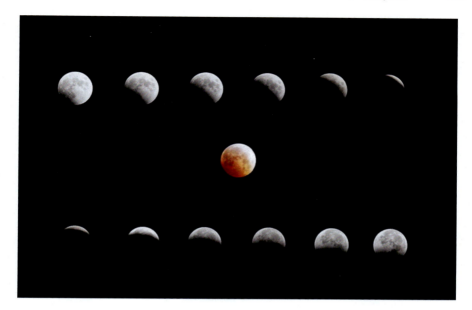

Image 8.6 This montage shows the Moon entering the umbra on the top row, leaving the umbra on the bottom row, and in the umbra in the middle. Taken on October 8, 2014, from Koloa, Hawaii, using a Canon 600D with 70–200 mm f/2.8 lens set at 200 mm f/3.5 ISO200. The partial phases had exposures from 0.001 to 0.01 s while the total eclipse exposure was 4 s

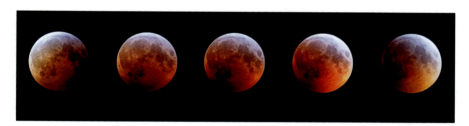

Image 8.7 This series shows that when the Moon passes through the umbra, except when it is in the very center of the umbra, the side of the Moon farthest from the center of the umbra will be brighter than the opposite side. These images are from the same lunar eclipse in Image 8.2

The maximum theoretical width of the Moon's umbra on the surface of the Earth is 167 miles (269 km). The eclipse would have to occur when the Moon is at perigee (its closest point to the Earth on its elliptical orbit). Calculations show that the maximum theoretical duration of totality is 7 min 31 s. The longest actual eclipse will occur on July 5, 2168. It will last 7 min 28 s.

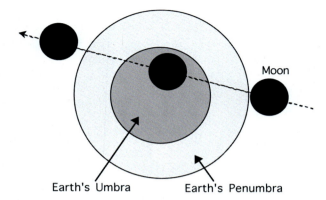

Fig. 8.3 The diameter of the Earth's umbra and penumbra at the distance of the Moon are illustrated here. The dashed line shows a possible path of the Moon through the Earth's shadow

Fig. 8.4 During a partial solar eclipse, the Moon covers only a part of the Sun (left). During a total solar eclipse, the Moon covers the entire Sun (center). When a solar eclipse occurs when the Moon is near its farthest orbital point from the Earth, it is too small to cover the entire Sun (right). This is an annular eclipse

The maximum theoretical width of the antiumbra on the surface of the Earth, for an annular solar eclipse, is 230 miles (370 km). The eclipse would occur when the Moon is at apogee (its farthest point to the Earth on its elliptical orbit). Therefore, the maximum theoretical duration of annularity is 12 min 30 s. The longest annular eclipse ever recorded was on December 14, 1955. It lasted 12 min 9 s.

Lunar eclipses can typically be viewed by more people than a solar eclipse. That is because the Moon is above the horizon for half of the globe at any one time. But the path of the Moon's umbra on the surface of the Earth during a solar eclipse is very narrow. So only a small strip on our globe is under the umbra during a total solar eclipse. All locations on Earth average one total solar eclipse every 400 years. Anyone who wants to see myriad solar eclipses in a lifetime must be willing to travel around the globe into the path of totality.

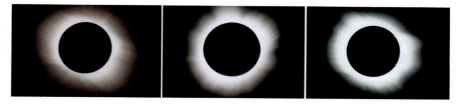

Image 8.8 Images of three different solar eclipses showing how the structure of the solar corona varies. Left: February 26, 1998, Aruba, 4-inch Schmidt-Cassegrain taken with Minolta X-570 35-mm SLR camera with Kodak Gold 100 film and a 2-s exposure. Middle: June 21, 2001, Zambia, Africa, 5-inch Schmidt-Cassegrain taken with Minolta X-570 35 mm SLR with Fujicolor 400 film and 0.5 s exposure. Right: March 29, 2006, Side, Turkey, 4-inch Schmidt-Cassegrain taken with Minolta X-570 35-mm SLR with Fujicolor 400 film and a 1-s exposure

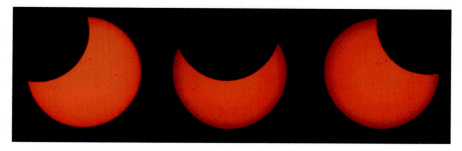

Image 8.9 A partial solar eclipse occurred on Christmas Day, 2000. Images taken from New London, Connecticut, using an 8-inch f/10 Schmidt-Cassegrain with a Thousand Oaks Type 2 solar filter, Minolta X-570 35-mm SLR camera, Kodak Gold 100 film, and 1/250-second exposures

Lunar eclipses are always safe to view. Since we can always look at the full Moon without the brightness hurting our eyes (much), seeing the Moon dim while passing through the Earth's shadow is not problematic.

However, it is not safe to look at partial solar eclipses, including annular solar eclipses, without a safe solar filter in front of your eyes or covering the front of a telescope if looking through one. However, during the total phase of a total solar eclipse, it is perfectly safe to view the eclipse with the naked eye. The views are mesmerizing. No single photographic image can reproduce what our eyes can see during a total solar eclipse. It takes your breath away!

Image 8.10 An annular eclipse at sunset seen through the clouds. The picture was taken from San Clemente Beach, California, on January 2, 1992

8 Eclipses 143

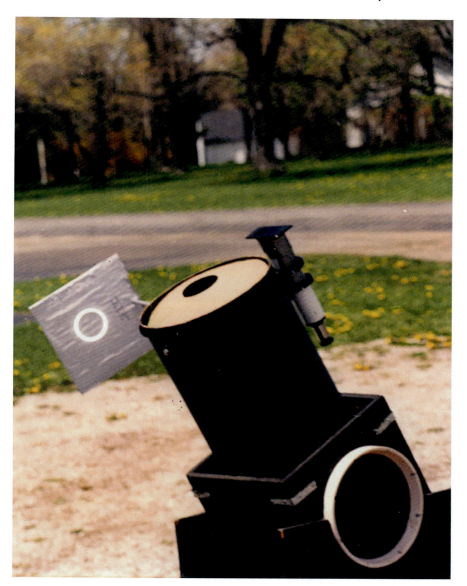

Image 8.11 A 6-min long annular solar eclipse occurred May 10, 1994, and was seen from Texas through Northern New England. Projecting a solar eclipse with a Newtonian is a great way to watch a solar eclipse. An appropriate eyepiece must be used that can take the heat generated where the Sun's rays converge. Note the aperture was stopped down to reduce the image brightness and eyepiece heat load. For a total solar eclipse, this method will reveal solar prominences and the corona. The image was taken in Silver Creek, New York. This is a safe method to view the Sun. **Never look directly at the Sun or through a telescope pointed at the Sun unless the telescope has an approved solar filter covering the tube**

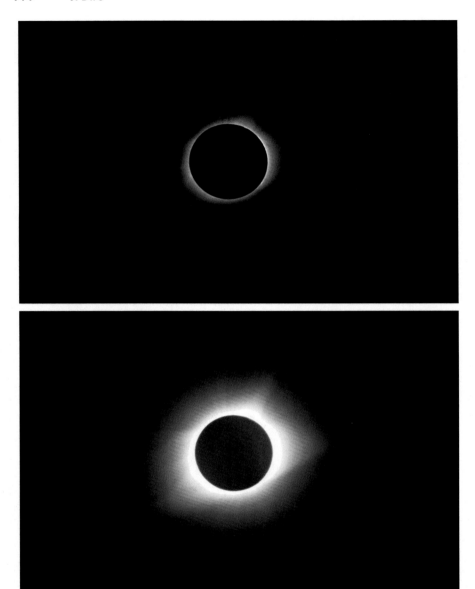

Image 8.12 Different length exposures of the same solar eclipse bring out different features as seen in these two images from the August 21, 2017, eclipse taken 40 miles east of Jefferson City, Missouri. The images were captured with a Canon 600D camera through a Stellavue 70-mm f/6 triplet refractor. The top photo was a 1/250-s exposure. It captured very little of the corona but many pinkish solar prominences. The bottom photo was a 1/25-s exposure where the corona drowns out the solar prominences. The dynamic range of the human eye allows both regions to be seen simultaneously during an eclipse

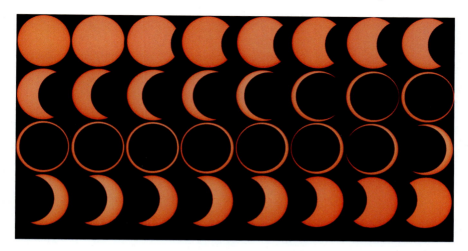

Image 8.13 A series of images tracking the entire annual solar eclipse of May 20, 2012, at Cathedral Gorge State Park, Nevada. All were taken with a Canon 600D camera, a 4-inch Schmidt-Cassegrain telescope, and a Thousand Oaks Type 2 solar filter

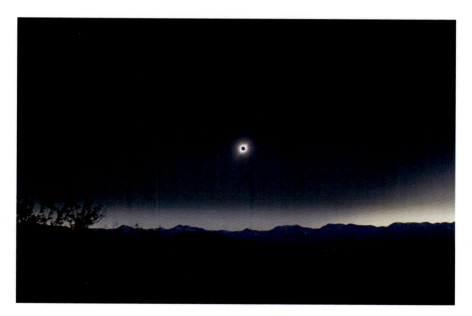

Image 8.14 Total solar eclipse over the snow-capped Andes Mountains. Taken July 2, 2019, on an 8000-ft elevation ridge east of Bella Vista, San Juan Province, Argentina. The image was shot with a Canon 30D camera with an 18–55-mm f/4.5–5.6 lens. The exposure was 0.1 s. The snow-capped peaks in the distance were more than 60 miles away and ranged from 16,000 to 18,000 feet in elevation

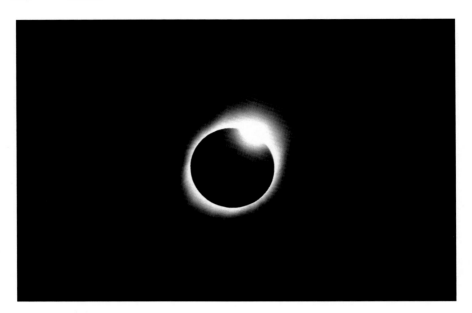

Image 8.15 During a total solar eclipse, the last bit of sunlight passing through a valley on the edge of the Moon the instant before totality begins, or the first bit of sunlight passing through a valley on the edge of the Moon at the instant totality ends, is called the diamond ring. This is the same eclipse in the last image shot with a Canon 600D camera and a Stellarvue 70-mm f/6 triplet refractor. The equipment used here is pictured in Image 1.15

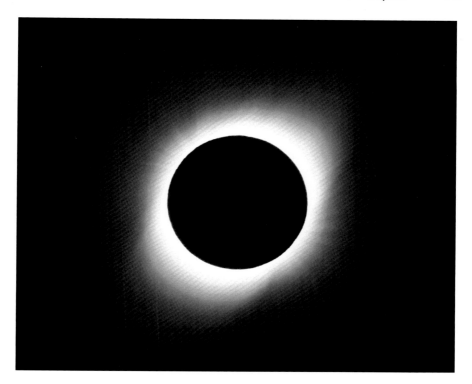

Image 8.16 Same eclipse and equipment used for the last image. This 1/20-s exposure captured a large extent of the corona with fine detail in its structure. The curving rays are caused by the Sun's magnetic field

9

Planetary Nebulae and Supernovae Remnants

In the heavens, a nebula is a cloud of gas that emits, reflects, or absorbs light. The word comes straight from the Latin word "nebula," which means cloud or mist. The plural of nebula is nebulae, again coming from Latin. This chapter only covers only two types of nebulae, planetary nebula and supernovae remnants, since they are formed by end-of-life stars. All other types of nebulae are covered in the next chapter.

Planetary nebulae (Images 9.1, 9.2, 9.3, 9.4, 9.5, 9.6, 9.7, 9.8, 9.9, 9.10, 9.11, 9.12, 9.13, 9.14, 9.15, 9.16, and 9.17) have nothing to do with planets. The name goes back to the English astronomer William Herschel (1738–1822). Herschel discovered the planet Uranus in 1781. In 1790, he discovered the planetary nebula NGC1514, which like Uranus, was small, round, and blue in the telescope. Herschel was able to see the object's central star. He hypothesized that the blue glow around it was gas or dust. Prior to this, he thought planetary nebulae were glowing unresolved stars.

Since many tiny nebulae looked like Uranus in the telescopes of the time, Herschel coined the term "planetary nebula" for these objects. Herschel cataloged 79 objects he thought were planetary nebulae. Only 20 of those turned out to truly be such. Another 13 objects he classified as something else turned out to be planetary nebulae. So, Herschel actually discovered 33 planetary nebulae.

The first planetary nebula discovered was M27, the Dumbbell Nebula. French astronomer Charles Messier (1730–1817) found M27 in the year 1764. M27 is one of the largest and brightest planetary nebulae known and is easy to see in a 3-inch telescope such as that used by Messier. Today, M27 is exceedingly popular among visual astronomers to spy using any size telescope.

© The Author(s), under exclusive license to Springer Nature Switzerland AG 2024 **149**
J. Dire, *Exploring the Universe*, The Patrick Moore Practical Astronomy Series,
https://doi.org/10.1007/978-3-031-65346-9_9

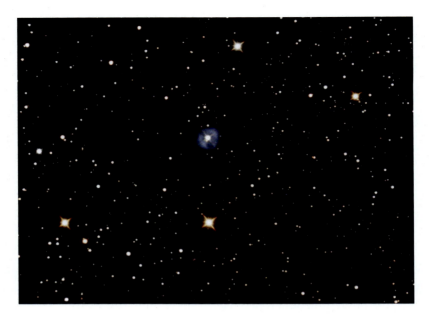

Image 9.1 NGC1514 is a magnitude 10.9 planetary nebula in the Constellation Taurus. The object is 2.3 × 2.0 arcminutes in size. The central star has a magnitude of 9.4. The image was captured with a 190-mm f/5.3 Maksutov-Newtonian telescope with a SBIG ST-2000XCM CCD camera. The total exposure was 40 min

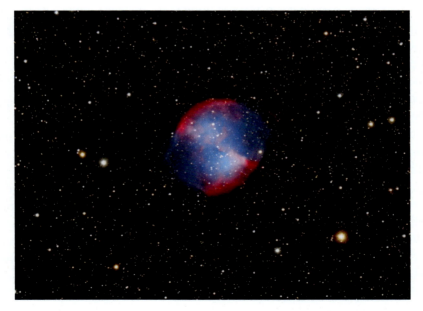

Image 9.2 The Dumbbell Nebula, M27, taken with a 10-inch f/6 Newtonian with a Paracorr II coma corrector yielding an effective focal ratio of 6.9. The total exposure was 60 min using a SBIG ST-2000XCM CCD camera. M27 has a magnitude of 7.3. It is 8.0 × 5.7 arcminutes in size and is located in the constellation Vulpecula

9 Planetary Nebulae and Supernovae Remnants 151

Image 9.3 NGC2371 is a magnitude 11.9 planetary nebula in Gemini 1.2x0.9 arc-minutes in size. The wide-field view on the left was taken with a Stellarvue 70-mm f/6 triplet refractor with a SBIG STF-8300C CCD camera. In that image, it is difficult to identify the nebula among the myriad stars. Zooming in on the region inside the yellow rectangle, the image on the right was taken with an 8-inch f/8 Ritchey–Chrétien telescope with a 0.8× focal reducer/field flattener yielding f/6.4 using a SBIG ST-2000XCM CCD camera. This 150-min exposure resolves the blue-white planetary nebula

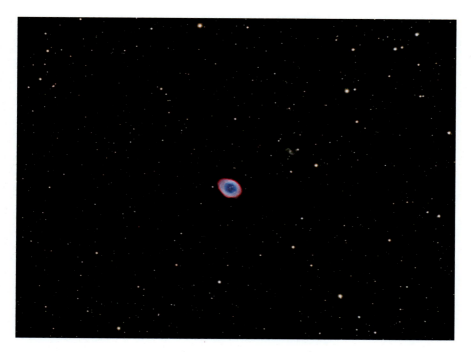

Image 9.4 M57, commonly referred to as the Ring Nebula is one of the most popular planetary nebulae viewed by visual astronomers. This magnitude 8.8 nebula resides in the constellation Lyra and measures 1.4 × 1.0 arcminutes in size. This 30-min exposure was taken with an 8-inch f/8 Ritchey–Chrétien telescope with a SBIG ST-2000XCM CCD camera

In rich field telescopes (telescopes with very small focal ratios) at low magnification, many planetary nebulae appear very small and star-like. Higher magnification is sometimes required to resolve the nebulae to confirm their nature.

Stars like the Sun produce their energy through nuclear fusion of hydrogen in their cores. The fusion of hydrogen produces helium. Therefore, the core of the Sun is decreasing in hydrogen abundance and increasing in helium abundance. In another five billion years, the Sun will not have enough hydrogen in its core for the outward nuclear fusion radiation pressure to balance the inward weight of the star.

At this time, the temperature in the core of the Sun will not be high enough for helium fusion to begin. However, there will still be a shell of hydrogen undergoing fusion around the core. The weight of the Sun will cause the mostly helium core to contract. As it contracts, the core temperature will increase causing the hydrogen shell to burn at a greater rate. This will increase the thermodynamic pressure of the gas surrounding the core pushing out the outer layers of the Sun. The outer layers of the Sun will expand and cool turning the Sun into a red giant star.

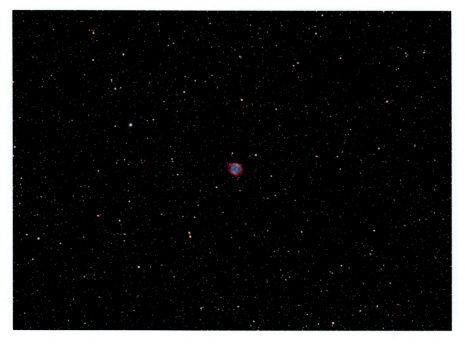

Image 9.5 NGC6563 looks similar to M57 although it is not as bright or as large. This magnitude 10.8 nebula is 50 × 37 arcseconds in size. It is located in the Constellation Sagittarius. The image was taken with a 10-inch f/6 Newtonian with a Paracorr II coma corrector yielding f/6.9. The total exposure was 40 min using a SBIG ST-2000XCM CCD camera

The Sun will remain a red giant until its core is hot enough for helium fusion to begin. When helium fusion begins in the core, the Sun's diameter will decrease and the photosphere will be much hotter, making the Sun less red in color. For a while, the outward radiation pressure from the helium fusion will balance the inward gravitational forces of the Sun and the star will be in steady state. Helium fuses into carbon and oxygen, so the core will gain these elements as it depletes helium. Eventually, there will not be enough helium in the core for helium fusion to balance the weight of the star. The core will once again contract and heat up. However, the core will never get hot enough for carbon fusion to occur.

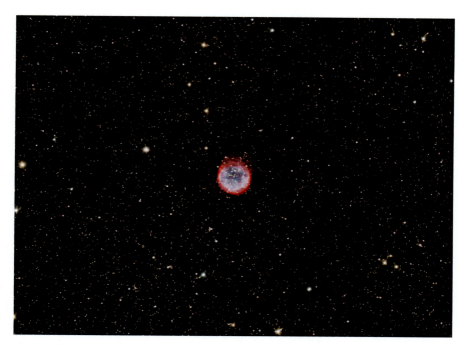

Image 9.6 Found in the constellation Aquila, NGC6781 is a magnitude 11.6 planetary nebula measuring 4.1 arcmintes in diameter. The same equipment was used here that was used for Image 9.5, except the total exposure time here was 150 min

There will be a shell of helium around the core undergoing fusion and a shell of hydrogen around also undergoing fusion. As the carbon core contracts and heats up, the rate of fusion in the shells surrounding the core increases. The increased radiation pressure will push out the outer layers of the Sun. For a while, the Sun will be a red supergiant. Its outer layers will continue to

expand away from the Sun and form a planetary nebula. The Sun may lose up to half its mass in layers that are thrown off. The Sun will turn into a blue giant as the remaining hot layers will have a blue color. The remaining star will eventually contract into what is called a white dwarf, a hot star that no longer has nuclear fusion occurring and is just radiating its stored thermal energy. Most stars between one and eight times the mass of the Sun will end their lives just like the Sun and go through a planetary nebula phase.

In some planetary nebulae, the central white dwarf star can be observed using a telescope. For NGC1514 in Image 9.2, the central star has a magnitude of 9.4 and can be seen in most telescopes. The central star in M27 has a magnitude of 13.7. It can be seen in 12- to 14-inch telescopes. The central star in M57 has a magnitude of 15.75 and can only be seen in the largest amateur telescopes. However, the star is easily captured in pictures such as Image 9.4 above.

Image 9.7 NGC6826 in the constellation Cygnus is 27 arcseconds in diameter. Its magnitude is 8.9. The image was taken with a 10-inch f/6 Newtonian with a Paracorr II coma corrector yielding f/6.9. The total exposure was 50 min using a SBIG ST-2000XCM CCD camera

NGC6826, pictured in Image 9.7, has a magnitude of 8.5 central star. The object is called the Blinking Planetary Nebula because when looking directly at it, only the central star is seen. However, looking slightly away from it, the nebula appears and the star fades from view. So, as the eye sweeps back and forth onto and off of the object, both the nebula and the star appear to alternately blink on and off. This effect is related to the placement of the rods and cones on the eye's retina and their different sensitivities to faint colored light.

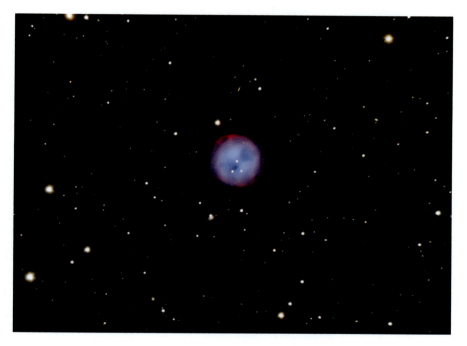

Image 9.8 M97, the Owl Nebula, is located in Ursa Major. The nebula has a magnitude of 9.8 and measures 3.4 arcminutes in diameter. The image was taken with the same equipment as Image 9.7 using a 150-min exposure. There are three 16th magnitude stars in the nebula. The central star is truly the only star in the nebula while the other two stars are either foreground or background stars

It is estimated that there are 20,000 planetary nebulae in the Milky Way Galaxy, although only about 1800 have been identified. Most of the others are probably obscured by the gas and dust in the plane of the galaxy. As can be seen in the photographs herein, they come in all sorts of shapes. Astronomers are not sure why their shapes vary so widely. Possible causes are different stellar winds, the effects of gravity from nearby objects, and of course the orientation they present to our line of sight.

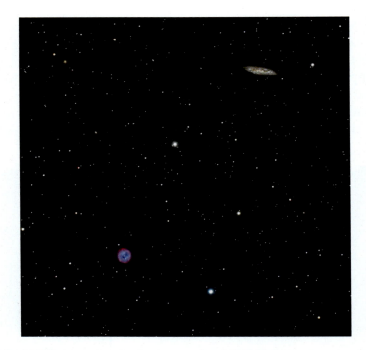

Image 9.9 M97 lies very close in the sky to galaxy M108. This image was captured with a William Optics 132-mm f/7 apochromatic refractor using a 0.8× focal reducer/field flattener to yield f/5.6. This 90-min total exposure was taken using a SBIG ST-4000XCM CCD camera. Many of the small star-like dots in this image are smaller, fainter galaxies. The author has counted approximately 70 galaxies in the image down to magnitude 18

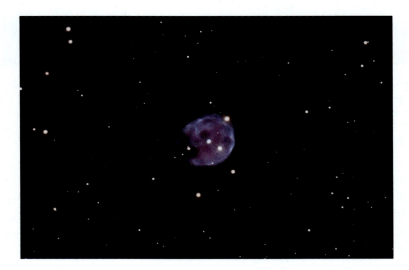

Image 9.10 NGC246, a.k.a. the Skull Nebula, is found in the Constellation Cetus. This nebula is 4.3 × 3.5 arcminutes in size and shines at magnitude 10.4. The image was taken with an 8-inch f/8 Ritchey–Chrétien Cassegrain with a 0.8× focal reducer/field flattener yielding f/6.4 using a SBIG ST-2000XCM CCD camera. The exposure was 240 min

9 Planetary Nebulae and Supernovae Remnants

Image 9.11 NGC7662 is also known as the Blue Snowball Nebula. This tiny nebulae is 37 arcseconds in diameter. The enlarged insert shows some of the structure within the nebula. The image was taken with a William Optics 132-mm f/7 apochromatic refractor and a SBIG ST-2000XCM CCD camera with a 20-min exposure. The nebula has a magnitude of 8.6

The gases in the nebulae are easy to identify using spectroscopy. The most abundant gases tend to be hydrogen, helium, carbon, oxygen, and nitrogen. While stars such as the Sun will undergo nuclear fusion for some ten billion years, the planetary nebula stage is very short, perhaps 10,000–30,000 years.

Stars of different masses age at different rates. Since at least half of the stars in the galaxy are binary stars, when two low-mass stars exist in a binary pair, one will likely reach the planetary nebula phase before the other. One example of such is NGC1360. The central star clearly visible in Image 9.13 consists of two stars with masses of 0.555 M_\odot and 0.679 M_\odot, respectively (M_\odot is the symbol astronomers use for the mass of the Sun.) The orbit of the pair along with different stellar winds probably played a part in forming the egg shape of the planetary nebula.

Some planetary nebulae are observed in star clusters, but this is rare. Stars like the Sun were born in galactic star clusters (Chap. 11). Most of these star clusters dissipate long before their stars reach the end of their lives. Therefore, very few planetary nebulae exist in galactic star clusters. There is one in the cluster NGC6067 in the constellation Norma. Four planetary nebulae have been identified in globular star clusters (Chap. 12). This is surprising because globular star clusters do not tend to have Sun-like stars in them. All of the planetary nebulae found in star clusters are too faint to be seen or imaged in small telescopes.

Image 9.12 NGC3242 is most frequently called the Ghost of Jupiter Nebula. The image was taken with an 8-inch f/8 Ritchey–Chrétien Cassegrain with a 0.8× focal reducer/field flattener yielding f/6.4 using a SBIG ST-4000XCM CCD camera. Twenty-five arcseconds in size, this nebula shines at magnitude 8.6. The insert shows a structure similar to that seen in the Blue Snowball Nebula

9 Planetary Nebulae and Supernovae Remnants

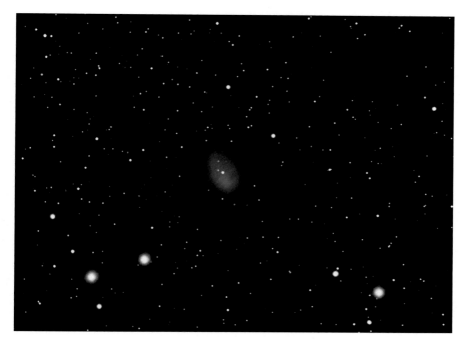

Image 9.13 NGC1360, the Robin's Egg Nebula lies in the Constellation Fornax. The nebula has a magnitude of 9.4 and is 11.0 × 7.5 arcminutes in size. This image was taken with a Stellarvue SV102 102 mm apochromatic refractor using a 0.8× focal reducer/field flattener to achieve f/6.3. The exposure was 130 min using a SBIG ST-2000XCM CCD camera

A planetary nebula (NGC2438) appears to reside in the open star cluster M46 in Puppis. However, it is actually a line-of-sight foreground object. The nebula lies approximately 1370 light years away, while the cluster is approximately 5000 light years away. NGC 2438 is receding from us at approximately 77 km/s, much faster than the cluster's radial velocity of 41.4 km/s. While the nebula is moving away faster than the cluster, its direction of motion is not exactly toward the star cluster. They will never meet. Nonetheless, viewing M46 with an apparent planetary nebula within it is quite spectacular.

The human eye does not see color well in faint light conditions. Therefore, in telescope eyepieces, many of the colorful planetary nebula shown here appear as shades of gray. A blue color is visually discernible in some planetary nebulae, especially NGC 3242 and NGC7662.

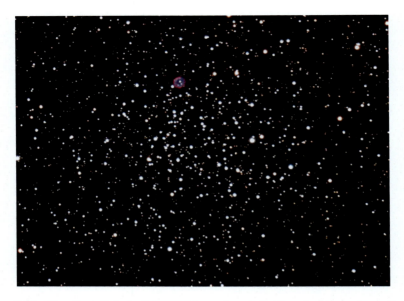

Image 9.14 Planetary Nebula NGC2438 (near top, left of center) has a magnitude of 10.8 and is 66 arcseconds in diameter. The image was taken with a Parallax 20-inch Ritchey–Chrétien Cassegrain with a SBIG ST-2000XCM CCD camera. The exposure was 20 min

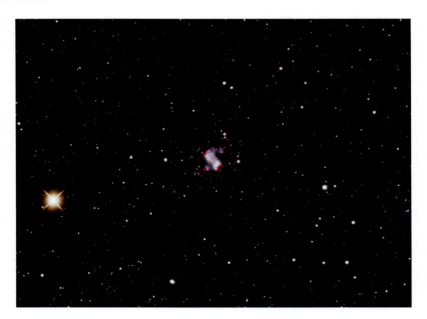

Image 9.15 M76 is also called the Little Dumbbell Nebula. It shines at magnitude 10.1 in the constellation Perseus. The nebula is 2.7 × 1.8 arcminutes in size. The image was taken with an 8-inch f/8 Ritchey–Chrétien Cassegrain with a 0.8× focal reducer/field flattener yielding f/6.4 using a SBIG ST-2000XCM CCD camera. The total exposure was 240 min

9 Planetary Nebulae and Supernovae Remnants 161

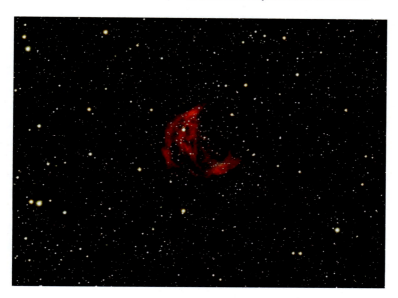

Image 9.16 This nebula is known by the names Abell 21 and the Medusa Nebula. The nebula is much brighter on one side than on the other due to composition differences and/or obscuring dust along our line of sight. The central star is a faint little blue star barely visible in the image. The image was captured with a 190-mm f/5.3 Maksutov-Newtonian with a SBIG ST-2000XCM CCD camera. The total exposure was 180 min

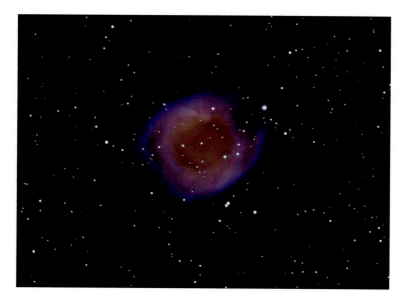

Image 9.17 One of the brightest, largest, and most beautiful planetary nebulae is NGC7293, the Helix Nebula, found in the constellation Aquarius. This nebula has a magnitude of 7.6 and is 25 arcminutes in diameter. The image was taken with the same equipment as in Image 9.16 but with an 80-min exposure. The central star is a white dwarf shining at magnitude 13.4, well within reach of the large amateur telescopes

Stars larger than eight to ten times the mass of the Sun end their lives much differently than dwarf stars. Whereas the Sun will end up as a white dwarf star with a carbon-oxygen core, having lost possibly half its mass in the planetary nebula phase, these more massive stars can fuse carbon and oxygen. When one of these more massive stars stops fusing helium in its core, the weight of the star is no longer balanced by the outward radiation pressure from the core. The core will compress and heat up enough to ignite carbon and oxygen fusion. This fusion stage creates mostly silicon. When the core is depleted of carbon and oxygen, it heats up enough for silicon to fuse into iron.

The higher the mass of a star, the quicker the star goes through successive fusion stages. A 20-solar mass star will undergo hydrogen fusion in the core for ten million years (compared to ten billion years for the Sun). The helium produced will all be used up in 100,000 years. Carbon fusion will last approximately 1000 years, oxygen fusion about 1 year, and silicon fusion about 1 week.

Stars with masses under ten times that of the Sun end up as white dwarfs. The theoretical largest size a white dwarf can be 1.4 solar masses. Therefore, a ten-solar mass star would have to lose 86% of its mass to become a white dwarf. The core of a white dwarf holds up the weight of the star with outward pressure astrophysicists called electron degeneracy pressure. This is because the electrons are compressed together as closely as possible. Electron degeneracy pressure is sufficient to counter the weight of a 1.4-solar mass star.

Stars larger than ten solar masses will end up with iron cores. Iron cannot undergo nuclear fusion, ever. Therefore, the core will be compressed and heat up enormously. The temperature heats up so much that atoms are broken apart into protons, neutrons, and electrons. The protons combine with the electrons to become neutrons, leaving nothing but neutrons in the core. The contraction starts pushing the neutrons closer together.

Neutron degeneracy pressure could support the weight of the star. However, the core contraction is so rapid that it overshoots the equilibrium density. The core rebounds in a giant explosion blasting apart the rest of the star.

This type of stellar explosion is called a supernova. The word "nova" comes from Latin and means "new." When a distant, faint star undergoes a supernova explosion, it can radiate more energy than our Sun during its ten-billion-year lifespan. When a supernova occurs, a new bright star may appear in our sky for weeks to months. Some supernovae can even outshine their host galaxy!

9 Planetary Nebulae and Supernovae Remnants

The supernova that created the Crab Nebula was first seen in the year 1054. It was so bright that it was visible during the day. Prior to the explosion, there was no visible star at its location. The supernova was visible at night for nearly 2 years.

The expanding gases from supernovae create nebulae known as supernova remnants. Examples of these are shown in Images 9.18, 9.19, 9.20, 9.21, and 9.22.

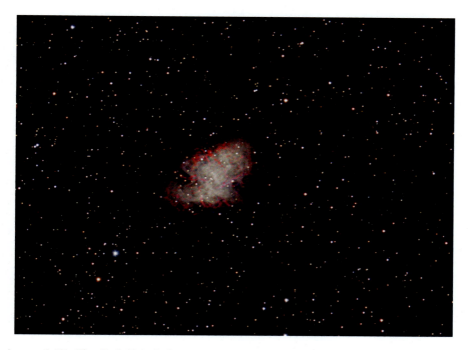

Image 9.18 The Crab Nebula in Taurus is entry 1 in Charles Messier's famous catalog. M1 is the remnant of a star that exploded, i.e., a supernova, in the year AD 1054. The image was taken with a Discovery 10-inch f/6 Newtonian with Paracorr II Coma Corrector to yield f/6.9. This 180-min total exposure was captured with a SBIG ST-2000XCM CCD camera. The Crab Nebula shines at magnitude 9 and measures roughly 6 × 4 arcminutes in size

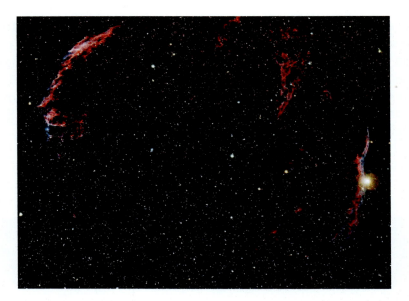

Image 9.19 The Veil Nebula in Cygnus formed 8000 years ago when a star of possibly 20 solar masses underwent a supernova explosion. This image was captured with a William Optics 71-mm f/4.9 apochromatic refractor using a SBIG STF-8300C CCD camera. The exposure was 3 h. The nebula spans 3°. The bright star on the right is 52 Cygni, a magnitude 4.2 yellow giant star

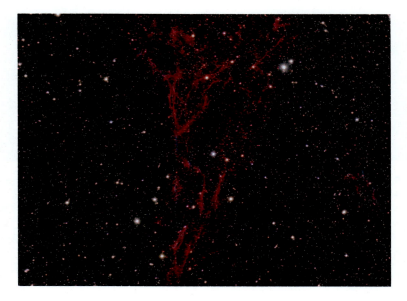

Image 9.20 This section of the Veil Nebula is known as Pickering's Triangle, named after the American astronomer Edward Pickering (1846–1919). Pickering served as the director of the Harvard College Observatory for 42 years. This image was taken with a William Optics 132-mm f/7 apochromatic refractor using a SBIG ST-2000XCM CCD camera. The total exposure was 165 min

9 Planetary Nebulae and Supernovae Remnants 165

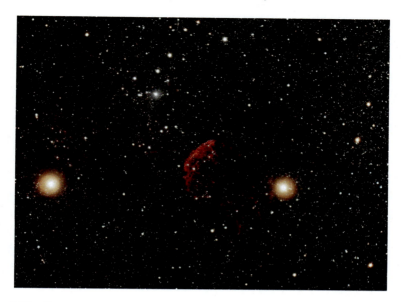

Image 9.21 Known as IC443 or the Jellyfish Nebula, this supernova remnant resides in the constellation Gemini. The remnant lies between the bright stars Mu and Eta Geminorum. IC443 lies approximately 5000 light years away. The supernova creating it may have occurred between 3000 and 30,000 years ago. This wide-field image was taken with a Stellarvue 70-mm f/6 refractor using a 0.8× focal reducer/field flattener and a SBIG STF-8300C CCD camera. The total exposure was 240 min

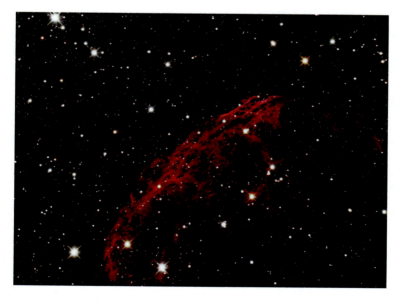

Image 9.22 A zoomed in image of the brighter side of IC443 showing the filamentary structure in the expanding gases. Taken with an 8-inch f/8 Ritchey–Chrétien using a 0.8× focal reducer/field flattener and a SBIG ST-2000XCM CCD camera. The total exposure was 170 min

The explosion that creates a supernova does not destroy the entire star. A remnant of the core can survive. This object is called a neutron star because it is made of neutrons. Neutron stars weigh between 1.4 and 3 solar masses but are only 10–20 kilometers in diameter. Their densities are enormous. Neutron stars rotate very fast. If they have strong magnetic fields, they can radiate strong radio waves, similar to a rotating lighthouse beacon. These neutron stars are called pulsars.

The first pulsar was discovered in 1967. Hundreds more have since been discovered. The periods of their radio wave flashes range from 0.03 to 0.3 s. The pulsar that was left over from the star created the Crab Nebula pulses 30 times per second. Pulsars will die out in a few million years as their magnetic fields fade away and their rotation slows down.

If the remnant core remaining after a supernova explosion is greater than three solar masses, neutron degeneracy pressure cannot support the weight of the core. The core will compress to a very small size. These objects are called black holes since their gravity is so strong, and not even light can escape the gravitational pull. Theories predict that the star must be greater than 20–30 solar masses to end up as a black hole.

There is another type of supernova explosion that involves white dwarfs. As stated before, white dwarfs have a maximum mass of 1.4 solar masses. If a white dwarf is in a closely spaced binary system with another star and the other star evolves into a red giant or red supergiant, it may expand enough so that some of its outer layers are pulled in by the white dwarf. Thus, the white dwarf gains mass. Another way a white dwarf can gain mass is if it collides with another white dwarf. Either way, when the mass of a white dwarf exceeds 1.4 solar masses, electron degeneracy pressure can no longer support the weight of the star. The core contracts and rebounds in a supernova explosion. This type of supernova completely destroys the star, so no core remains.

Supernova explosions are so energetic that all of the naturally occurring elements not created by fusion in the cores of stores are created. The first generations of stars contained only hydrogen and helium, and they had no rocky planets. Heavy elements created by supernova explosions are dispersed throughout the cosmos. Subsequent generations of stars, such as our Sun, contain these heavier elements. These heavy elements can also form into rocky planets around new stars. In essence, we can say the atoms forming Earth and most contained in our bodies were formed by fusion reactions in the cores of stars and supernovae explosions!

The nebulae in this chapter (the same is true for the next chapter) display various colors. Our explanation begins in Chap. 4, where I discussed emission spectra and the fact that when atoms emit photons, the wavelength corresponds to the difference in atomic energy levels of the various elements.

9 Planetary Nebulae and Supernovae Remnants

Plank's equation in Chap. 4 relates the energy of a photon to its frequency. The energy transition in an atom is the same as the energy of an emitted photon. Since the frequency is directly related to the wavelength, both are related to the energy transition.

Energy transitions in an atom occur when an election in the atom is elevated to a higher energy level. For nebulae, two processes are predominantly responsible for an electron promotion to higher energy levels. The first is if the atom absorbs energy from an ultraviolet photon from a nearby hot star. The more ultraviolet energy coming from a star, the more atoms in a nebula absorb energy.

The second is when an atom absorbs energy from a collision with another atom. Collisional excitation depends on the temperature and density of the gas. The hotter the gas is, the more energy atoms carry as they fly around. The more dense the gas is, the more collisions occur.

When an atom has an electron in an excited state (at a higher energy level), when the electron returns to a lower energy level, a photon is emitted. If the wavelength of the photon emitted corresponds to a visible wavelength, the nebula has color. Table 4.1 shows the most common narrowband filters used in astronomy. These filters are named after atomic gases because they are the most common emission lines seen in nebulae.

Hydrogen is the most abundant gas in nebulae. Nebulae that appear mostly red have hydrogen alpha light at 656 nm. Blue nebulae can be caused by hydrogen beta emissions at 486 nm. Magenta-colored nebulae have a mixture of both of these energy transitions. Although oxygen is nowhere near as abundant as hydrogen in nebulae, if the electron excitation in a nebula is mostly collisional, the lines from doubly ionized oxygen (i.e., oxygen atoms that have lost two electrons), called oxygen III, can dominate the color of the emissions. Of the two oxygen III wavelengths in Table 4.1, 486 nm is blue, while 501 nm is green. Some blue- and blue-green-colored nebulae get their color from oxygen III.

Finally, I should note that in atomic spectroscopy, neutral atoms (atoms with equal numbers of protons and electrons) are designated by a Roman numeral I after the element name. HI is neutral hydrogen, HeI is neutral helium, and OI is neutral oxygen. Atoms that have lost electrons are called ions. The process of losing an electron is called ionization. Atoms that have lost one electron are designated by Roman numeral II. HII, HeII, and OII are singly ionized hydrogen, helium, and oxygen, respectively. For atoms that have two or more electrons, if they are doubly ionized, they are designated with a Roman numeral III. The Roman numerals continue for atoms that have lost more of their electrons. Hydrogen alpha and hydrogen beta are two different electron energy transitions from neutral hydrogen, HI.

10

Emission, Reflection, and Dark Nebulae

The interstellar medium is mostly devoid of matter. The average density is one atom per cubic centimeter. However, with the vastness of space, the number of atoms along any line of sight is significant. The interaction of these atoms with light cannot be ignored.

So what is out there in interstellar space? Astronomers break it down into two components: gas and dust. Gas essentially consists of individual atoms of various elements. Ninety percent of the gas in interstellar space is hydrogen. Another 9% is helium. This is similar to the composition of stars except that on average the interstellar medium has a smaller abundance of some of the heavier elements. Most light passes through interstellar gas except for individual wavelengths, which are absorbed depending on the individual gas atoms present. (Refer back to absorption spectra in Chap. 4.)

Whereas atoms are typically smaller than a nanometer (nm), dust particles are larger. A typical size is of the order of 100 nm. Dust accounts for 1% of the interstellar matter and is probably composed of silicates, graphite (carbon), and iron compounds. Whereas atoms are typically round, dust grains are elongated or rod shaped. Dust is partially opaque to (i.e., partially blocks) blue light, ultraviolet light, and X-rays. This dimming effect is called *extinction*. Because of this, starlight passing through dust is reddened.

Nebulae are clouds of gas and dust that commonly span tens to hundreds of light years. (A light year is the distance light travels in 1 year, approximately 5.9 trillion miles or 9.5 trillion kilometers). Two types of nebulae were introduced in the previous chapter: planetary nebulae and supernovae. The other three types of nebulae are called emission nebulae, reflection nebulae, and dark nebulae.

© The Author(s), under exclusive license to Springer Nature Switzerland AG 2024
J. Dire, *Exploring the Universe*, The Patrick Moore Practical Astronomy Series,
https://doi.org/10.1007/978-3-031-65346-9_10

Some celestial objects predominantly contain one of these nebular types (Images 10.1, 10.2, 10.3, 10.4, 10.5, 10.6, 10.7, 10.8, 10.9, 10.10, 10.11, 10.12, 10.13, 10.14, 10.15, 10.16, 10.17, 10.18, and 10.19). Whereas other celestial objects contain two or all three types of these nebula classifications (Images 10.20, 10.21, 10.22, 10.23, 10.24, 10.25, 10.26, 10.27, 10.28, 10.29, 10.30, 10.31, 10.32, 10.33, 10.34, and 10.35).

Emission nebulae are glowing clouds of dense gas and dust. They are much denser than the average interstellar medium. However, they would still be considered superb laboratory vacuums on Earth. Emission nebulae contain or are close to newly formed, hot O and B stars. The ultraviolet light emitted by these stars ionizes the gas (knocks electrons from the gas atoms). As the electrons recombine with the atoms, light is emitted. The color of the light depends on the elements contained in the gas.

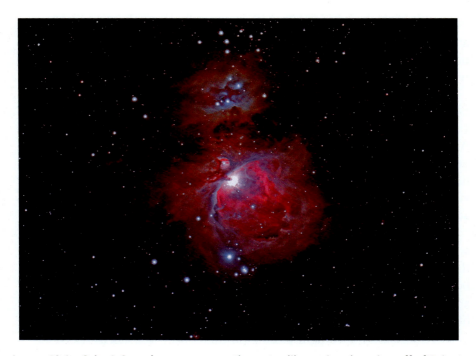

Image 10.1 Orion's Sword may appear as three star-like regions hanging off of Orion's Belt. Long-exposure photography revealed that the sword is surrounded by myriad reflection and emission nebulae. The northern (top) region is called the Running Man Nebula (NGC1275) and contains the fifth magnitude star 45 Orionis. In the center is the Great Orion Nebula (M42). At magnitude 4, this is one of the few naked-eye nebulae in the heavens. The central region of M42 contains the multiple star system Theta Orionis, shining at magnitude 5. At the Sword's bottom is a small star cluster, NGC1980, which has a combined visual magnitude of 2.5. The brightest star in NGC1980 is Iota Orionis shinning at magnitude 2.8. This image was taken with a William Optics 71-mm f/4.9 apochromatic refractor using a SBIG STF-8300C CCD camera. The exposure was 70 min

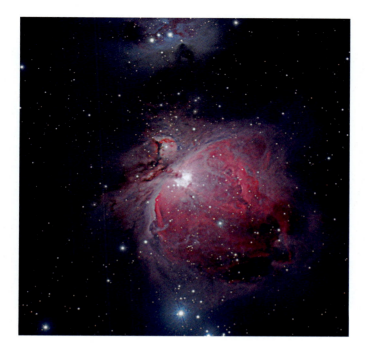

Image 10.2 A higher magnification image of the M42 region taken with a William Optics 132-mm f/7 apochromatic refractor with a 0.8× focal reducer/field flattener to yield f/5.6. This 90-min exposure was captured with a SBIG ST-4000XCM CCD camera. Note the dark nebula to the upper left of the center

Image 10.3 Image of a small portion of the Sagittarius Milky Way captures countless stars and this dark region called the Ink Spot Nebula (left of center). To the left of the dark nebula is a galactic star cluster known as NGC6520. This image was taken with an 8-inch f/8 Ritchey–Chrétien with a Televue 0.8× focal reducer/field flattener using a QSI 583 CCD camera. The total exposure times through clear, red, green, and blue filters were 60, 20, 20, and 20 min, respectively

Image 10.4 Located in the constellation Orion, M78 is considered the brightest reflection nebula in the sky. It is visible in binoculars from a dark site. This image of M78 was captured with a SBIG ST-2000XCM CCD camera on a Discovery 10-inch f/6 Newtonian with a Televue Paracorr II coma corrector to yield f/6.9. The total exposure time was 280 min. The dark nebulae in the image are not visible at the eyepiece

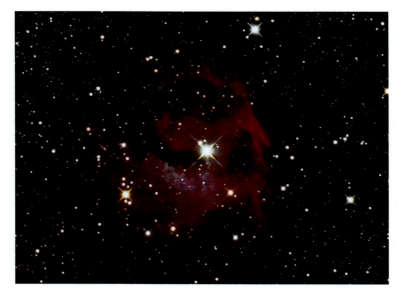

Image 10.5 The Australian astronomer Stanley Gum (1924–1960) created a catalog of 84 emission nebulae. This object is entry 1, so it is called Gum 1. Part of the Seagull Nebula complex in the constellation Monoceros, Gum 1 is about 20 arcminutes in diameter. The bright star in the center is V750 Monocerotis, a hot B star that varies in brightness. This image was taken with an 8-inch f/8 Ritchey–Chrétien with a 0.8× focal reducer/field flattener yielding f/6.4 using a SBIG ST-2000XCM CCD camera. The total exposure was 3 h

10 Emission, Reflection, and Dark Nebulae

The light emissions are predominantly red due to light at a wavelength of 656.3 nm coming from hydrogen atoms (e.g., Image 10.8). This wavelength is called hydrogen alpha (Hα). Emission nebulae that are predominantly red are sometimes called HII (pronounced H-two). This is because astronomers call neutral hydrogen HI (H-one) and ionized hydrogen HII.

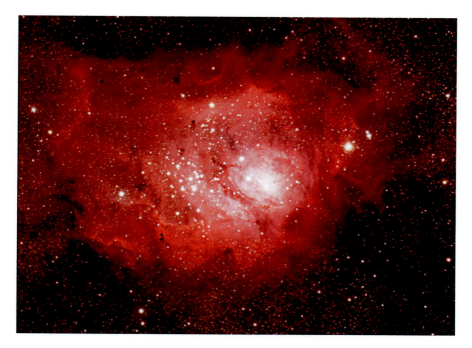

Image 10.6 M8, the Lagoon Nebula in Sagittarius, is one of the brightest emission nebulae in the sky. A 102-mm f/7 apochromatic refractor with a 0.8× FR/FF and a SBIG ST-2000XCM CCD camera were used with an 80-min exposure. At magnitude 6, the nebula and newly formed star cluster inside can be seen (sans color) to the naked eye from a dark site

Nitrogen gas can also emit red light. Blue light can come from hydrogen, helium, or oxygen. Green emissions can also be produced by oxygen and yellow from sulfur.

Many times, the light captured in images of nebulae is a combination of emissions at different wavelengths that result in the different colors seen.

Reflection nebulae are clouds of dust that simply reflect or scatter light from nearby stars. These clouds are typically regions where stars are forming,

such as M78 in Image 10.4. Blue light is scattered more readily than red light, so often, reflection nebulae appear blue. Reflection nebulae often appear with emission nebulae. Sometimes, these conglomerates of gas and dust are called diffuse nebulae.

Dark nebulae are clouds of dust that block light from behind them. The light blocked may be from stars, or it may be from emission or reflection nebulae.

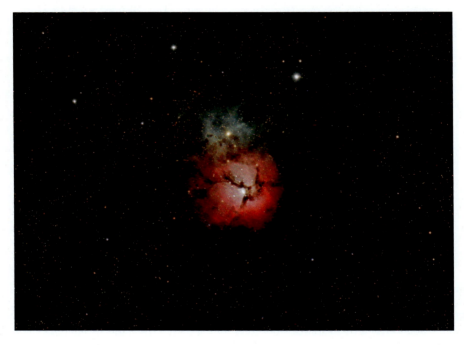

Image 10.7 M8, the Trifid Nebula, is a bright emission nebula in Sagittarius separated into three regions by dark dust lanes. Seen in a telescope or binoculars, this nebula, like most, shows little color since the human eye cannot see color in faint light emissions. The blue region on the north side of the Trifid is a reflection nebula. The red region is approximately 28 arcminutes in diameter and is nearly the same size as the Moon. The nebula has a magnitude of 6.3, easily captured in binoculars from a dark site. The image was taken with a William Optics 132-mm f/7 apochromatic refractor with a 0.8× focal reducer/field flattener to yield f/5.6. A total of 90 min with a SBIG ST-2000XCM CCD camera created this composition

10 Emission, Reflection, and Dark Nebulae 175

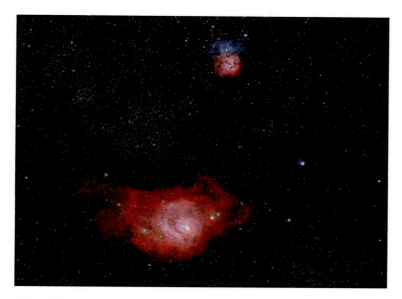

Image 10.8 M8 and M20 can be simultaneously captured with a small telescope. A William Optics Star 71-mm f/4.9 apochromatic refractor and a SBIG STF-8300C CCD camera were employed here. The total exposure was 80 min. Knowing the Trifid Nebula is the size of the Moon, the Lagoon Nebula covers a region that spans at least four Moon diameters

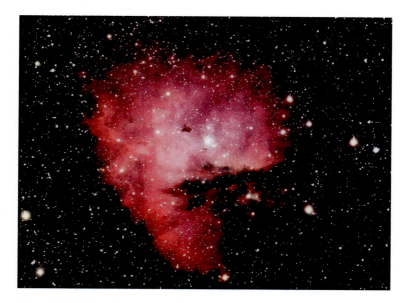

Image 10.9 NGC281 is affectionately known as the Pacman Nebula. This 30 × 35 arc-minute nebula resides in Cassiopeia and has a magnitude of 7.4. The image was taken with a 190-mm f/5.3 Maksutov-Newtonian with a SBIG-ST-2000XCM camera. The exposure was 2 h

Image 10.10 This image was centered on the globular star cluster M9 in the Ophiuchus Milky Way. Another globular star cluster, NGC6365, appears in the upper left. Swirls of dust created myriad dark nebulae here. The two largest and darkest regions are called LDN173 (rightmost) and LDN175, which are located to the right and lower right of M9. This image was captured with the same equipment as Image 10.8, but the total exposure was 60 min

Molecules are found in the densest and largest interstellar clouds. The density of these clouds can exceed 100 molecules per cubic centimeter. However, density fluctuations in these clouds can create densities near 100,000 particles per cubic centimeter in regions where stars are forming. These clouds can span several hundred light years in size. Typical molecules include hydrogen (H_2), carbon monoxide (CO), water (H_2O), ammonia (NH_3), methane (CH_4), and formaldehyde (H_2CO), among others. Glycine (NH_2CH_2COOH), an amino acid, has also been detected in molecular clouds. Glycine and other amino acids, which are building blocks for DNA, have also been found in meteorites. To date, more than 125 different molecules have been found in molecular clouds.

10 Emission, Reflection, and Dark Nebulae

Normally, light cannot pass through these molecular clouds. However, there is a particular radio wavelength, 21 centimeters, which passes through these clouds allowing radio astronomers to study them. This wavelength is emitted from cold, neutral hydrogen atoms.

The remainder of this chapter is a gallery of some of the most beautiful emission, reflection and dark nebulae in the sky.

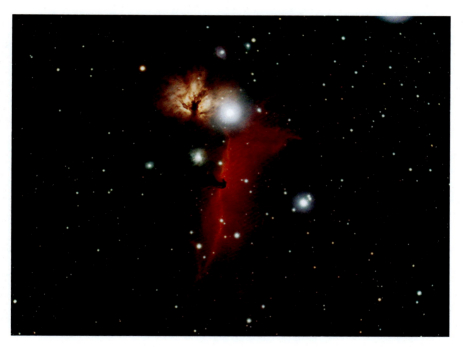

Image 10.11 This image captures the field of view around the star Alniak, the easternmost star in Orion's Belt. To the left of Alniak is NGC2024, the Flame Nebula. Below it is IC343, the Horsehead Nebula. The bright red nebula behind the Horsehead is NGC2023. This image was taken with the same equipment as Image 10.10 using a total exposure of 110 min

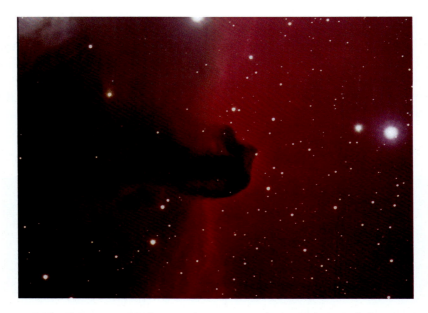

Image 10.12 This zoomed-in image of IC434 was taken with a 10-inch f/6 Newtonian with Paracorr II coma corrector yielding f/6.9. The 330-min exposure was obtained with a SBIG ST-2000XCM CCD camera. Red and magenta colors are emissions from HI. Foreground dust creates dark horse head shape

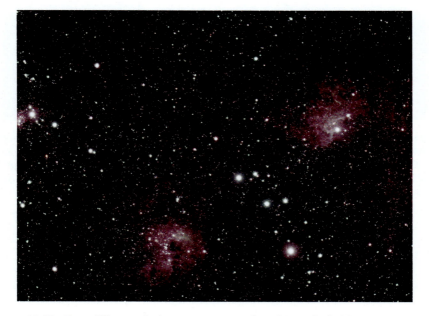

Image 10.13 Two diffuse nebulae were captured in this wide-field image. Near the bottom left is IC410. To the upper right is IC405. At 1500 light years distance, IC405 is closer to us than IC410, which is 12,000 light years away. The image was taken with the same equipment as Image 10.11. The exposure was 140 min

10 Emission, Reflection, and Dark Nebulae 179

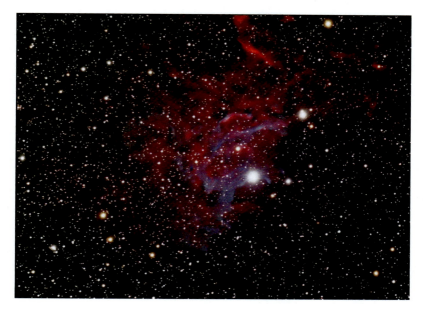

Image 10.14 Another view of IC405 which is also called the Flaming Star Nebula. This image was taken with a 190-mm f/5.3 Maksutov-Newtonian telescope using a SBIG ST-2000XCM CCD camera with an integrated exposure of 4 h

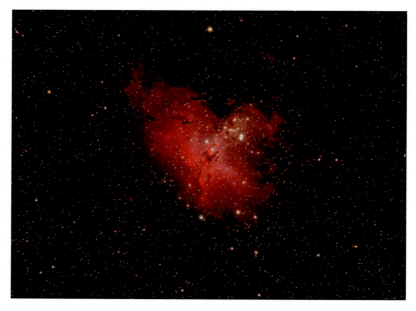

Image 10.15 The Eagle Nebula, a.k.a. M16, is found in the constellation Serpens. The nebula shines at magnitude 6.4 and is roughly 35 × 28 arcminutes in size. Taken with a 132-mm f/7 apochromatic refractor at f/5.6 using a 0.8× FF/FR and a SBIG ST-2000XCM CCD camera. The total exposure was 120 min

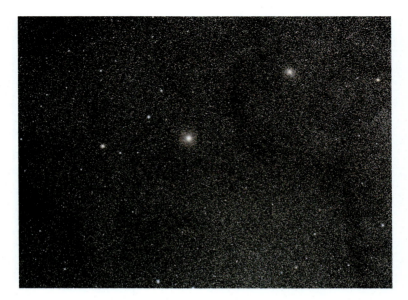

Image 10.16 This photo of the Sagittarius Milky Way is centered on the naked eye star Kaus Borealis (Lambda Sagattarii). To the upper right is the globular star cluster M28. The dark nebula between the two is LDN236, which snakes its way to the lower right corner of the image. The image was captured with a 71-mm f/4.9 apochromatic refractor and a SBIG STF-8300C CCD camera. The exposure was 30 min

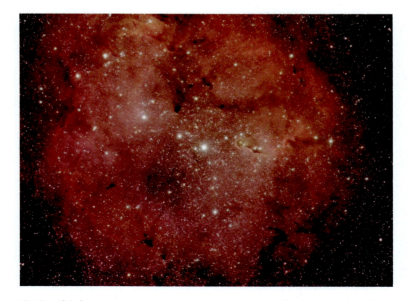

Image 10.17 This large structure containing emission, reflection, and dark nebulae is known as IC1396 and the Elephant Trunk Nebula. The structure spans more than 2.5° of the sky. It was captured with the same equipment as in Image 10.16 using a total exposure of 220 min

10 Emission, Reflection, and Dark Nebulae

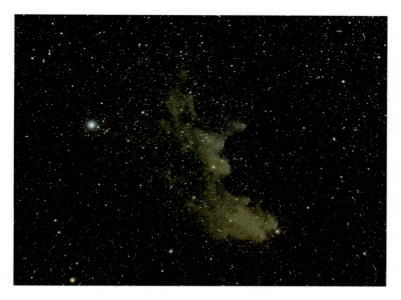

Image 10.18 IC2118, the Witch Head Nebula, is a faint reflection nebula 3° × 1° in size. The nebula was captured using a 72-mm f/5.6 quintuplet refractor with a 0.7× focal reducer yielding f/3.9. The exposure was 300 min using a SBIG STF-8300C CCD camera

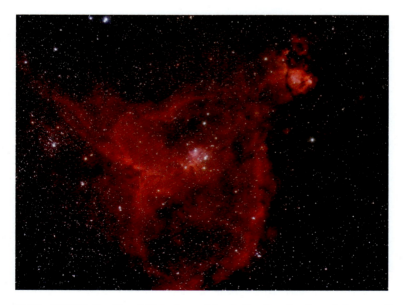

Image 10.19 IC1805, the Heart Nebula, resides in Cassiopeia. It contains mostly emission nebulae but has some reflection and dark nebulae. Captured with a 71-mm f/4.9 apochromatic refractor and a SBIG STF-8300C CCD camera. The exposure was 140 min

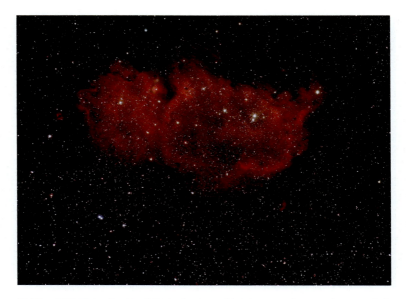

Image 10.20 IC1848 is the Soul Nebula. It resides just to the southeast of the Heart Nebula in Cassiopeia and was captured with the same equipment with a 300-min exposure

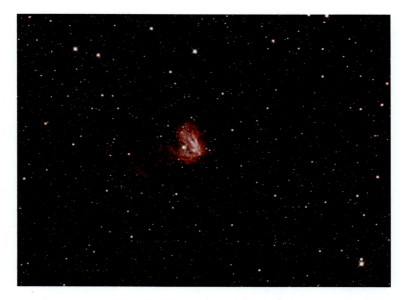

Image 10.21 NGC1491 is a small emission nebula in Perseus measuring approximately 3 arcminutes across. The image was captured with a Parks Optical 10-inch f/4.6 Newtonian using a Paracorr II coma corrector and a SBIG ST-2000 XCM CCD camera. The exposure was 70 min

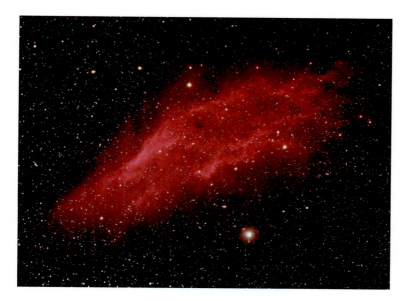

Image 10.22 NGC1499 is known as the California Nebula due to its stately shape. The nebula spans 2.4° and resides in Perseus. The photo was taken with the same equipment as the Heart and Soul nebulae above with a six-hour total exposure (thirty-six 10-min subframes)

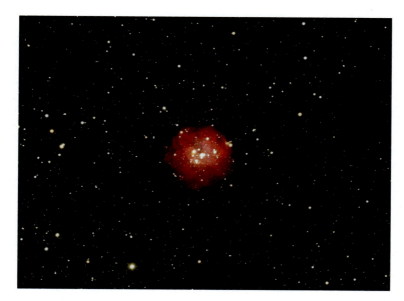

Image 10.23 NGC1624 is a small star cluster in the constellation Perseus embedded in an emission nebula. The cluster is estimated to be approximately four million years old, a tiny fraction of the age of the Sun. The nebula is about three arcminutes in diameter. The image was taken through a Discovery 10-inch f/6 Newtonian with a Televue Paracorr II coma corrector giving an effective focal ratio of f/6.9. The 80-min exposure was captured with a SBIG ST-2000XCM CCD camera

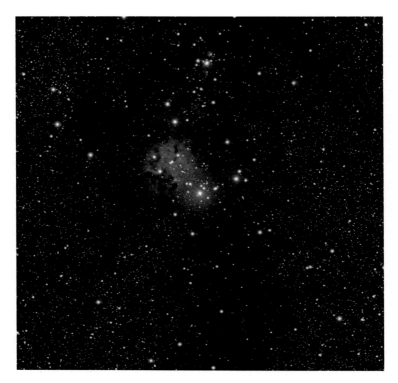

Image 10.24 This image contains a large nebular region and a star cluster, both of which are cataloged as NGC2264. The star cluster is also called the Christmas Tree Cluster due to its shape. The base of the Christmas tree is the bright star in the center of the image, while the top of the tree is the blue-white star near the top center of the image. The Cone Nebula is also shaped like a Christmas tree whose peak coincided with the peak of the star cluster. The base of the Cone Nebula is along the bottom of this image. Most of the Cone Nebula is an emission nebula. However, the blue regions are reflection nebulae. At the top of the Cone Nebula is a dark nebula affectionately known as the Dark Cone Nebula. The Dark Cone Nebula consists of cold molecular hydrogen and dust that block the light from the emission nebula behind it. In this image unlike the others in this book, north is down and east is to the right. This image was captured using a William Optics 132-mm f/7 refractor with a 0.8× focal reducer/field flattener yielding f/5.6 and a SBIG ST-4000XCM CCD camera. The integrated exposure was 290 min

10 Emission, Reflection, and Dark Nebulae

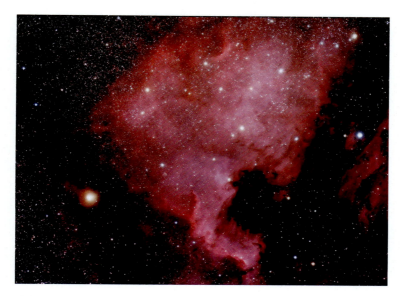

Image 10.25 NGC7000 or the North America Nebula in Cygnus spans more than 2° and is visible naked eye in dark skies (although the eye does not see the color). It is best viewed in binoculars or a small rich-field telescope with low magnification. The image was taken with a William Optics Star 71-mm f/4.9 apochromatic refractor with a SBIG STF-8300C CCD camera. The total exposure was 270 min

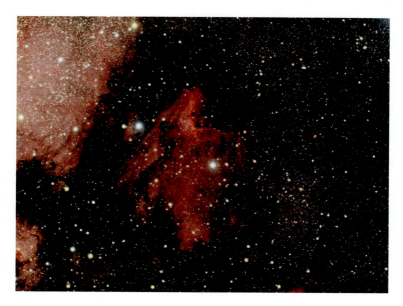

Image 10.26 IC5070 is called the Pelican Nebula. It is located just west of NGC7000. The image was taken with a Stellarvue SV70T 70 mm f/6 apochromatic refractor with 0.8× focal reducer/field flattener using a SBIG STF-8300C CCD camera. The total exposure was 330 min

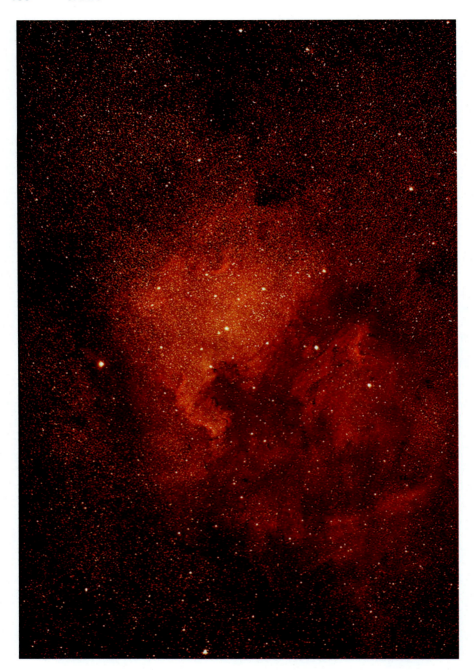

Image 10.27 Another image of The North America Nebula and Pelican Nebula. The color differences between Images 10.25 and 10.26 were caused by the different optics used and different image processing techniques. This image appears redder than either of the previous two images because it was taken with a Canon 600D camera with the IR filter removed. Infrared light appears as red light on the digital sensor. A Canon 70–200-mm zoom lens set at 70 mm and f/2.8 was employed. The total exposure was 45 min

10 Emission, Reflection, and Dark Nebulae

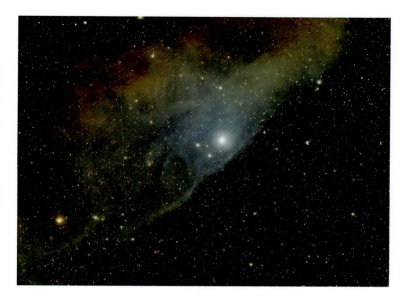

Image 10.28 This frame captured the brighter regions of IC4592, a reflection nebula in the constellation Scorpius. It is one of the few nebulae exhibiting yellow and brown colors. The image was captured with the same equipment as Image 10.25 with a 150-min exposure. The bright star Jabbah (Nu Scorpii) illuminates the blue regions surrounding it

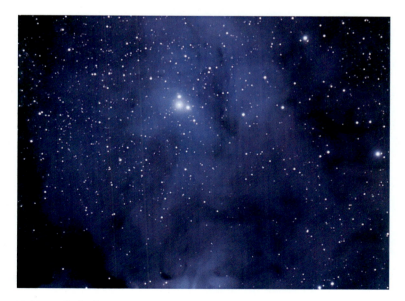

Image 10.29 A little farther south and east of IC4592 lies IC4604, the Rho Ophiuchus Nebula. The triple star Rho Ophiuchus is embedded in this reflection nebula along with rivers of dark nebulae. This 180-min exposure was obtained with the same equipment as the previous image

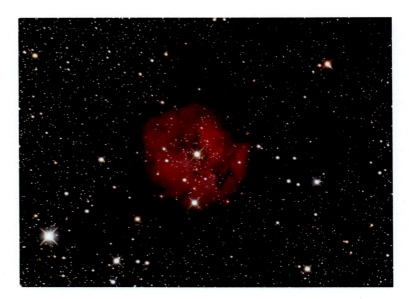

Image 10.30 NGC7129 is a small star cluster within a reflection nebula. NGC7129 shines at magnitude 11.5 and is 7 arcminutes in size. It is located in Cepheus. The image was taken with the same equipment as Image 10.30 with a total exposure of 120 min

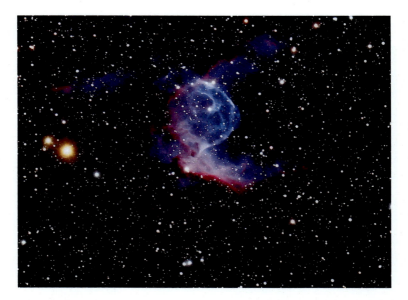

Image 10.31 NGC2359 is known as Thor's Helmut. Thor's Helmut is an emission and reflection nebula in Canis Major. The image was taken through a Discovery 10-inch f/6 Newtonian with a Televue Paracorr II coma corrector giving an effective focal ratio of f/6.9. The 240-min exposure was captured with a SBIG ST-2000XCM CCD camera

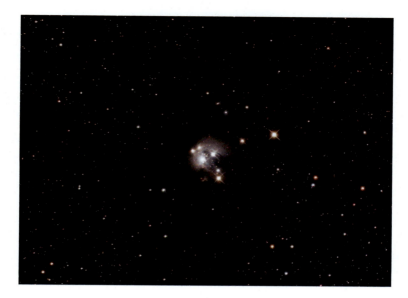

Image 10.32 NGC7129 is a small star cluster within a reflection nebula. NGC7129 shines at magnitude 11.5 and is 7 arcminutes in size. It is located in Cepheus. The image was taken with the same equipment as Image 10.30 with a total exposure of 120 min

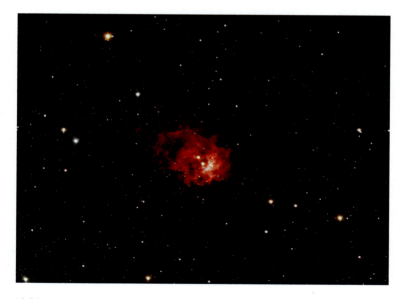

Image 10.33 NGC7538 is a small 15 × 10 arcminute reflection nebula in Cassiopeia. The image was taken with the same equipment as Image 10.31 with a total exposure of 120 min

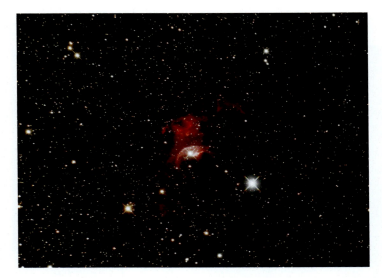

Image 10.34 NGC7635 is best known as the Bubble Nebula. The image was taken with the same equipment as Image 10.30 with a total exposure of 180 min. Like Thor's Helmut, NGC7635 has a complex shape and curved bow-shock structure. The fast solar winds from the central star form a bubble as it sweeps through the surrounding molecular cloud

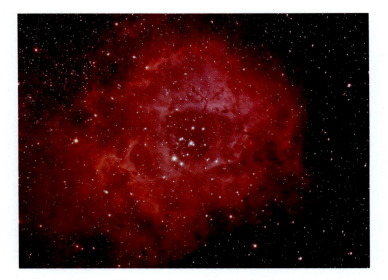

Image 10.35 NGC2237 is one of the best nebulae visible from both Earth hemispheres due to its proximity to the celestial equator in the constellation Monoceros. Known as the Rosette Nebula, NGC2237 is a vast cloud of gas and dust extending several degrees across. Its integrated magnitude is 5.5, but it takes dark skies and a telescope with very low magnification to see. NGC2237 contains mostly emission with some reflection and dark nebula. The hole in the center has been cleared by stellar winds from a hot, young star cluster. The full Moon could easily fit within the hole if it passed in front of the Rosette. NGC2237 is 5500 light years away. The image was taken with a William Optics Star 71-mm f/4.9 apochromatic refractor with a SBIG STF-8300C CCD camera. The total exposure was 180 min

11

Galactic Star Clusters

Groupings of stars are broken down into what are called star associations, open star clusters, and globular star clusters. The former two will be covered in this chapter. The latter will be covered in the next chapter.

The difference between a star association and an open star cluster is merely the number of stars in each. Star associations are made up of a few dozen to hundreds of stars (see) of similar type and a common origin. Open clusters also have a common origin. These clusters contain hundreds to thousands of stars. For the remainder of the chapter, I will not differentiate between these two groups and will call them both star clusters. Their life cycles are essentially the same. These clusters are found in the disk of the galaxy and are therefore called galactic star clusters. The star clusters in Images 11.1, 11.2, 11.3, 11.4, 11.6, 11.7, 11.8, 11.9, 11.16, 11.17, 11.18, 11.19, 11.21, 11.25, 11.26, 11.28, 11.32, 11.33 and 11.35, would technically be star associations. The star clusters in remaining images in the chapter – 11.5, 11.10, 11.11, 11.12, 11.13, 11.14, 11.15, 11.20, 11,22, 11.23, 11.24, 11.29, 11.30, and 11.31 – would be called open star clusters. But they are all galactic star clusters!

To fully understand galactic star clusters, it is important to understand how stars form. Therefore, this chapter covers star formation and then returns to the dynamics of open clusters as stars of different sizes form and die.

Stars form from cold dark molecular clouds, which are comprised of gas and dust. These clouds typically have temperatures around 10 K. Dozens to thousands of stars can form from an individual cloud. When several high

© The Author(s), under exclusive license to Springer Nature Switzerland AG 2024
J. Dire, *Exploring the Universe*, The Patrick Moore Practical Astronomy Series,
https://doi.org/10.1007/978-3-031-65346-9_11

Image 11.1 Centered in this image is a star cluster known as Collinder 399, which contains a few dozen stars spanning a degree of the sky. The image was taken with a Askar 72-mm f/5.6 quintuplet Apo with a 0.7× focal reducer to yield f/3.9. A SBIG ST-83000C CCD camera was employed. The integrated exposure was 35 min

mass stars form, their light can excite gas to emit light or reflect light creating visible nebulae. Myriad nebulae are pictured in the previous chapter. In a many cases, star formation continues to occur in these nebulae.

For stars to form from dark molecular clouds, there must be the correct balance between density and size so that the gravity between the atoms and molecules can overcome the thermal radiation they emit. Gravitational forces tend to cause the gas to contract. Radiation pressure tends to push gas molecules apart.

As a region of a cloud collapses, it heats up (i.e., its temperature increases). If the cloud region collapses faster than it can radiate away the heat, the cloud region will stop collapsing and never become a star. For regions of the molecular cloud to ultimately form stars, the mass must contract in such a way that gravity overwhelms the radiation pressure.

11 Galactic Star Clusters 193

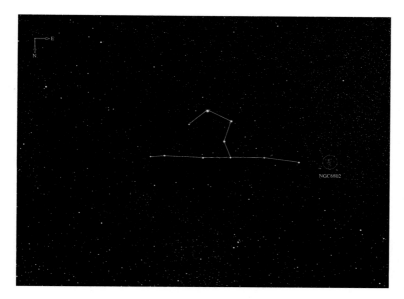

Image 11.2 Collinder 399 is affectionately called the Coat Hanger Cluster. This image is the same as Image 11.1 except that line segments are shown outlining the hanger. Also, circled is a small open star cluster NGC6802. NGC6802 contains several hundred stars and is farther away than Collinder 399. Departing from the standard convention, in this image north is down and east to the right

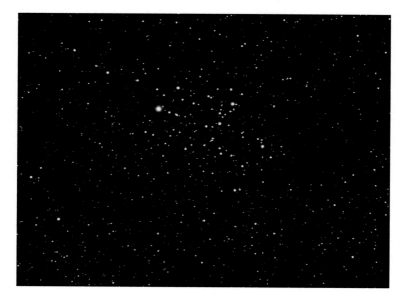

Image 11.3 M6, the Butterfly Cluster, is a magnitude 4.2 star cluster with a diameter of 20 arcminutes. The cluster is located in the constellation Scorpius. The cluster is 1600 light years away. The brightest star in the image is a red supergiant star located at half the distance of the cluster. The image was captured with a 102-mm f/7.9 apochromatic refractor using a SBIG ST-2000XCM CCD camera. The exposure was 30 min

Stars typically form in giant molecular clouds in local regions of higher density. There are several mechanisms that can create these higher density regions. They are (1) shock waves from nearby supernovae; (2) galactic shock waves—the waves that travel around the galaxy forming the spiral arms; (3) collisions between two giant molecular clouds; (4) radiation from newly formed nearby hot stars; (5) periodic massive release of high-speed material from nearby massive stars; and (6) radiation pressure from nearby hot, massive stars. The remainder of the star formation discussion below considers a star forming that is the same mass as the Sun. Afterward, I will discuss the differences for larger and smaller stars.

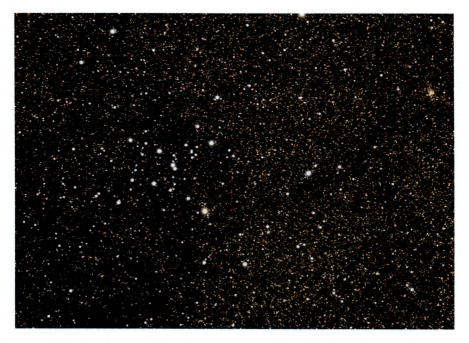

Image 11.4 Star cluster M7 (bright star group on the left side of the image) is found in the Milky Way where stars and dark nebulae are abundant. M7 is called Ptolemy's Cluster since Claudius Ptolemy (ca.100–ca.170) wrote about it in AD130. M7 is 970 light years away and has a magnitude of 3.3. The cluster has an actual diameter of 18–25 light years and has around 80 telescopic stars. This image was taken with the same equipment as Image 11.2 with a 50-min exposure

A fragment of an interstellar cloud that collapses will be extremely luminous, not because it has heated up much yet, but because it is so large. This is a result of the Stefan-Boltzmann equation from Chap. 5. The radiation it emits at this point is mostly in radio and infrared spectral regions (Fig. 4.1).

As the high-density cloud fragment starts to gravitationally collapse, its temperature does not increase much since most of the heat generated by the contracting gas radiates away into space. The gaseous blob may contain one to two solar masses and is 100 times bigger than our solar system.

When the cloud fragment has contracted to the size of our solar system, the central region becomes opaque to radiation. Radiation can still escape to space from within the cloud; it just cannot pass through the center. The inner temperature of the cloud is 10,000 K while the edges are still relatively cool, approximately 100 K.

By the time the fragment has contracted to a hundred times larger than the Sun, it has a very hot core and has formed a photosphere. The object is now classified as a *protostar*. It has a star-like appearance, but nuclear fusion has not started in the core. It is not yet officially a star. The photosphere may be as hot at 3000 K. The core has reached a 10^6 K (a 1 followed by 6 zeros or 1,000,000 K), hot enough to strip most the electrons off of the gas atoms. Due to its large radius, the protostar may be 300 times as luminous as the Sun. Mass from the cloud fragment continues to fall into the core increasing its density, pressure, and temperature.

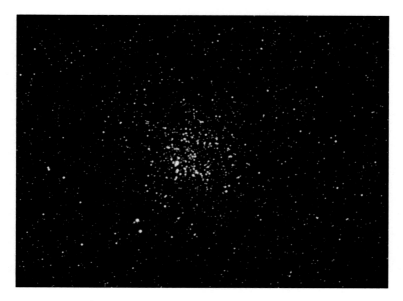

Image 11.5 M11 is also known as the Wild Duck Cluster. This cluster of nearly 3000 stars lies in Scutum. It shines at magnitude 5.8. Located 6100 light years away, the cluster has a physical diameter of 57 light years. The image was taken with a 10-inch f/6.9 Newtonian using a SBIG ST-2000XCM CCD. The exposure was 30 min

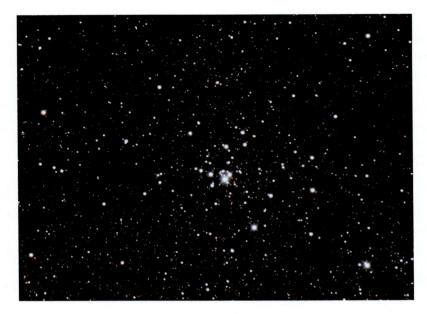

Image 11.6 M21 in Sagittarius contains 57 stars. It shines at magnitude 5.9 and is 14 arcminutes in diameter. It is located 3900 light years away. The image was taken with an 8-inch Ritchey–Chrétien Telescope (RCT) using a SBIG ST-2000XCM CCD. The exposure was 40 min

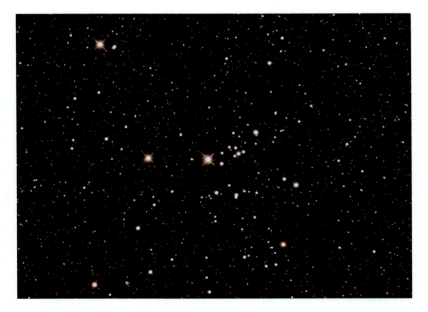

Image 11.7 M25 in Sagittarius contains around 35 stars. It shines at magnitude 4.6 and is 29 arcminutes in diameter. The cluster is located 2000 light years away. The image was taken with an 8-inch RCT using a SBIG ST-2000XCM CCD. The exposure was 50 min

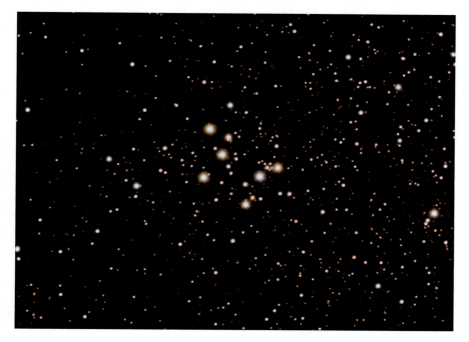

Image 11.8 M29 is a magnitude 6.6 cluster in Cygnus. M29 contains around 30 stars in a 7-arcminute diameter area. The cluster is located 5000 light years away. The image was taken with a 10-inch f/6.9 Newtonian using a SBIG ST-2000XCM CCD. The exposure was 30 min

By the time the protostar has contracted to ten times the diameter of the Sun, the core temperature has reached approximately 5 million degrees. The temperature is still too low to initiate hydrogen fusion. The core contains nothing but ions, as it is too hot for atoms to retain their electrons. The protostar's evolution slows down considerably, meaning it is now contracting and heating up at a much slower rate. The protostar is referred to as a T Tauri star, named after the first such object ever observed, T Tauri.

From the start of the process to the T Tauri stage, somewhere between 10 and 15 million years have elapsed. It will take another 30 million years for the core to heat up to ten million Kelvin, the temperature at which hydrogen fusion begins. Once fusion begins in the core, a new star the mass of the Sun is born. The star has a radius of 1 million kilometers.

Solar winds from the newborn star will blow away any remaining gas and the star ceases growing. It will still take several hundred million more years until the star stabilizes and becomes a main sequence star (Fig. 5.3). The star will fuse hydrogen into helium it its core for another 10 billion years.

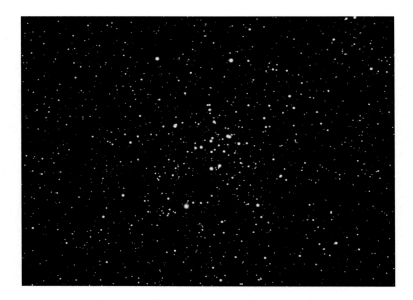

Image 11.9 M34 is a loose cluster of 60 stars in the constellation Perseus. The combined magnitude is 5.2. The cluster is 1600 light years away and spans 34 arcminutes of the sky. The image was taken with a 102-mm f/7.9 apochromatic refractor with a 0.8× focal reducer/field flattener yielding f/6.4. The 30-min exposure was captured with a SBIG ST-2000XCM CCD camera

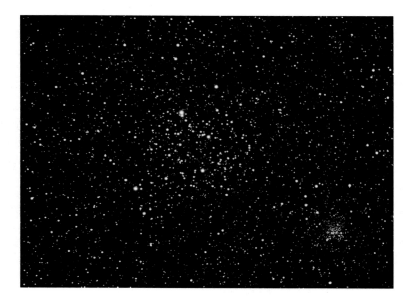

Image 11.10 Two star clusters appear in this image. The larger cluster is M35. To the lower right is NGC2158. The clusters are found in Gemini. M35 has a magnitude of 5.1 and is 40 arcminutes in diameter, whereas NGC2158 has a magnitude of 8.6 and is only 5 arcminutes in diameter. NGC2158 only appears smaller and dimmer than M35 because it is 17,000 light years away compared to 3000 light years for M35. This image was captured with the same equipment and exposure as Image 11.9

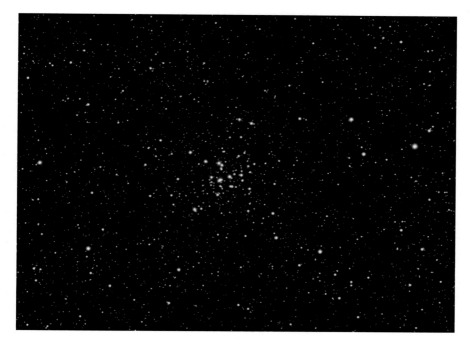

Image 11.11 M36 is located in Auriga and contains 90 stars. The cluster has a magnitude of 6 and is 10 arcminutes in size. The eye might see the clusters as a three-sided propeller or pinwheel. Thus, it is sometimes called the Pinwheel Cluster. This image was captured with the same equipment and exposure as Image 11.9

The complete size range of stars is not exactly known. We do know that there are very few stars larger than 30 times the mass of the Sun. A more massive star than this typically cannot form because a high-mass prestellar object has such strong gravity that it too rapidly becomes extremely hot and luminous. The radiation pressure force from the hot gas is much greater than the inward pull of gravity and the prestellar fragment cannot collapse into a star.

The lower limit for the size of a star is approximately one tenth the mass of the Sun. Protostellar objects smaller than this have core temperatures too low to ever initiate nuclear fusion. These objects are still warmer than their surroundings and emit light, mostly in infrared wavelengths, as they slowly radiate away all the heat from the gas contraction. These objects are called *brown dwarfs*.

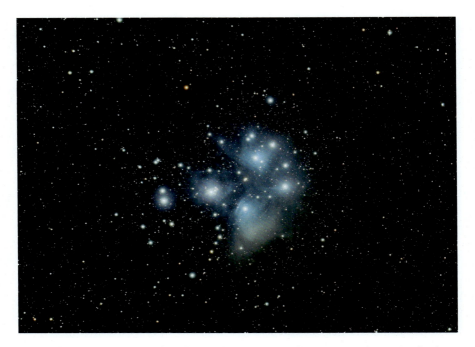

Image 11.12 The Pleiades (M45) is perhaps the best-known star cluster in the heavens. Sometimes called the Seven Sisters or Subaru, six stars can be seen with the naked eye in moderate light pollution. In darker skies, I see more than seven. Scores are captured with binoculars or a telescopes. The nebulosity shown here can be seen, sans color, with a sufficiently large telescope. The blue gas is a reflection nebula. The blue gas is not from the cloud that formed the cluster, as it has long dissipated. The star cluster just happens to be passing through a gas cloud creating, for the time being, a reflection nebula. The Pleiades may contain up to 500 stars. The apparent diameter is approximately 2° and the integrated magnitude is 1.5. This image was captured with a William Optics 61 mm f/5.9 Apo with a 0.8× focal reducer/field flattener and a SBIG STF-8300C CCD camera. The exposure was 60 min. M45 lies a mere 470 light years away

11 Galactic Star Clusters 201

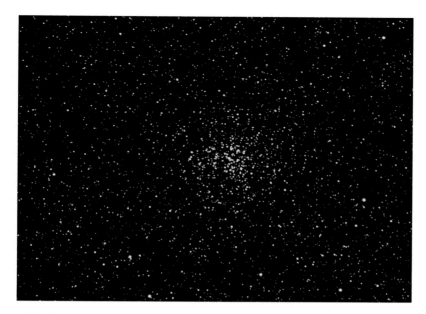

Image 11.13 M37 contains 150 stars lying 4500 light years away. The cluster has a magnitude of 5.6 and is 14 arcminutes in size. M37 is in the constellation Auriga. This image was captured with the same equipment and exposure as Image 11.9

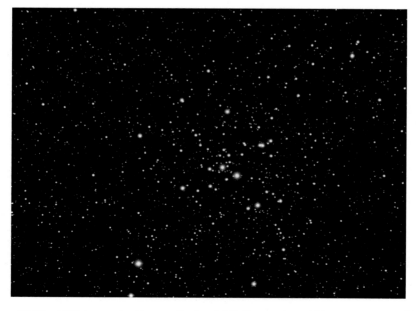

Image 11.14 M41 has a visual magnitude of 4.5. It contains ~100 stars, scattered over an area 38 arcminutes in diameter. It resides in Canis Major. The cluster is 2300 light years away. This image was captured with the same equipment and exposure as Image 11.9

The time required to form a star depends on the mass of the star. A star the size of the Sun takes 50 million years to form. A 15-solar mass spectral type O star can form in 150,000 years. Spectral class M stars having only one tenth the Sun's mass take a billion years to form. Paths for different masses on a Hertzsprung-Russell (H-R) diagram are illustrated in Fig. 11.1.

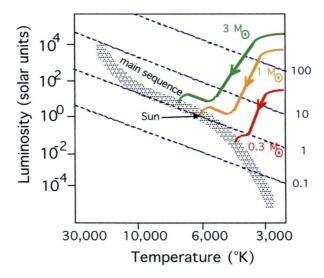

Fig. 11.1 This H-R diagram shows the path protostars of three different solar masses (3, 1, and 0.3) take as they form into stars. The smaller the mass, the longer it takes the stars to form. The blue dashed lines with values on the right side of the graph are the sizes of the objects in solar radii

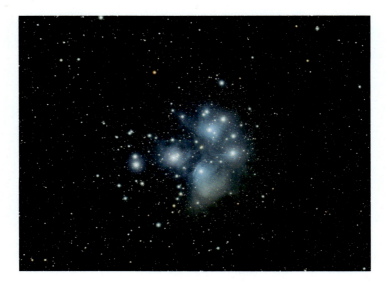

Image 11.15 Another image of M45 taken with 71-mm f/4.9 apochromatic refractor using a SBIG STF-8300C CCD camera. The exposure was 150 min

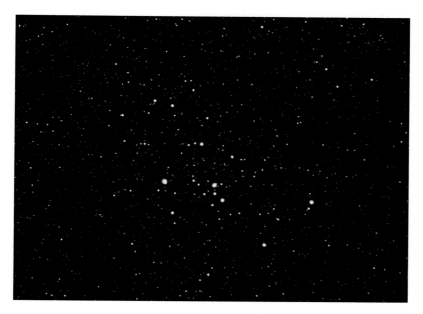

Image 11.16 M47 is a magnitude 4.4 star cluster in the constellation Puppis lying very close to M46 (Image 9.14) in the celestial sphere. The cluster has approximately 50 stars spread over an area the size of the Moon. The cluster lies 1600 light years away. This image was captured with a 102-mm f/7.9 refractor with a 0.8× focal reducer/field flattener to yield f/6.3. The exposure was 10 min using a SBIG ST-2000XCM CCD camera

Astronomers have determined that the lifetimes of stars are inversely proportional to their masses, or more specifically the square of their masses. The reason for this is that the greater the mass a star has, the hotter the temperature in the core of the star where hydrogen is fused into helium. Higher core temperatures lead to vastly faster fusion reaction rates. Thus, more massive stars burn through their hydrogen fuel much faster and therefore have much shorter lifetimes.

A one-solar mass star, like our Sun, has a life expectancy of 10 billion years. A star ten times the mass of the Sun has a much-reduced life expectancy—only 100 million years. A star one tenth the Sun mass can survive for an estimated trillion years! This is much longer than the age of the Universe. Stars one tenth of the solar mass are red dwarfs. All red dwarf stars that have ever formed are still burning (unless they have collided with other stars or black holes, or have encountered another untimely demise).

Image 11.17 M48 is a magnitude 5.8 star cluster in the constellation Hydra. The cluster has approximately 80 stars spread out over 54 arcminutes. The cluster lies 2500 light years away. This image was captured with the same equipment as the previous image using a 40-min exposure

Image 11.18 The open star cluster M50 is found in the constellation Monoceros. The cluster has a magnitude of 5.9 and contains 200 stars is an area around 15 arcminutes in diameter. The cluster is 3200 light years away. The image was captured with a 190-mm f/5.3 Maksutov-Newtonian with a SBIG ST-2000XCM CCD camera. The exposure was 20 min

Table 11.1 Stellar lifetimes

Star mass(solar masses)	Estimated lifetime (million years)
50	4
10	100
1	10,000
0.1	1,000,000
Age of universe	13,800

As shown in Table 11.1, the most massive stars, spectral class O, survive only a few million years. These stars die with a blast. The shock waves from the resulting supernova explosions can stimulate new star formation in their host molecular cloud. Spectral class B stars can also contribute to further star formation in molecular clouds as they too overlap the range of stellar masses that end their lives with supernovae.

Image 11.19 M67 is a magnitude 6.1 open cluster in Cancer 25 arcminutes in size. The cluster contains nearly 100 stars. M67 is 2500 light years away. This image was taken with the same equipment and exposure as Image 11.18

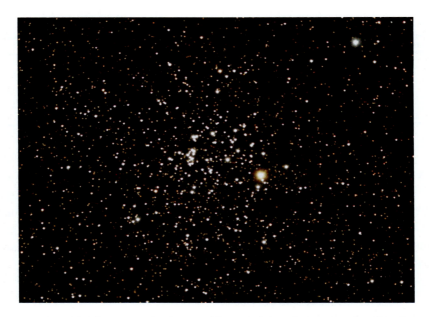

Image 11.20 M52 is a magnitude 7.3 rich star cluster in Cassiopeia. The cluster is young as it contains some B class stars. The cluster is fan shaped to the north (top) and east (left). The image was taken with a 10-inch f/6.9 Newtonian with a SBIG-ST-2000XCM CCD camera with a 30-min exposure

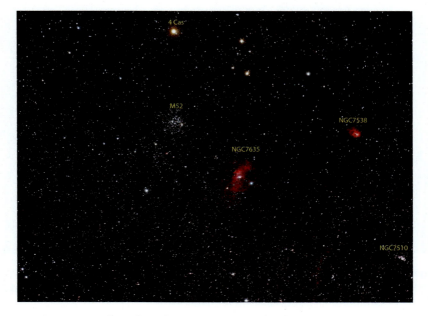

Image 11.21 M52 is found in the same region of Cassiopeia as emission nebulae NGC7635 and NGC7538. The image was taken with a 71-mm f/4.9 refractor using a SBIG ST-8300C CCD camera with a 110-min exposure

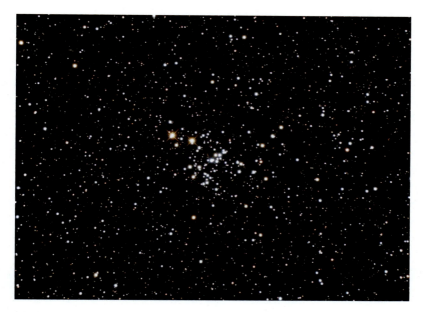

Image 11.22 M93 is a beautiful cluster in the constellation Puppis. Its integrated magnitude is 6.2 and spans 22 arcminutes. The cluster contains 80 stars lying 3900 light years away. The image was captured using an 8-inch f/8 Ritchey–Chrétien Cassegrain with a Televue 0.8× focal reducer/field flattener yielding f/6.4 and a SBIG ST-2000XCM CCD camera with a one-hour exposure.

Image 11.23 M103 is a loose 5-arcminute diameter cluster in Cassiopeia containing 40 stars brighter than magnitude 12 and 107 stars overall. The image was taken with the same equipment and exposure as Image 11.22. The cluster lies between 8000 and 9200 light years away

The study of star clusters is important for many reasons:

1. All of the stars in a cluster are approximately the same distance from us. Therefore, their relative magnitudes are directly related to their absolute magnitudes.
2. All of the stars in a cluster formed from the same materials at approximately the same time. The only difference among them is their varying masses.
3. Since more massive stars age faster, the most massive stars in a cluster limit the age of the entire cluster. This allows us to study the less massive stars with an estimate of their age. Studying similar mass stars in clusters of different ages allows the evolution of those classes of stars to be tracked.

Image 11.24 The Double Cluster in the constellation Perseus is one of the most popular sights visible in small telescopes. On the right is NGC869. NGC869 contains more than 250 stars. The cluster has a magnitude of 3.7 and is 18 arcminutes in diameter. The cluster is 7500 light years away. On the left is NGC884. NGC884 has a magnitude of 3.8 and is approximately 18 arcminutes in size. It lies 7600 light years away. So, the two clusters are not immediate neighbors. NGC884 contains about 150 stars. Based on stellar populations, NGC884 is estimated to be 3.2 million years old, while NGC869 is 5.6 million years old. They are both quite young star clusters! The image was taken using a 132-mm f/7 refractor with a 0.8× focal reducer/field flattener. The exposure was 25 min with a SBIG ST-4000XCM CCD camera. The Double Cluster is visible to the naked-eye from dark sites

11 Galactic Star Clusters 209

Open star clusters are held together by the gravity of the member stars and the gas out of which they were formed. Eventually, when enough stars have formed in a cluster, their combined stellar winds blow away all of the gas. No new stars are born. In most cases, the remaining stars combined do not have enough gravity to keep all of the stars bound to the cluster.

Over time, individual stars are cast out of the cluster due to random close encounters between the stars. When a star leaves its birth cluster, the overall gravity of the cluster diminishes. This means that the next star to leave will not need as high of a velocity to escape the gravitational pull of the cluster. In essence, star clusters eventually evaporate. The stars still exist, until they reach the end of their lives. They are no longer present together and become dispersed throughout the galaxy as it rotates.

Some 4.6 billion years ago, the Sun formed in a galactic star cluster. We do not know where this star cluster was birthed in the galaxy. We do not know how many stars were in the cluster, or the total mass of the cluster. The cluster and the gas cloud from which its stars formed are long gone.

The galaxy has rotated approximately 20 times since the Sun was born. The galaxy rotates like a solid disk. Therefore, stars that left our Sun's original star cluster have probably been dispersed throughout the galaxy. Wherever they are, they should have the same chemical composition as the Sun. Should we ever find a star that matches this composition, there is a good probability the star is a sibling of the Sun.

In 2014, astronomers found a star, HD 162826, that had the same chemical fingerprint as the Sun. HD 162826 is 110 light years away from us in the constellation Hercules. The star shines at magnitude 6.57. It has approximately the same mass and temperature as the Sun. Therefore, it has a similar age. HD 162826 is the first sibling of the Sun identified.

In 2018, astronomers found the same chemical fingerprint in HD 186302. HD 186302 is a magnitude 8.77 star in the southern constellation Pavo (which is not visible from north of 20°N latitude). HD 186302 is another yellow dwarf star similar to the Sun in mass and temperature. It lies 176 light years away.

How many hundreds or thousands of more sibling there are for the Sun is unknown. Any siblings that were much more massive than the Sun have already died. Any siblings the same mass as the Sun or smaller are probably still around somewhere in the Milky Way Galaxy.

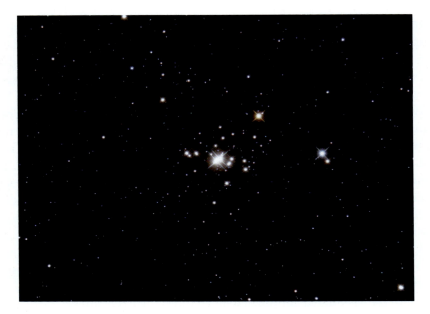

Image 11.25 This small but relatively bright cluster in Camelopardalis is known as NGC1502. The cluster has a magnitude of 6.9 and spans 8 arcminutes. The image was taken with the same equipment and exposure as Image 11.22

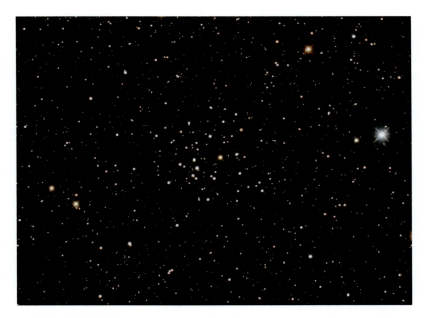

Image 11.26 NGC2215 is a sparse cluster that blends into the background. The cluster has a magnitude of 8.4 and is 8 arcminutes in diameter. The cluster contains around 40 stars. The image was captured with the same equipment as Image 11.22 with a 30-min exposure

11 Galactic Star Clusters 211

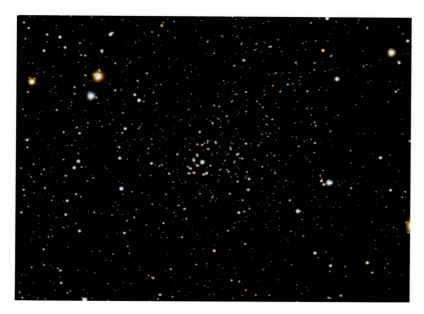

Image 11.27 NGC2236 is a small young open cluster in Monoceros. It shines at magnitude 8.5 and is 7 arcminutes in diameter. The cluster contains ~50 stars. The image was taken with the same equipment as Image 11.20 with a 150-min exposure

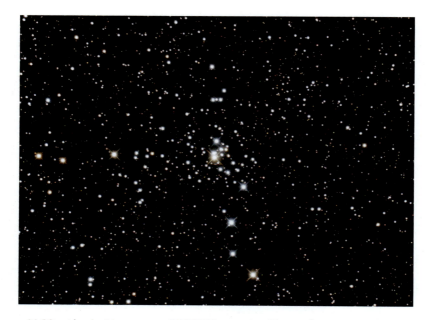

Image 11.28 Also in Monoceros, NGC2301 contains 80 stars in a 14-arcminute diameter region and shines at magnitude 6. The image was captured with an 8-inch f/8 Ritchey–Chrétien telescope with a Televue 0.8× field flattener/focal reducer to give f/6.4. The exposure was 40 min with a SBIG ST-2000XCM CCD camera. NGC2236 is 9600 light years away, while NGC2301 is 2800 light years away

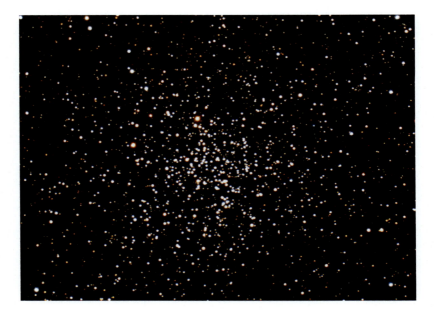

Image 11.29 NGC2477 is a rich, splendid star cluster in Puppis containing more than 300 stars in a 25-arcminute field. The cluster is estimated to be 700 million years old and shines at magnitude 5.8. The image was taken with the same equipment as the previous image using a 50-min exposure

Image 11.30 NGC6603 is a magnitude 11 star cluster in Sagittarius measuring 6 arcminutes in size. The image was taken with the same equipment as Image 11.20 with a 30-min exposure. Note the dense line of stars in the center of NGC6603

Image 11.31 The faintness of the stars in NGC6791 is due to its distance, which is approximately 13,300 light years. With an estimated age of 8 billion years, the cluster is extremely old. It contains only yellow, orange, and red stars. The cluster has a magnitude of 9.5 and is 10 arcminutes in diameter. The image was captured with an 8-inch f/8 Ritchey–Chrétien telescope with a Televue 0.8x field flattener/focal reducer to give f/6.4. The exposure was 60 min with a SBIG ST-4000XCM CCD camera

Image 11.32 NGC7510 is a magnitude 7.9, 6-arcminute cluster 11,400 light years away in the constellation Cepheus. The cluster was captured with a 132-mm f/7 triplet refractor with a Televue 0.8x focal reducer/field flattener yielding f/6.4. The exposure was 50 min with a SBIG ST-4000XCM CCD camera

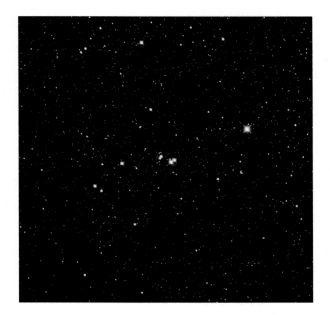

Image 11.33 NGC6871 is a magnitude 5.2 cluster in Cygnus with a diameter of 29 arcminutes. The cluster fills most of this image. Shining at magnitude 5.2, the cluster is 5100 light years away. The image was captured with an 8-inch f/8 Ritchey–Chrétien telescope with a Televue 0.8x field flattener/focal reducer to give f/6.4. The exposure was 30 min with a SBIG ST-4000XCM CCD camera

11 Galactic Star Clusters 215

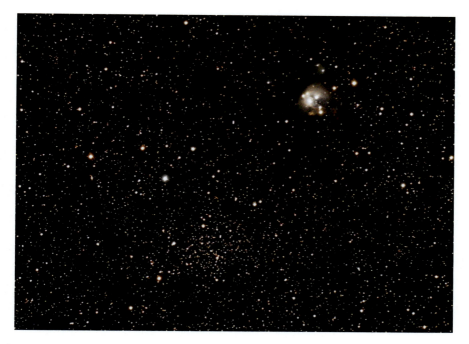

Image 11.34 NGC7142 (lower left) is a rich cluster of approximately 60 stars, most between 13th and 14th magnitude with several brighter stars. The cluster has a magnitude of 9.3 and is 12 arcminutes in diameter. Lying in the constellation Cepheus, the cluster is 6800 light years distant. The cluster is paired with the reflection nebula NGC7129, which was featured in Image 10.32. The image was taken with a William Optics 132-mm f/7 apochromatic refractor with a 0.8× focal reducer/field flattener yielding f/5.6. The exposure was 220 min using a SBIG ST-2000XCM CCD camera

All of the star clusters featured in this chapter are relatively close to us in that they reside on the same side of the Milky Way Galaxy. All of these images show that galactic clusters come in all kinds of shapes, sizes, and ages. These clusters are representative of galactic clusters found throughout our galaxy. Most of the galactic star clusters scattered around the galaxy cannot be viewed in amateur telescopes. Fortunately, professional ground-based and space telescopes are able to resolve star clusters throughout the Milky Way Galaxy as well as in nearby galaxies for astronomers to study.

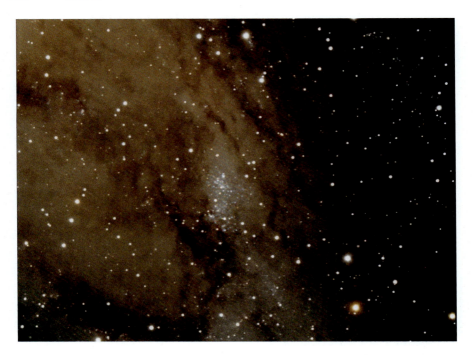

Image 11.35 NGC206 is a star association in the Andromeda Galaxy. The association contains approximately 300 O and B stars. There may be myriad less massive stars in the group making it an open star cluster rather than an association. However, less massive stars are not bright enough to see that far away. The image was captured with a 10-inch f/6 Newtonian with a Paracorr Type 2 coma corrector yielding f/6.9. The exposure was 180 min with a SBIG ST-2000XCM CCD camera

12

Globular Star Clusters

The last chapter discussed how stars are formed and in most cases start out as members of galactic star clusters. This chapter focuses on globular star clusters and how they vastly differ from galactic star clusters.

Globular star clusters contain an enormous number of stars. Most contain at least 100,000 stars. Some contain millions of stars. Unlike in galactic star clusters, the amount of mass in a globular star cluster is sufficient to keep all of the members gravitationally bound to the cluster (Image 12.1).

Because of the strong gravitational forces acting on member stars, globular clusters tend to be symmetric in shape. Most appear spherical, although some appear slightly ellipsoidal.

More than two-dozen images of globular clusters appear in this chapter. Some may argue that all globular clusters look alike. To some extent, they are right. However, there are many differences that the images in this chapter highlights.

In all of the globular clusters pictures in this chapter, except Image 12.2, north is up and east is to the left. A variety of focal lengths and sensor sizes were used to capture these images. So, the relative cluster sizes in the images are not necessarily the real size differences. Therefore, the angular sizes of the clusters are noted in the image descriptions (Images 12.3, 12.4, 12.5, and 12.6).

© The Author(s), under exclusive license to Springer Nature Switzerland AG 2024
J. Dire, *Exploring the Universe*, The Patrick Moore Practical Astronomy Series,
https://doi.org/10.1007/978-3-031-65346-9_12

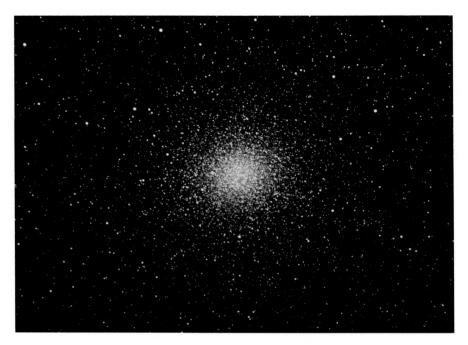

Image 12.1 NGC5139 (VIII) is the brightest and most massive globular cluster known in the Milky Way Galaxy. The cluster contains millions of stars, spans 57 arcminutes, and shines at magnitude 3.9. Most of the stars out to the edges of this image are members of the cluster. The cluster was captured with a 102-mm f/7.9 refractor with a 0.8× focal reducer/field flattener to give an effective focal length of 640 mm. The full Moon would cover about half the width of this image. NGC5139 is located 17,090 light years away. The cluster has a diameter of approximately 170 light years. Edmond Halley is credited with first identifying NGC5139 as a nonstellar object in the year 1677. This was the second globular cluster discovered. Twelve years earlier, M22 was identified as one by the German amateur astronomer Abraham Ihle (1627–1699). The Roman numeral VIII in parentheses above is not part of the cluster's catalog name. It refers to the concentration class. These are described later in this chapter

12 Globular Star Clusters

Image 12.2 NGC5139 was given the star designation Omega Centauri, since it is easily visible and appears star-like to the unaided eye. This image was taken with a Canon 600D camera with a 100-mm lens set at f/3.5 ISO800. The exposure was 10 min

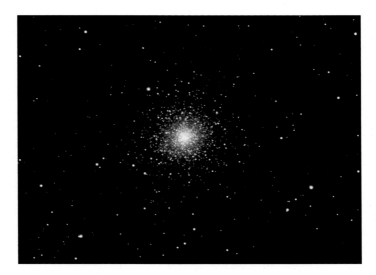

Image 12.3 M2 or NGC7089 (II) in the constellation Aquarius. Although it contains less than 10 % of the number of stars as Omega Centauri, M2 has about the same diameter. It is not as big in our sky since it is 55,000 light years away. It spans 16 arcminutes and has a magnitude of 6.5. The image was taken with an 8-inch f/8 Ritchey–Chrétien telescope with a 0.8× focal reducer/field flattener (1300 mm focal length) using a SBIG ST-2000XCM CCD camera. The exposure was 30 min

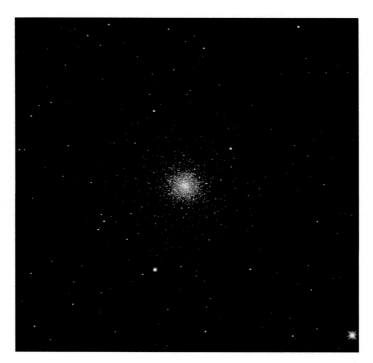

Image 12.4 M3 or NGC5272 (VI) lies in Canes Venatici. The cluster has a magnitude of 6.4 and is 18 arcminutes in size. It is 33,900 light years away. The image was taken with the same optical train as Image 12.3. However, a SBIG ST-4000XCM CCD camera was employed for a 40-min exposure. The image was cropped in the vertical dimension

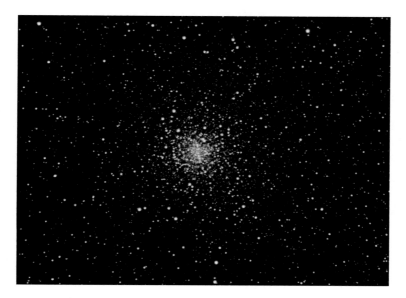

Image 12.5 M4 or NGC6121 (IX) lies in Scorpius very close to the bright red star Antares. The cluster has a magnitude of 5.6 and spans 26 arcminutes. It is located a mere 7200 light years away. Compared to the clusters in the previous images, M4 has a sparse core. The core has what appears to be a north–south bar structure. This bar is just a random 2.5 arcminute-long line of 11th magnitude stars. This image was taken with a 102-mm f/7.9 refractor using a SBIG ST-2000XCM CCD camera. The exposure was 30 min

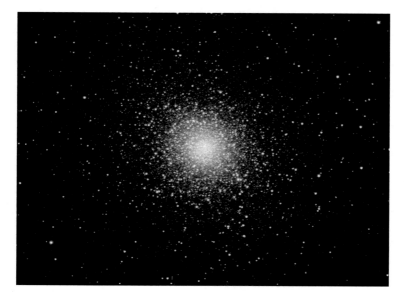

Image 12.6 M5 or NGC5904 (V) is a rich, magnitude 5.6 cluster in Serpens. The cluster is 23 arcminutes in size and is 24,500 light years away. M5 may contain 500,000 stars. Taken with a 10-inch f/6 Newtonian with a Televue Paracorr Type 2 coma corrector (1753-mm focal length) using a SBIG ST-2000XCM CCD camera. The exposure was 60 min

Whereas galactic star clusters are mostly confined to the plane of the Milky Way Galaxy, globular star clusters reside in a spherical halo around the galaxy. They have highly elliptical orbits around the galaxy in random planes, requiring hundreds of millions of years to complete one orbit. Studying of these orbits first led to determining the location of the center of our galaxy.

Charles Messier, the famous eighteenth-century French comet hunter, discovered numerous globular star clusters. Using a small refractor, Messier came across many of these clusters, which looked like tailless comets in his eyepiece. Messier observed these objects for hours, not to be fooled into announcing another new comet. After noting no proper motion (movement with respect to farther away stars), he knew they were not comets and recorded their positions so he would not confuse them for comets the next time he spied them. His famous catalog contains 29 globular star clusters.

The New General Catalog (NGC) contains 138 globular clusters. Most of them are part of the Milky Way Galaxy. It is estimated that there are 150–200 globular clusters gravitationally bound to the Milky Way Galaxy. Globular clusters are also seen in other galaxies. Almost 300 have been identified in M31, the Andromeda Galaxy, and it may have between 500 and 1000 total globular clusters. The Triangulum Galaxy, M33, may have around 50. There might be around 15 in the Large Magellanic Cloud. Finally, approximately 1000 globular clusters have been seen in the giant elliptical galaxy M87, which may only constitute a small fraction of the total! (Images 12.7, 12.8, 12.9, 12.10, 12.11, and 12.12).

12 Globular Star Clusters 223

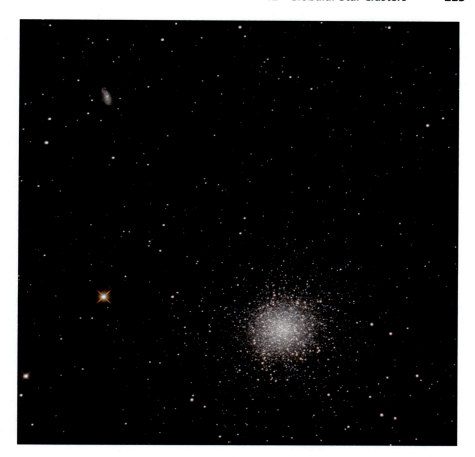

Image 12.7 M13 or NGC 6205 (V) is considered by many to be the best globular star cluster visible from mid-northern hemisphere latitudes. Also known as the Great Globular Cluster in Hercules, M13 is the brightest and largest of three such clusters in the constellation. M13 has a magnitude of 5.8. The cluster is 20 arcminutes in diameter which corresponds to ~160 light years at its distance of 25,000 light years. M13 is home to more than 100,000 stars. This image frames the cluster with galaxy NGC6207 (upper left) and a magnitude 6.8 red star (lower left). The image was captured with an 8-inch f/8 Ritchey–Chrétien Cassegrain (with a Televue 0.8× focal reducer/field flattener yielding f/6.4) using a SBIG ST-4000XCM CCD camera. The exposure was 60 min

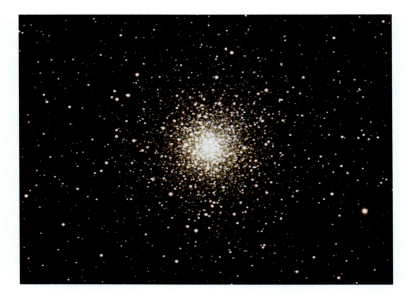

Image 12.8 M10 or NGC6254 (VII) is a magnitude 6.6 cluster in Ophiuchus. It is 21.5 arcminutes in diameter and is 14,400 light years away. The image was captured using a 10-inch f/6 Newtonian with a Paracorr Type 2 coma corrector and a SBIG ST-2000XCM CCD camera. The exposure was 20 min

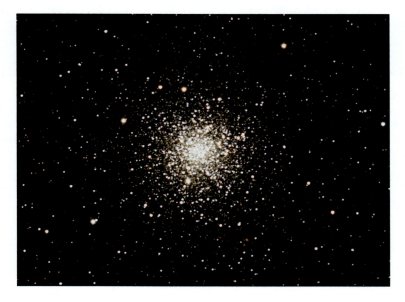

Image 12.9 M12 or NGC6218 (IX) is a magnitude 6.7 cluster, also in Ophiuchus. It is 17.6 arcminutes in diameter and is 15,600 light years away. The image was captured using the same equipment as Image 12.8 with a 30-min exposure

12 Globular Star Clusters 225

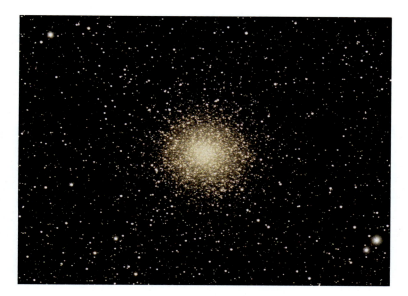

Image 12.10 M14 or NGC6402 (VIII) is a magnitude 7.6 cluster, also found in Ophiuchus. It is 16.0 arcminutes in diameter and is 30,300 light years away. The image was captured using the same equipment as Image 12.8 with a 40-min exposure

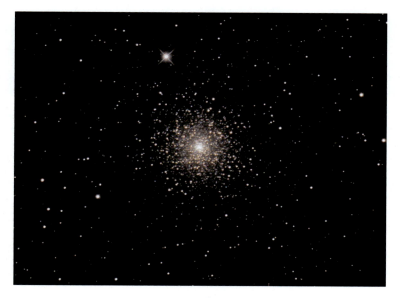

Image 12.11 M15 or NGC7078 (IV) is a beautiful cluster in the constellation Pegasus. The cluster shines at magnitude 6.2 and is 21.5 arcminutes in diameter. M15 is 33,300 light years away. The image was taken with an 8-inch f/8 Ritchey–Chrétien telescope with a 0.8× focal reducer/field flattener using a SBIG ST-2000XCM CCD camera. The exposure was 30 min. M15 was found to be emitting X-rays. Two X-ray sources were resolved in it by the Chandra X-ray Observatory. Astronomers suspect M15 may have a large black hole at its center

The star density at the center of globular star clusters is high, ranging from three to 30 stars per cubic light year. In the region of space around the Sun, the star density is only 0.004 stars per cubic light year. Any planet orbiting a star within a globular cluster would have a night sky tremendously crowded with bright stars!

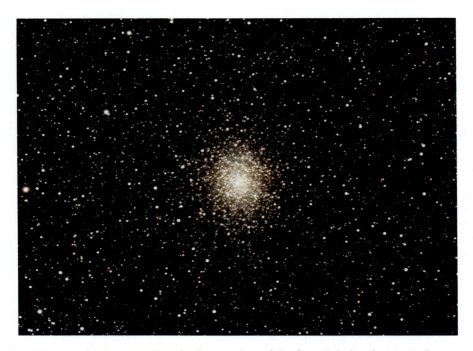

Image 12.12 M19 or NGC6273 (VIII) is another of the fine globular clusters in the constellation Ophiuchus. The cluster is magnitude 6.8 and is 14 arcminutes in diameter. M19 is 28,700 light years away. The image was captured using a 10-inch f/6 Newtonian with a Paracorr Type 2 coma corrector and a SBIG ST-2000XCM CCD camera. The exposure was 20 min. The image shows that M19 is elliptical, with the north-south axis longer than the east-west axis. It is the most oblate globular cluster known. The cluster is currently a mere 5200 from the galactic center. This close approach to the Milky Way's center may be responsible for its nonspherical shape

Astronomers classify stars as those that contain metals (called Population I stars) and those that do not contain metals (called Population II stars). To astronomers, metals are any elements heavier than hydrogen and helium. Metals are created in the cores of stars during nuclear fusion and during supernova explosions. Stars that formed early in the universe, before many metals were created, contain only hydrogen and helium and are therefore Population II stars.

Almost all globular clusters contain only Population II stars. This means that they are very old and formed when the universe was young. The clusters are between 11 and 13 billion years old. Because of this age, they contain no O, B, or A spectral class stars. Any O, B, or A stars that formed within a globular cluster would have all burned out in the first few billion years after the cluster formed, since these are the shortest-lived types of stars (Image 12.13).

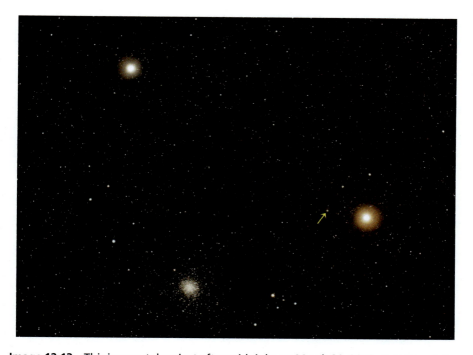

Image 12.13 This image, taken just after midnight on March 30, 2018, contains globular cluster M22 (near bottom, left of center), the planet Saturn (brightest object upper left), and the planet Mars (bright red object on the right side). The yellow arrow points to a much smaller and fainter globular star cluster called NGC6642. M22 has a magnitude of 5.1 and spans 29 arcminutes. It is located 10,400 light years away. NGC6642 has a magnitude of 9.1 and lies 27,400 light years away. NGC6642 is 10 arcminutes in size. However, the exposure was too short to pick up anything but the core of that cluster. This image was taken with a Stellarvue SV70T, a 70-mm f/6 apochromatic refractor, using a 0.8× focal reducer/field flattener and a SBIG STF-8300C CCD camera. The exposure was 30 min. The planets are grossly overexposed. But this was intentional to bring out details in M22

In 1926, Harvard astronomer Harlow Shapley (1885–1972) and a graduate student Helen Sawyer (1905–1993; married name Helen Hogg) developed a scale for classifying the concentration or density of globular clusters. Today, this is known as the Shapley-Sawyer Concentration Class. The classification scheme has 12 levels denoted with Roman numerals, although some catalogs use the numbers 1–12. Level I clusters have the highest concentration of stars in their core, while Level XII clusters have virtually no concentrated cores (Table 12.1).

All of the globular clusters pictured in this chapter have the Shapley-Sawyer concentration classification Roman numerals in parentheses in the image captions. Do you agree with all of them? (Images 12.14, 12.15, 12.16, 12.17, 12.18, 12.19, 12.20, 12.21, and 12.22)

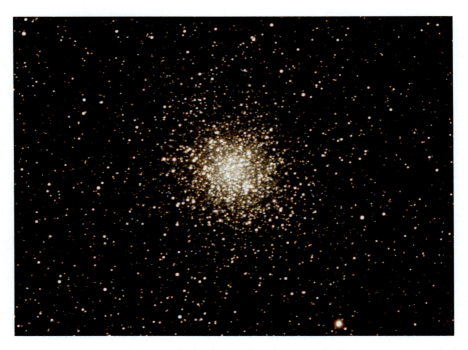

Image 12.14 M22 or NGC6656 (VII) is located in the constellation Sagittarius. It rivals M13 as the best globular cluster visible from mid-latitudes in the Northern Hemisphere. M22 has a diameter of about 97 light years and may contain up to 500,000 stars. The image was captured using a 10-inch f/6 Newtonian with a Paracorr Type 2 coma corrector and a SBIG ST-2000XCM CCD camera. The exposure was 60 min

12 Globular Star Clusters

Table 12.1 The Shapley-Sawyer concentration classifications

I	High concentration toward the center
II	Dense central concentration
III	Strong inner core of stars
IV	Intermediate rich concentrations
V	Intermediate concentrations
VI	Intermediate mild concentration
VII	Intermediate loose concentration
VIII	Rather loosely concentrated toward the center
IX	Loose toward the center
X	Loose
XI	Very loose toward the center
XII	Almost no concentration toward the center

Image 12.15 This image, a wide-field shot of the Milky Way in Sagittarius, contains two globular star clusters: M28 and NGC6638. M28 or NGC6626 (IV) has a magnitude of 6.8 and is 11.4 arcminutes in size. The cluster is 17,940 light years away. NGC6638 (V) is magnitude 9 and a mere 5 arcminutes in diameter. This cluster is 27.4 light years distant. Three stars are labeled in this image for references as well as the dark nebula LDN236. The image was captured with a William Optics 71-mm f/4.9 four-element apochromatic refractor with a SBIG STF-8300C CCD camera. The exposure was 30 min

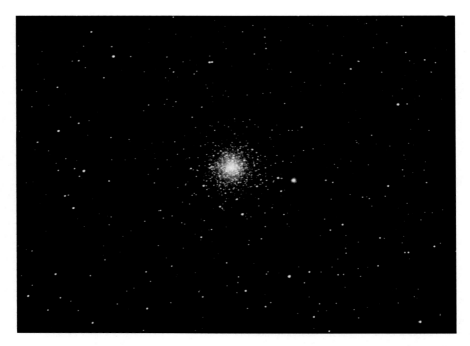

Image 12.16 M30 or NGC7099 (V) is found in the constellation Capricornus. M30 has a magnitude of 7.2 and is 11 arcminutes in size. The cluster is 26,100 light years away. This image was taken with a 190-mm f/5.3 Maksutov-Newtonian telescope using a SBIG ST-2000XCM CCD camera. The exposure was 20 min

Capturing multiple globular clusters in a single frame, such as in Image 12.15 and Image 12.17 below, is more likely in constellations near the starry swath of the summer Milky Way. This is due to our location in the Milky Way Galaxy. The galaxy has a diameter of 105,000 light years. We are in the plane of the galaxy 25,800 light years from the center. The center of the galaxy lies within the constellation Sagittarius. So we see more globular clusters in Sagittarius and nearby constellations since most of the visible galaxy is in that direction. Table 12.2 shows the number of globular clusters in various constellations.

Image 12.17 M53 (center) and NGC5053 (lower left). This is one of the few pairings of globular clusters found looking perpendicular to the plane of the Milky Way Galaxy. These globular clusters are in the constellation Coma Berenices. The brightest star in the frame is magnitude 4.3 Alpha Comae Berenices. NGC5053 (XI) has a magnitude of 9.5 and is 10.5 arcminutes in size. The cluster is 55,700 light years away. M53 will be described in the next image. This image was taken with a Stellarvue 70-mm f/6 apochromatic refractor with a 0.8× focal reducer/field flattener using a SBIG STF-8300C CCD camera. The exposure was 40 min. The combination of optics and CCD camera employed to create this image yielded a frame 3° wide

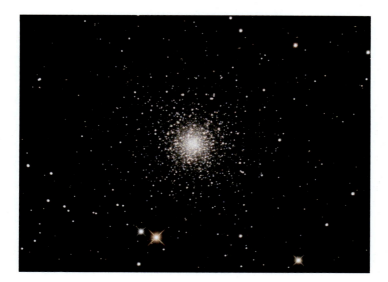

Image 12.18 M53 or NGC5024 (V) has a magnitude of 7.6 and is 12.6 arcminutes in size. At a distance of 59,700 light years, M53 is one of the most distant globular clusters in the Milky Way Galaxy. Were it as close as M13, it would be brighter and much larger than M13 in our sky. The image was taken with same equipment as Image 12.14 with a 40-min exposure

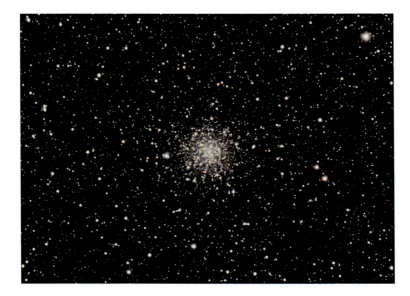

Image 12.19 M56 or NGC6779 (X) is the only globular cluster in Lyra. The cluster has a magnitude of 8.3 and is 8.8 arcminutes in diameter. It lies 32,900 light years away. The image was taken with an 8-inch f/8 Ritchey–Chrétien telescope with a 0.8× focal reducer/field flattener using a SBIG ST-2000XCM CCD camera. The exposure was 40 min

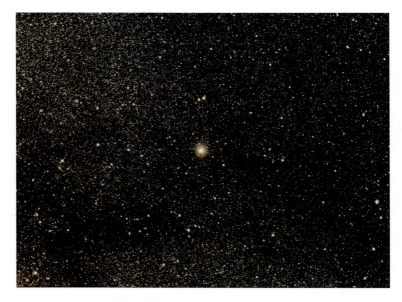

Image 12.20 Globular cluster M62 or NGC6266 (IV) lies within the multitude of stars in the Milky Way on the Ophiuchus-Scorpius border. The cluster has a magnitude of 6.5 and has a diameter of 15 arcminutes. It resides 21,500 light years away. This image was captured with a 70-mm f/6 refractor with a 0.8× focal reducer/field flattener and a SBIG STF-8300C CCD camera. The exposure was 40 min

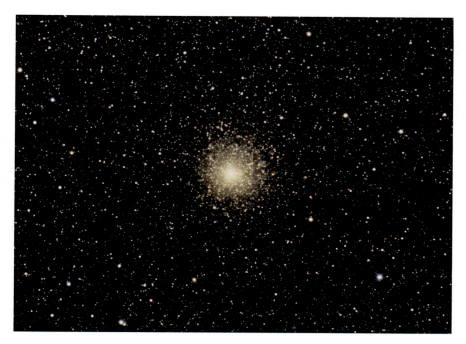

Image 12.21 This more zoomed-in image of M62 was taken using an 8-inch f/8 Ritchey–Chrétien with a 0.8× focal reducer/field flattener and a SBIG ST-2000XCM CCD camera. The exposure was 40 min. M62 is in the top ten most massive and luminous clusters in our galaxy

M62 (previous image) lies roughly between Earth and the center of the galaxy. That is approximately true. The disk of the galaxy is roughly 1000 light years thick. M62 resides 900 light years above the center of the disk. The cluster is actually moving away from the disk. So sometime in the past, it passed through the galactic disk!

The information in Table 12.2 indicates that 44 of the 88 constellations contain at least one cataloged globular cluster. Sagittarius contains the most as explained earlier in the chapter. Ophiuchus and Scorpius contain regions of the Milky Way, thus they have high numbers of globular clusters. But the Milky Way does not go through the southern constellation Dorado, so the large count there seems anomalous. It would be except Table 12.2 includes the globular clusters in the Large Magellanic Cloud, which resides in Dorado. These clusters are included in the table because many of them are bright enough to be included in the New General Catalog and can be spied in amateur telescopes.

Table 12.2 Number of globular clusters in various constellations

Constellation Name	Globular clusters Count	Constellation Name	Globular clusters Count
Sagittarius	36	Musca	2
Ophiuchus	27	Telescopium	2
Dorado	20	Ursa Major	2
Scorpius	19	Virgo	2
Tucana	7	Bootes	1
Mensa	5	Carina	1
Serpens	5	Cetus	1
Aquila	4	Chamaeleon	1
Ara	4	Columba	1
Coma Berenices	4	Corona Austrina	1
Lupus	4	Canes Venatici	1
Aquarius	3	Eridanus	1
Centaurus	3	Fornax	1
Hercules	3	Gemini	1
Hydra	3	Lepus	1
Norma	3	Libra	1
Pegasus	3	Lynx	1
Sagitta	3	Lyra	1
Apus	2	Pavo	1
Capricornus	2	Pyxis	1
Delphinus	2	Scutum	1
Horologium	2	Vela	1

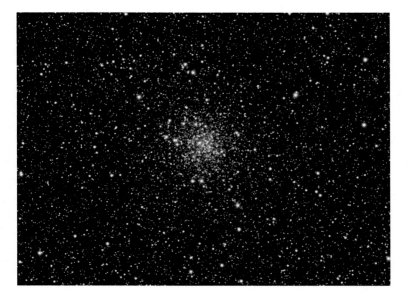

Image 12.22 M71 or NGC6838 (XI) has a sparse magnitude of 8.3 cluster in Sagitta. It is 8 arcminutes in diameter and is 13,000 light years away. The image was captured using a 10-inch f/6 Newtonian with a Paracorr Type 2 coma corrector and a SBIG ST-2000XCM CCD camera. The exposure was 60 min

12 Globular Star Clusters

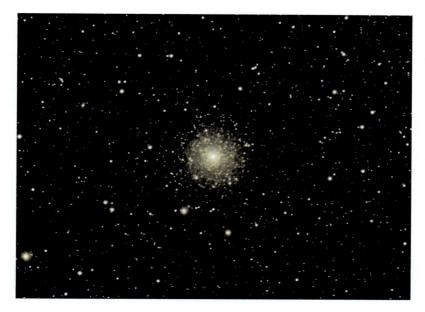

Image 12.23 M75 or NGC6864 (I) in Sagittarius has a magnitude of 8.5 and is 7 arc-minutes in diameter. It is 67,500 light years away. The image was captured using the same equipment as Image 12.22 with a 40-min exposure

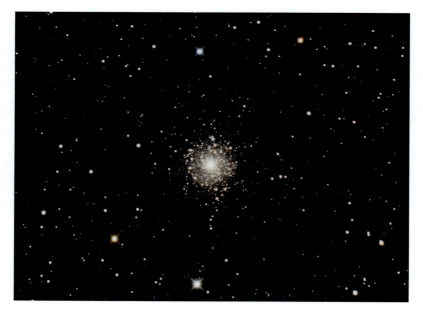

Image 12.24 M79 or NGC1904 (V) is a magnitude 8.7 cluster in the constellation Lepus. It is 8.0 arcminutes in diameter and is 42,000 light years away. The image was taken using an 8-inch f/8 Ritchey–Chrétien with 0.8× focal reducer/field flattener and a SBIG ST-2000XCM CCD camera. The exposure was 50 min

The previous two pages contained images of three vastly different globular clusters: M71, M75, and M79. The Shapley-Sawyer classifications are XI, I, and V. So M75 has a very sparse core while M75 has a very dense core. M79 falls somewhere in between.

M71 and M75 are located close to the plane of the galaxy. However, M75 is on the other side of the galactic center from us, while M71 is on the same side as us, even though they are only 41° apart from one another in the sky. The other cluster is south of the galaxy's disk (Images 12.23, 12.24, 12.25, 12.26, 12.27, 12.28, 12.29, 12.30, 12.31, and 12.32).

Like the three clusters on the previous page, the three clusters on the next two pages, M80, M92, and M107, also look vastly different from one another. M80 has a very dense core, while M107 has a sparse core. M92 falls somewhere in between.

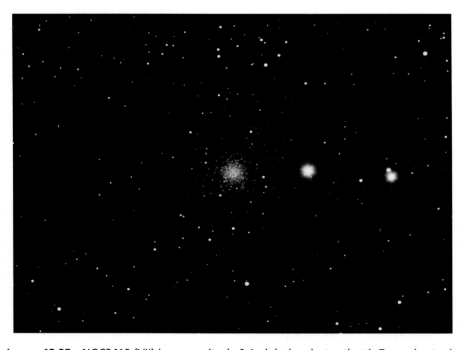

Image 12.25 NGC2419 (VII) is a magnitude 9.1 globular cluster that is 7 arcminutes in diameter. The cluster is unique in that it is not in the galactic disk or halo, like all other Milky Way globular clusters, nor does it reside in another galaxy. NGC2419 is 274,600 light years away, farther from the center of the Milky Way than either of the Magellanic Clouds (satellite galaxies of the Milky Way). The cluster is often called the Intergalactic Wanderer since for a long time it was thought to be passing through the region containing the Milky Way and its satellite galaxies. Now it is believed to be gravitationally bound to the Milky Way taking three billion years to complete one orbit. The image was captured using a 10-inch f/6 Newtonian with a Paracorr Type 2 coma corrector and a SBIG ST-2000XCM CCD camera. The exposure was 330 min! The cluster is found in the constellation Lynx

12 Globular Star Clusters 237

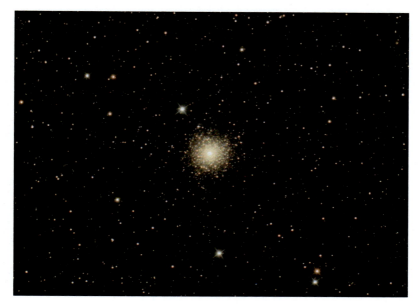

Image 12.26 M80 or NGC6093 (II) has a sparse magnitude of 7.3 cluster in Sagitta. It is 10 arcminutes in diameter and is 32,600 light years away. The image was taken using an 8-inch f/8 Ritchey–Chrétien with a 0.8× focal reducer/field flattener and a SBIG ST-2000XCM CCD camera. The exposure was 50 min

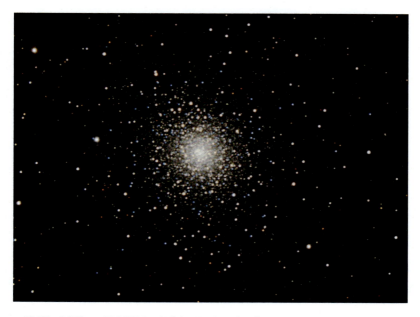

Image 12.27 M92 or NGC6341 (IV) in Sagittarius has a magnitude of 6.4 and is 15 arcminutes in diameter. It is 26,700 light years away. The image was captured using a 10-inch f/6 Newtonian with a Paracorr Type 2 coma corrector and a SBIG ST-2000XCM CCD camera. The exposure was 20 min

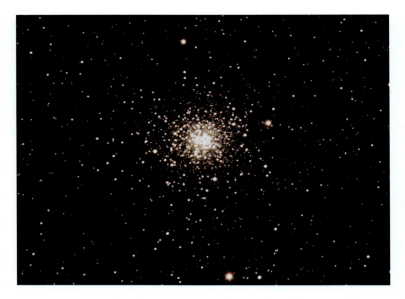

Image 12.28 M107 or NGC6171(X) is a magnitude 7.9 cluster in the constellation Ophiuchus. It is 10 arcminutes in diameter and is 20,900 light years away. The image was taken with the same equipment as Image 12.26 but with a 30-min exposure

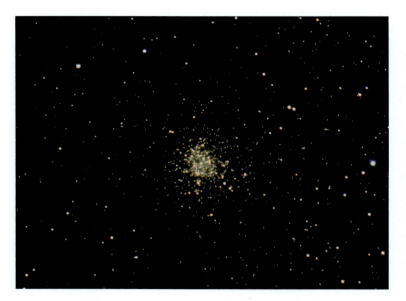

Image 12.29 NGC3201 (X) is in the southern constellation Vela. The cluster has a magnitude of 8.2 and is 18.2 arcminutes in size. NGC3201 is 16,300 light years away. This is the southernmost globular cluster that the author has imaged from the United States. The image was taken using an 8-inch f/8 Ritchey–Chrétien with a 0.8× focal reducer/field flattener and a SBIG ST-2000XCM CCD camera. The exposure was 60 min

12 Globular Star Clusters 239

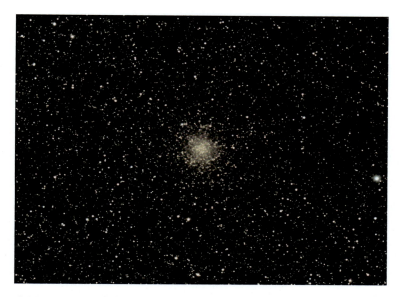

Image 12.30 NGC6760 (IX) in Aquila has a magnitude of 9.0 and is 9.6 arcminutes in diameter. The cluster is 24,100 light years away. The cluster is passing though the Milky Way's disk. The image was taken with the same equipment as Image 12.27 but with a 30-min exposure

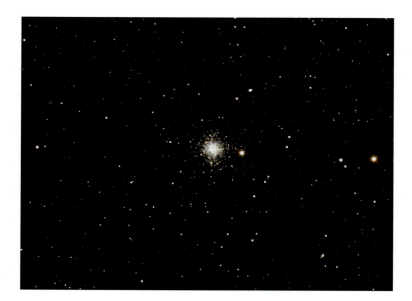

Image 12.31 NGC6934 (VIII) shines at a magnitude of 8.8. The cluster is 8.8 arcminutes in size and resides in the constellation Delphinus 51,200 light years away. The image was captured using a 10-inch f/6 Newtonian with a Paracorr Type 2 coma corrector and a SBIG ST-2000XCM CCD camera. The exposure was 60 minutes. The two brightest stars in the image, magnitudes 9.5 and 9.3, are foreground stars

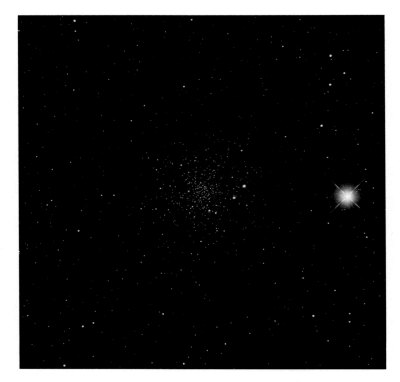

Image 12.32 NGC6366 (XI) is one of the least concentrated globular clusters in the Milky Way. The cluster has a magnitude of 9.5 and is 13.5 arcminutes in diameter. NGC6366 is 11,700 light years away. The cluster is in the constellation Ophiuchus, not far from the cluster M14 (Image 12.10). The bright star to the right of the cluster is SAO141665 with shining magnitude 4.5. SAO141665 is a mere 98 light years away and can be seen without optical aid in dark skies, making finding NGC6366 quite easy

While it may appear that all globular clusters may look alike, studying the images in this chapter shows that each is unique. They are all beautiful objects to view in their own right, whether seen through the eyepiece of a telescope or captured in a photograph!

13

Comets

Comets are ancient solar system objects much smaller in size than a typical planet or moon. Astronomers think that comets may be leftover chunks of material out of which planets formed billions of years ago. Image 13.1 shows a typical comet as it travels through the inner solar system (roughly inside the orbit of Mars).

Comets are solid bodies consisting of a mixture of ices, dust and rock. The ices can be frozen water, carbon dioxide, methanol, methane, ammonia, hydrogen sulfide, or carbon monoxide, just to name a few. Most of it (~80%) is frozen water. When a comet comes within five astronomical units (AUs) from the Sun, sublimation of the ice creates an atmosphere around the comet's *nucleus* (solid body). [Recall that an astronomical unit is the mean Earth-Sun separation, approximately 150 million kilometers or 93 million miles.]

The atmosphere around the comet is not a permanent feature as comets are too small to gravitationally hold onto an atmosphere. So, this gaseous envelope is simply called the *coma*.

The tail of a comet forms as it approaches closer to the Sun. A comet can have two types of tails. The *ion tail* is formed by gas molecules that have been ionized by ultraviolet light from the Sun. Ionization is when a molecule or atom loses electrons leaving behind a positive ion.

The other type of tail is the *dust tail*. The dust tail contains microscopic, electrically neutral dust particles that have been thrown off the surface of the comet entrained in the ices that underwent rapid sublimation. As seen in Image 13.1, dust tails are broad and diffuse. They can reflect a lot of sunlight and be seen from far away. The ion tails are narrower and straight. Therefore, ion tails do not reflect as much sunlight, making them more difficult to see.

© The Author(s), under exclusive license to Springer Nature Switzerland AG 2024
J. Dire, *Exploring the Universe*, The Patrick Moore Practical Astronomy Series,
https://doi.org/10.1007/978-3-031-65346-9_13

Since comets move in arcing paths through the solar system, the tails are not necessarily behind the comets direction of motion. They are affected by the solar wind, the invisible stream of matter, and radiation escaping the Sun. Therefore, the tails generally lie outside a comet's orbit. The ion tail is more affected by the solar wind, so that the tail always points closer to the comet's anti-Sun direction. Since the dust tail is less affected by the solar wind, it tends to fan out more in the direction behind the comet's motion, curving because the comet's motion is along an arcing path. Comet tails can be between a few hundred thousand and a few hundred millions of miles (or kilometers) long!

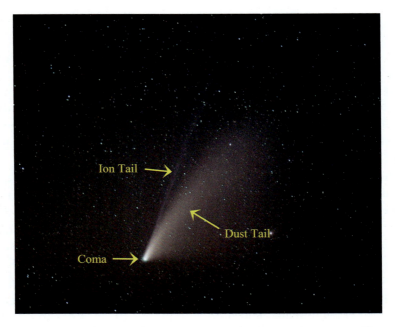

Image 13.1 Picture of a typical comet entering the inner solar system. The comet's coma, ion tail, and dust tail are labeled

Most likely, the most famous comet is known as Halley's Comet, named after Sir Edmond Halley (1656–1742), an English astronomer. In the year 1681, the Italian astronomer Giovanni Domenico Cassini (1625–1712) told Halley his theory that comets were in orbits around the Sun. In 1682, Halley studied a comet that he thought might have been the same comet sighted in 1531 and 1607. In 1684, Halley went to Cambridge to visit Isaac Newton (1642–1727) to see if Newton could help him prove the comet was in orbit around the Sun. With the help of Newton, Halley predicted that the 1682 comet would return in 1758. It did and Halley's Comet has been famous ever since.

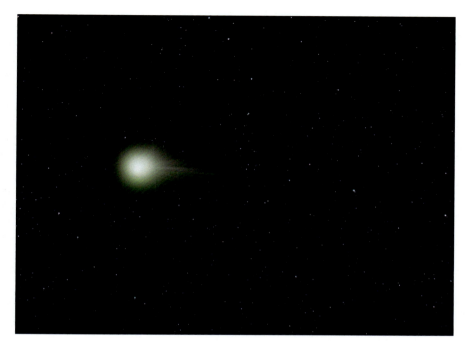

Image 13.2 Comet Lovejoy C/2014 Q2. The image was taken on January 20, 2015, with a 71-mm f/4.9 refractor using a SBIG ST-8300C CCD camera. The exposure was 48 min

Halley's Comet has an orbital period that varies between 75 and 79 years. Its perihelion (closest point in an orbit to the Sun) is 0.59 AU (between the orbits of Mercury and Venus) and its aphelion (farthest point from the Sun in an orbit) is 35 AU (past the orbit of Neptune). The comet returned in 1835, 1910, and 1986. The comet will next be in the inner solar system in the year 2061.

In 1986, Comet Halley, as it is also called, was not well placed for viewing from Earth. This was the least favorable passage of the comet since Edmond Halley viewed it in 1682. However, the comet did reach naked-eye visibility (Image 13.2).

Halley's Comet reached perihelion on February 9, 1986, as seen from behind the Earth-facing side of the Sun. As it swung around the Sun, it did not become visible until early March of that year when it was in the constellation Capricornus (Image 13.3).

244 J. Dire

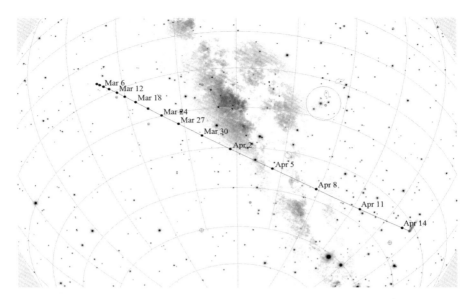

Image 13.3 The path of Halley's Comet through the celestial sphere in March and April 1986. Dots are placed on the path showing the comet's position every 3 days

Image 13.4 Comet Halley captured during morning twilight near Oviedo, Florida on March 8, 1986. The picture was taken with Kodak Tri-X black and white slide film with a Minolta X-570 camera on a tripod and a 50-mm lens set at f/1.7. The exposure was 30 s. The two bright stars to the left of the comet are Alpha (top) and Beta (bottom) Capricorni

13 Comets

I started searching for the comet in March 1986 in dark skies east of Orlando, Florida, before morning twilight. Spring mornings in central Florida are often accompanied by fog before and during twilight. I searched for the comet for 60 days straight, rising at 4:00 a.m. and driving to a dark site 30–60 min away from my home. The mornings I caught a glimpse of the famous comet were worth the mornings I sat in my car until sunrise, unsuccessful due to fog.

When Halley's Comet last visited, digital cameras had not yet been invented. Accordingly, my photographs of the comet were taken with film. With short exposures, I could capture the comet without tracking. Most of my pictures were taken with a camera on a tripod. This equipment is shown in Image 2.17. I mostly used slide film since I could develop it at home the same day and view the slides immediately to see how well I captured the comet.

On March 8, 1986, the comet was still too faint in the twilight to see with the naked eye. But it was visible in binoculars. I was able to capture my first image of it (Image 13.4). On March 12, 1986, the comet passed from Capricornus to Sagittarius. The next morning it passed within 30 arcminutes of globular cluster M75. Unfortunately, I was clouded out. Other pictures of Halley's comet are found in Images 13.5, 13.6, 13.7, and 13.8.

Image 13.5 Comet Halley was captured between the clouds during morning twilight near Oviedo, Florida on March 19, 1986, at 5:00 a.m. The picture was taken with Agfachrome 1000 color slide film with a Minolta X-570 camera on a tripod and 50-mm lens set at f/1.7. The exposure was 30 s. Note the Teapot asterism in Sagittarius on the upper right of the picture

Over the next 2 weeks, the comet crossed into the Milky Way, traveling westward south of the Teapot. By April 3, the comet had crossed into the constellation Scorpius. Around this time, the comet's tail appeared to become shorter. By the time the comet reached its closest approach to Earth on April 10, 1986, no tail was visible. The comet did not lose its tail. The orientation of the comet to Earth changed such that the tail was pointing directly away from Earth. Therefore, from our vantage point, the tail was behind the comet and not visible.

Halley's Comet left Scorpius on April 6. It cut across the northwest corner of the constellation Ara and entered Norma on April 8. By now, the comet was too far south to be visible throughout most of the Northern Hemisphere. However, it was still visible from southern US states April 9–12 in the constellation Lupus. On April 13, it entered Centaurus and started moving northwest receding from Earth and fading away from naked-eye visibility.

Halley's Comet will be much brighter when it returns in the year 2061. It reaches perihelion on July 28th. However, unlike 1986, this time the Earth will be on the same side of the Sun as the comet, providing fantastic views of this famous solar system wonder.

Image 13.6 Same location, equipment, and film as the last image. This is a 60-s unguided exposure taken on March 23, 1986

13 Comets 247

Image 13.7 Halley's Comet under the tail of the Scorpion April 5, 1986. Taken from James G. Bourbeau Memorial Park, Cocoa, Florida, with a Minolta X-570 camera, 200-mm f/5.6 lens, Agfachrome 1000 color slide film, piggyback on a tracking equatorial mounted telescope. The exposure was 5 min. Note the lack of a tail on the comet

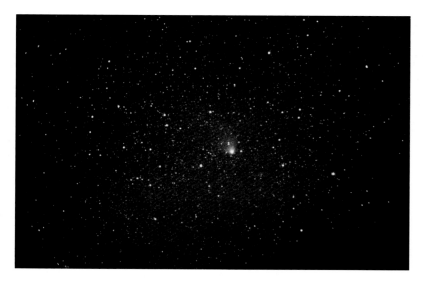

Image 13.8 Halley's Comet near its brightest on April 12, 1986. The broad and faint dust tail was behind the comet as viewed from Earth. The image was taken from Mahogany Hammock in the Everglades National Park using a Minolta X-570 camera, 100-mm f/4 lens, and Ektachrome P800/1600 color slide film. The camera was piggyback on a tracking equatorial mounted telescope. The exposure was 5 min. The brightest star in the image, to the lower right of the comet, is actually globular cluster Omega Centauri

Halley's Comet was given the designation 1P/Halley. The "P" indicates that the comet is a periodic comet. The number "1" in the name implies that this comet was the first known periodic comet. In this naming convention, the discoverer's name follows the forward slash. The second periodic comet was 2P/Encke named after Johann Franz Encke (1781–1865) who discovered its periodic nature in 1786. As of 2022, the highest numbered periodic comet is 446P/McNaught.

All periodic comets are in elliptical orbits around the Sun. Comets can also be in open orbits, either parabolas or hyperbolas. These comets only enter the solar system once. They make one pass around the Sun and then leave the solar system never to return. Open-orbit comets receive a designation "C" instead of a "P."

Today, when comets are discovered, they receive a name from a numbering convention similar to Comet Lovejoy, pictured in Image 13.2. This comet is C/2014 Q2 (Lovejoy). The "C" indicates the comet is not periodic, its period is longer than 200 years, or it was on its first known trip around the Sun. The discovery year follows the forward slash. This is followed by a space and then an uppercase letter. The uppercase letter signifies which half-month period in the year the comet was discovered, as shown in Table 13.1.

Table 13.1 Comet letter designations

Month	Days	Letter
January	1–15	A
January	16–31	B
February	1–15	C
February	15–29	D
March	1–15	E
March	16–31	F
April	1–15	G
April	16–30	H
May	1–15	J
May	16–31	K
June	1–15	L
June	16–30	M
July	1–15	N
July	16–31	O
August	1–15	P
August	16–31	Q
September	1–15	R
September	16–30	S
October	1–15	T
October	16–31	U
November	1–15	V
November	16–31	W
December	1–15	X
December	16–31	Y

Note that the letters "I" and "Z" are never used. The number after the letter gives the order in which the comet was discovered during the two-week period. The discoverer's name is often written in parenthesis at the end. Therefore, comet C/2014 Q2 (Lovejoy) was discovered by someone named Lovejoy (Australian amateur astronomer Terry Lovejoy 1966–), and it was the second comet discovered in the last 2 weeks of August 2014.

If a comet with a C designation is observed at perihelion a second time, the "C" will be changed to a "P" in its designation. Comet C/2012 O3 (McNaught) was observed at perihelion a second time in 2022. Therefore, it became P/2012 O3 (McNaught) and then 446P/McNaught. Astronomers tend to follow the naming rules herein, but they do not always strictly adhere to them. Images 13.9, 13.10, 13.11, 13.12, 13.13, 13.14, 13.15, and 13.16 show other comet pictures with their names and official designations.

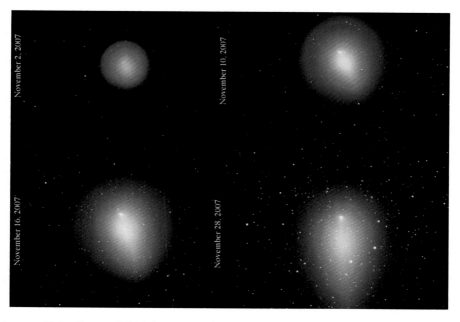

Image 13.9 Comet 17P/Holmes was discovered by Edwin Holmes (1839–1919) on November 6, 1892. The comet has a 6.88-year period. It does not come within 2 AU of the Sun and is usually pretty dim. In 1892, the year it was discovered, and again in 2007, the comet underwent a large outburst. The growth of the coma during the month of November 2007 is captured in the four-picture montage above. The images were taken with a 102-mm f/7.9 refractor with a 0.8× focal reducer/field flattener yielding f/6.3 using a SBIG ST-2000XCM CCD camera

The orbits of comets do not necessarily lie in or near the ecliptic. Short-period comets are more likely to be in the ecliptic and have prograde orbits (orbits around the Sun in the same direction as the planets). These comets do not tend to have orbits that extend beyond that of Pluto.

Long-period comets tend to have highly elliptical and inclined (to the ecliptic) orbits. Their aphelion distances are beyond the orbit of Pluto. Some travel as far as 50,000 AU from the Sun before heading back into the inner solar system. Since orbital bodies move much slower at aphelion than perihelion, these comets spend most of their time far away from the Sun and planets.

So where do comets originate and why do new ones appear in our skies? Short-period comets are thought to come from a region of the solar system beyond the planet Neptune named the Kuiper Belt (after Dutch astronomer Gerald Kuiper 1905–1973).

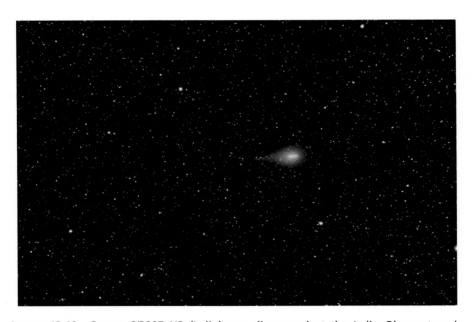

Image 13.10 Comet C/2007 N3 (Lulin) was discovered at the Lulin Observatory in Taiwan. It reached perihelion on July 6, 2009, and passed within 0.41 AU of Earth on February 24, 2009. This image shows the motion of the comet over 1 h on March 18, 2009. The image was taken with a 102-mm f/7.9 refractor with a 0.8× focal reducer/field flattener yielding f/6.3 using a Canon 30D digital camera

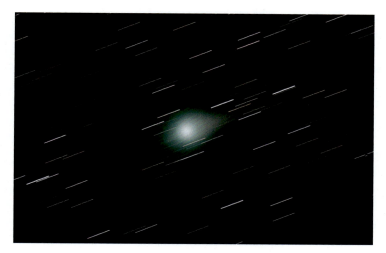

Image 13.11 Comet C/2007 N3 (Lulin) on February 20, 2009, taken with the same equipment as the previous image except with a 40-min exposure tracking on the comet. The discoverers of the comet chose to name it after the observatory rather than themselves. The comet appears larger in this image since it was much closer to Earth

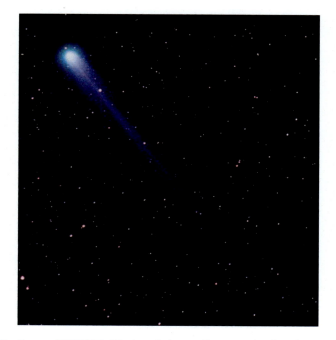

Image 13.12 Comet C/1996 B2 (Hyakutake) was discovered only a few months before it made a 0.1 AU close approach to Earth. This close approach occurred on March 25, 1996. At that time, the coma was 1.5–2° in diameter and reached magnitude 0. The tail extended 35°. This image was taken on March 23, 1996, with the equipment pictures in Image 12.2 (35-mm Minolta camera with a 50 mm lens at F/2) with a 5-min exposure. The image was taken in the Belleplain State Forest, New Jersey

The Kuiper Belt is a circular ring of asteroids located between 30 and 50 AU from the Sun. These asteroids have prograde orbits mostly in or slightly inclined to the ecliptic. More than 100,000 objects over 100 km in size exist in the Kuiper Belt. Some short-period (<200 years) comets may originate from the Kuiper Belt where interactions between two objects launch one toward the inner solar system. Likewise, a Kuiper Belt object could get too close to Neptune or Pluto launching it into the inner solar system. However, most periodic comets probably come from an extended scattered disk of objects that reach out to 100 AU. It is unclear what launches them into the inner solar system.

Unlike the Main Asteroid Belt between Mars and Jupiter, where asteroids are mostly composed of rock and metals, objects in the Kuiper Belt have a large amount of frozen ices (water, ammonia, methane, etc.). Some Kuiper Belt objects may wind up as *Centaurs*, icy asteroids that reside between Jupiter and Neptune. Because the Centaurs always experience gravitation pull from the outer planets, they are not in stable orbits and many become short-period comets.

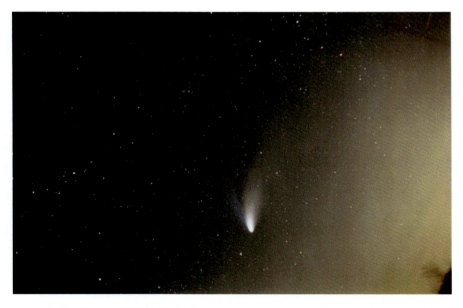

Image 13.13 Comet C/1995 O1 (Hale-Bopp) was discovered independently on July 23, 1995, by Thomas Bopp (1949–2018) and Alan Hale (1958–). Hale-Bopp was one of the most widely viewed comets of the twentieth century and one of the brightest comets of this generation. The comet reached magnitude -1.8 on April 1, 1997. This image from March 28, 1997, was taken with the same equipment as the previous image using Fugicolor 800 film with a 10-min exposure

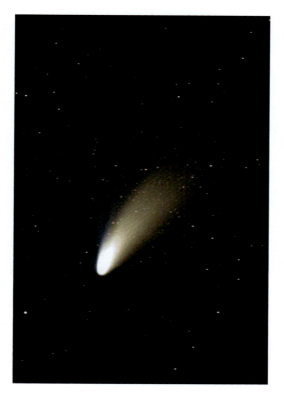

Image 13.14 Hale-Bopp sported a broad, bright white dust tail with a narrow blue ion tail. This image from April 2, 1997, was taken with a Minolta X-570 SLR camera with a 200-mm f/4 lens and Fugicolor 800 film. The exposure was 5 min. Both this image and the previous image were taken from Jarrettsville, Maryland

Long-period comets tend to have orbits randomly inclined to the ecliptic plane. Many astronomers feel that there must be a large spherical cloud of icy bodies far beyond the orbit of Pluto where these comets originate. This region of the solar system is called the Oort Cloud after Dutch astronomer Jan Oort (1900–1992). The Oort cloud may contain trillions of small icy objects. The total mass of these objects may be on the order of the mass of Earth. These objects lie between 2000 and 200,000 AU from the Sun. Tidal forces from the Milky Way may be responsible for the periodic launching of an Oort Cloud object toward the inner solar system creating a long-period or single-pass comet.

Image 13.15 Comet C/2020 F3 (NEOWISE) was the brightest comet since Hale Bopp. The comet was brighter than magnitude 1 when astronomers conducting a Near Earth Object (NEO) search using the Wide-field Infrared Survey Explore space telescope (WISE) discovered it on March 27, 2020. There are so many NEO searches underway using ground-based and space instruments that today a majority of the comets discovered are named after the search instrument, not a person. Comet NEOWISE reached perihelion on July 3, 2020. This wide-field image was captured on July 22, 2020, using a Canon 600D camera with an 18-mm lens set at f/3.5 along with a 0.43× focal reducer. The exposure was 2 min. The picture was taken near the end of twilight from Jubilee College State Park, Illinois. Note the Big Dipper in the center of the image and the Little Dipper on the right edge

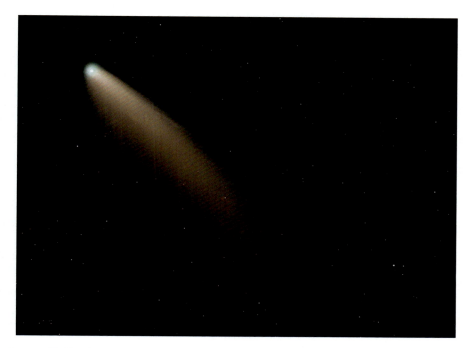

Image 13.16 Comet NEOWISE's blue coma and tail structure can be seen more clearly in this image taken on the same night from the same location as the previous image. The picture was taken with an Askar FRA 400 72-mm f/5.6 apochromatic refractor with a 0.7× focal reducer and a SBIG STF-8300C CCD camera. The exposure was 60 min

Comets are fascinating objects to study because they contain primordial solar system materials. They are equally fascinating to view because they are rare and many are visible without any optical aid. People who might not otherwise give the heavens a passing glance on most clear nights make an effort to find a dark site to spy these celestial wonders.

14

Galaxies

A galaxy is a large collection of stars, gas, and dust isolated in space and held together by its own gravity. Whereas stars, gas, and dust are all visible, astronomers believe most galaxies contain large amounts of matter that is not visible but contributes to the gravity that holds galaxies together. This unknown dark matter resides throughout galaxies. Most galaxies are thought to have an enormous black hole at their centers. These black holes may contain the same mass as millions of stars.

We reside in a galaxy called the Milky Way (Image 14.1). The name comes from the swath of irresolvable (to the naked eye) stars that circle the celestial sphere. This milky region marks the plane of the galaxy.

The Milky Way has a diameter of approximately 100,000 light years and is approximately 1000 light years thick. The central bulge is slightly larger with a diameter of around 10,000 light years. The galaxy contains at least 100 billion stars.

At the center of the Milky Way (approximate location indicated in Image 14.2) is a black hole called Sgr A* (pronounced Sagittarius A-star), with a mass of 4.1 million suns. The diameter of the black hole is estimated to be 120 astronomical units (11.2 billion miles). Everything in the galaxy orbits around this black hole. We orbit Sgr A* at a distance of 27,700 light years. It takes our solar system between 225 and 250 million years to make one orbit around the galaxy.

The Milky Way has three components: the disk, the bulge, and the halo. The disk is flat and contains many stars, galactic clusters, nebulae, dust, and star-forming regions. The halo is mostly devoid of gas and dust and forms a spherical region around the galaxy. The halo and bulge are redder than the disk because they contain older stars. No star formation is occurring in those

© The Author(s), under exclusive license to Springer Nature Switzerland AG 2024
J. Dire, *Exploring the Universe*, The Patrick Moore Practical Astronomy Series,
https://doi.org/10.1007/978-3-031-65346-9_14

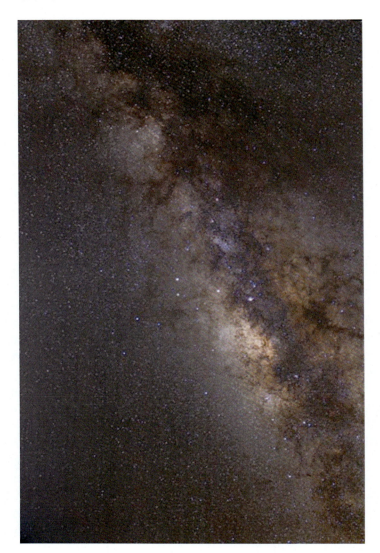

Image 14.1 The Milky Way Galaxy is disk shaped except for the central bulge (brightest region in the image), and it contains copious gas and dust that blocks our view of the center of the galaxy and points beyond it. This image was captured with a Canon 600D camera using an 18-mm lens at f/5.6 riding piggyback on an equatorial mounted telescope. The exposure was 10 min at ISO200

The Sagittarius Teapot asterism is difficult to spot in this image due to the bright glow of the Milky Way and the presence of two planets near the Teapot, which throws off the formation (see Image 14.2)

14 Galaxies 259

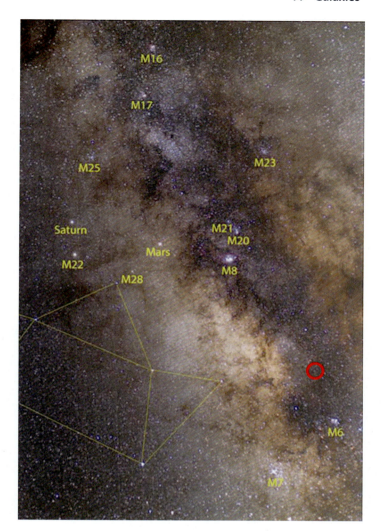

Image 14.2 The center of the Milky Way lies in the central dust lane inside of the red circle drawn on the image. This region is in the constellation Sagittarius. The Sagittarius Teapot Asterism is drawn to provide directions to the galactic center. Eleven Messier objects are labeled as are two planets that happened to be in Sagittarius when the image was taken. This image was captured with a Canon 600D camera using a 50-mm f/1.2 lens (set at f/1.4) riding piggyback on an equatorial mounted telescope. The exposure was 10 min at ISO200

regions and any blue stars that once were there have long since burned out. (Recall blue stars have the shortest lifetimes and red stars live the longest.)

The Milky Way is considered a large galaxy. It may have up to a few-dozen dwarf galaxies orbiting around it. The only two visible to the naked eye are the Large and Small Magellanic Clouds. However, some calculations of the speed of these two objects hint that they may be moving too fast to be in orbit around the Milky Way.

Prior to the twentieth century, other galaxies viewed or photographed with telescopes were thought to be nebulae within the Milky Way. In the 1920s, the American astronomer Edwin Hubble (1889–1953) was studying Cepheid variable stars that reside in these nebulae, including M31 (Images 14.3, 14.4, and 14.5) and M33 (Image 14.6). Hubble knew the maximum brightness of Cepheid variable stars is related to the period of their brightness variation. Hubble used the periods he calculated with their corresponding brightness to calculate the distance to these objects. He determined that they were not in the Milky Way but in galaxies very far away.

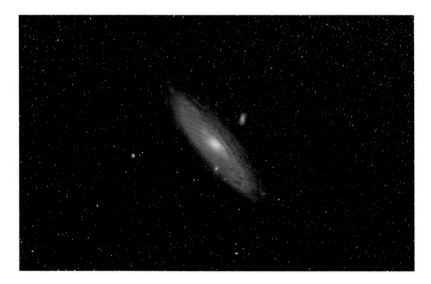

Image 14.3 M31, the Andromeda Galaxy, was called the Great Andromeda Spiral Nebula until Edwin Hubble proved that it was its own spiral galaxy. This image was captured with a Canon 30D camera using a 200 mm f/2.8 lens riding piggyback on an equatorial mounted telescope. The exposure was 120 min at ISO200. M31 has two satellite galaxies visible in small telescopes and in the image above. Satellite galaxy M32 is the tiny star-like point of light at the edge of M31's visible disk just below the galaxy's core. M110 is slightly above and to the right of M31. M31 is the closest large galaxy to the Milky Way. M31 lies 2.5 Mly (million light years) away and is approaching us at a speed of 300 km/s (671,000 MPH). In a few billion years, M31 will merge with the Milky Way to form a larger galaxy

14 Galaxies 261

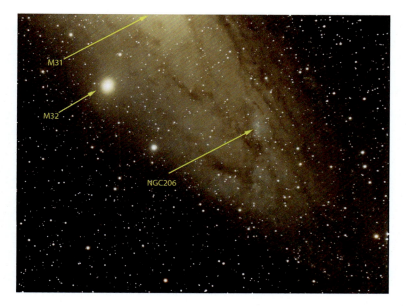

Image 14.4 This image shows the region of M31 below the core from the last image. M32, M31's closest satellite galaxy, is more clearly visible here. Almost all of the stars in this image are in the Milky Way Galaxy along the line of sight to M31. One arrow points to NGC206, a bright star cloud in M31. This image was taken with a 71-mm f/4.9 Apo using a SBIG STF-8300C CCD camera. The exposure was 60 min

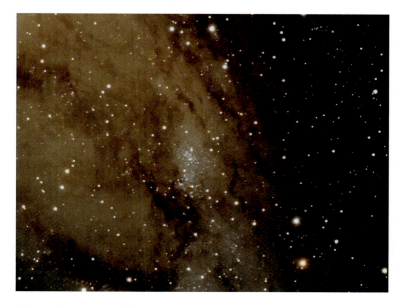

Image 14.5 A higher magnification view of the NGC206 star cloud in M31. The image was taken with a 10-inch f/6 Newtonian using a Paracorr II coma corrector and a SBIG ST-2000XCM CCD camera. The exposure was 180 min

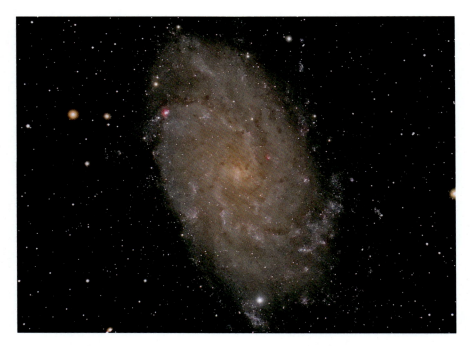

Image 14.6 Galaxy M33, the Triangulum Galaxy, is not much farther away than M31. These two galaxies and the Milky Way compose the three major galaxies in a small galaxy collection called the Local Group. There are at least 80 smaller galaxies in the Local Group. M33 may be gravitational bound to the larger M31. The Milky Way galaxy is intermediate in size between those two. This image was taken with a 132-mm f/7 Apo with a 0.8× focal reducer/field flattener. The exposure was 3 h using a SBIG ST-2000XCM CCD camera. Note the bright red emission nebulae in the spiral arms

Once Edwin Hubble determined that the universe contained an uncountable number of galaxies, he devised a classification system for the galaxies. The highest level of the system broke galaxies into three types based on their shape: *spiral* (S), *elliptical* (E), and *irregular* (Irr). The Andromeda Galaxy, the Milky Way, and the Triangulum Galaxy are all spiral galaxies.

When large accumulations of gas and dust contracted to form massive galaxies, angular momentum had to be conserved as the contraction progressed. This caused the gas and dust to rotate increasingly faster. This type of rotation tends to flatten a galaxy into a disk. Thus, spiral galaxies are relatively flat rotating disks. The spiral arms tend to show this rotation. The arms represent regions of star formation, whereas the regions between the arms tend to have smaller stellar populations. The arms are curved because the regions closer to the galactic core rotate faster.

In a normal spiral galaxy, the spiral arms originate at the central bulge. Not all spiral galaxies look the same. Some have more spiral arms than others. Some are more tightly wound than others. Finally, the relative size of the central bulge compared with the galactic diameter varies significantly.

Hubble classified spiral galaxies based on the size of the galactic bulges using the letters a, b, and c after the S. These were Sa, Sb, and Sc. Sa spiral galaxies have the largest central bulges. Sc spirals have the smallest central bulges, while Sb spirals are intermediate.

More modern classification schemes divide spirals into four classes, based on the size of the central bulges. These are Sa, Sb, Sc, and Sd. If a galaxy is on the border of two sizes, it may be written as Sab, Sbc, or Scd. A spiral galaxy could have a disk, but no discernable spiral arms. These galaxies are classified as S0 and are also called *lenticular* galaxies. These various types of galaxies are displayed in Images 14.7, 14.8, 14.9, 14.10, 14.11, 14.12, 14.13, 14.14, 14.15, 14.16, 14.17, 14.18, 14.19, and 14.20.

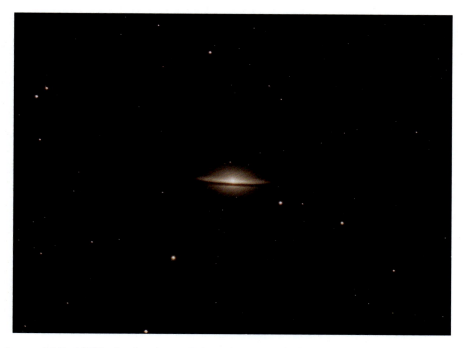

Image 14.7 M104, the Sombrero Galaxy, is a magnitude 8.2 Sa galaxy seen edge on. As seen in the image, the galactic bulge spans more than half the galaxy's diameter. The galaxy has a very prominent dust lane splitting the galactic plane. M104 is located in Virgo. The image was captured with an 8-inch f/8 Ritchey–Chrétien Cassegrain with a Televue 0.8× focal reducer/field flattener yielding f/6.4 using a SBIG ST-2000XCM CCD camera. The exposure was 160 min

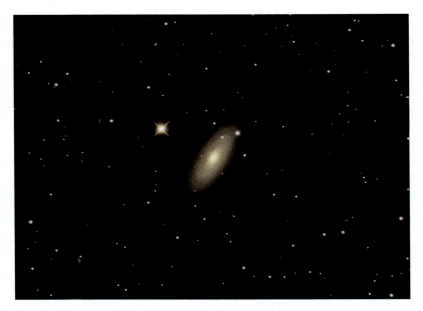

Image 14.8 NGC2841 is a magnitude 9.2 Sa galaxy in Ursa Major. The image was taken with the same equipment as the previous image with a 130-min exposure

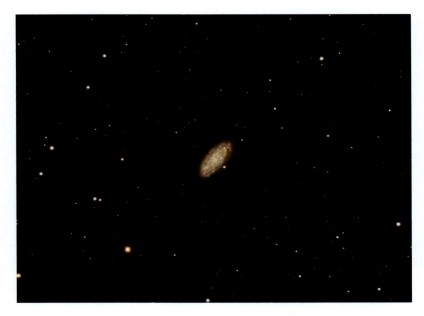

Image 14.9 NGC2976, also in Ursa Major, is a magnitude 10.1 Sa galaxy. The image was taken with the same equipment as the previous image with a 180-min exposure

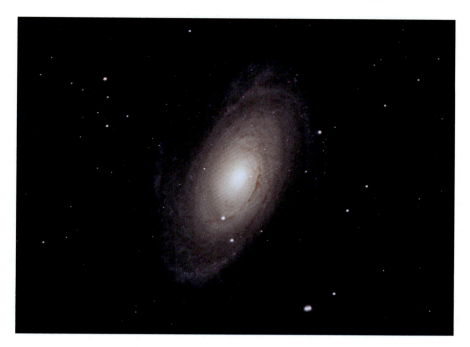

Image 14.10 M81 is a magnitude 6.8 Sab galaxy in Ursa Major. This image was taken with a 10-inch f/6 Newtonian with a Televue Paracorr Type 2 coma corrector using a SBIG ST-2000XCM CCD camera. The exposure was 240 min

Earlier in the chapter, it was stated that the galactic bulge and halo appear redder than the disk because they contain older stars. Stars of spectral classes O and B (see Chap. 5), which are blue in color, are only found in the galactic disk. These short-lived stars are exceedingly bright. Although red dwarf stars are more abundant in the disk, overall the O and B stars emit more light, thus making the galactic disk appear bluer in color. This is readily apparent in the picture of galaxy M81 (Image 14.10).

Astronomers classify the younger stars in the Milky Way's galactic disk as *Population I* stars. The older stars in our galactic halo and bulge are called *Population II* stars. Population I stars are metal-rich. This means that they contain roughly 2–3% elements heavier than hydrogen and helium. Extreme Population I stars have the highest concentration of metals and reside in the spiral arms. Intermediate Population I stars, like our Sun, are found in the disk between the spiral arms. Population I stars are only a few billion years old (4.6 billion years in the case of the Sun).

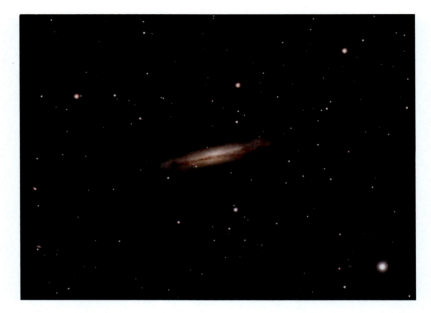

Image 14.11 NGC3628 is sometimes called the Hamburger Galaxy. This magnitude 9.2, edge-on Sb galaxy is located in Leo. The image was taken with a 190 mm f/5.3 Maksutov-Newtonian using a SBIG ST-2000XCM CCD camera. The exposure was 240 min

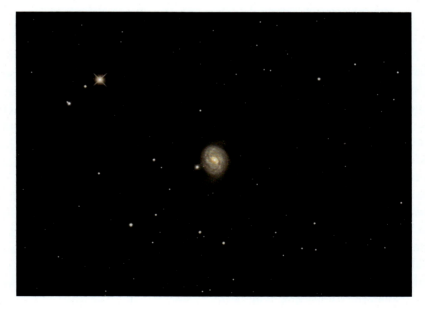

Image 14.12 M77 is a face-on Sb galaxy in the constellation Cetus. It shines at magnitude 9.0. The image was captured with the same equipment as Image 14.7 with a 160-min exposure

Population II stars are metal poor having less than 0.1 percent metals. These stars are between 2 and 13.7 billion years old. Extreme Population II stars are the most metal poor and are found in the galactic halo and globular clusters. The intermediate Population II stars are found in the galactic bulge.

The difference in ages between Population I and Population II stars suggested that Population II stars formed earlier during the formation of the galaxy. At this time, the galaxy would have been made up mostly of the elements hydrogen and helium, the only building blocks of the first generation of stars. Astronomers call elements heavier than hydrogen and helium metals. Metals are formed by nuclear fusion in the cores of stars and are dispersed throughout the galaxy by supernovae explosions of massive stars. These metals are incorporated into subsequent generations of stars.

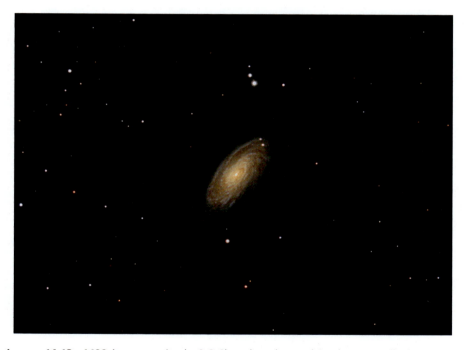

Image 14.13 M88 is a magnitude 9.6 Sb galaxy located in the constellation Coma Berenices. This image was taken with a 10-inch f/6 Newtonian with a Televue Paracorr Type 2 coma corrector using a SBIG ST-2000XCM CCD camera. The exposure was 140 min

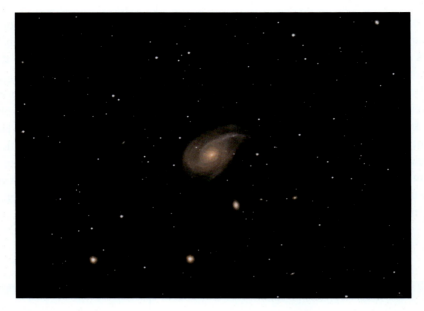

Image 14.14 NGC772 is a magnitude 10 Sb galaxy in Aries. The galaxy's distorted shape may be due to its satellite galaxy NGC770 (below and to the right of it). Taken with the same equipment as Image 14.13 with a 180-min exposure

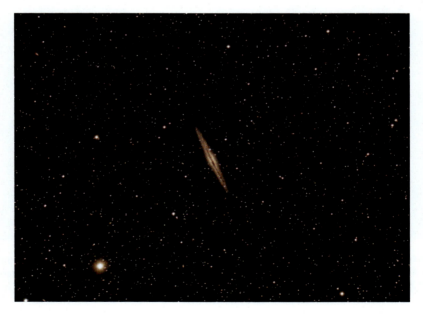

Image 14.15 NGC891 is a magnitude 10 Sb galaxy in Andromeda. This image was taken with a 132-mm f/6.5 Apo with a 0.8× focal reducer/field flattener and a SBIG ST-2000XCM CCD camera. The exposure was 120 min

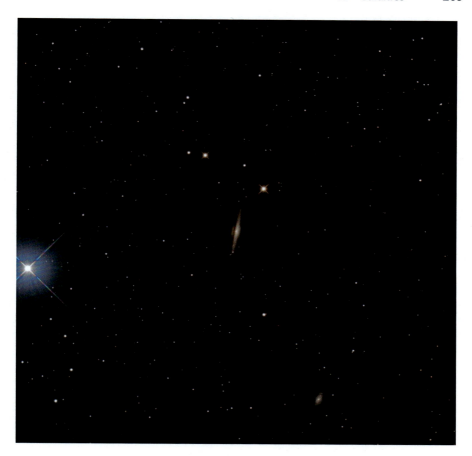

Image 14.16 NGC5746 is an edge-on Sb spiral galaxy similar to NGC891 shown in the above image. The galaxy resides in the constellation Virgo and has a magnitude of 11.9. NGC5746 is 2.7 arcminutes long and 1.4 arcminutes wide. NGC 891 is 13.0 arcminutes long and 2.8 arcminutes wide. NGC 891 appears larger to us because it is only 27 Mly away compared to 99 Mly for NGC5746. These two galaxies, like M104 and NGC3628 above, exhibit very prominent dust lanes. The smaller galaxy near the bottom right of the image is NGC 5740, a magnitude 11.9 spiral galaxy. 109 Virginis is a bright star on the left side of the image. It has a magnitude of 3.7. The exposure was 120 min

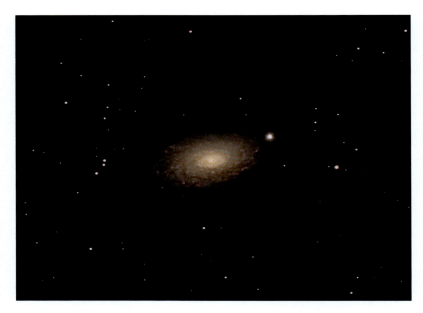

Image 14.17 M63 is an Sc spiral galaxy in Canes Venatici. The galaxy has a magnitude of 8.6. This image was taken with a 10-inch f/6 Newtonian with a Televue Paracorr Type 2 coma corrector using a SBIG ST-2000XCM CCD camera. The exposure was 280 min

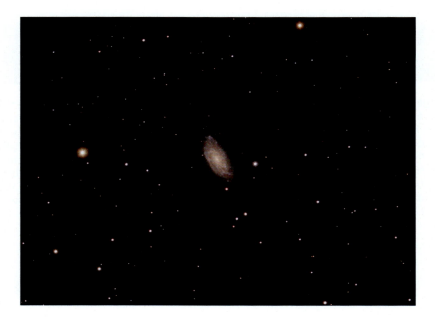

Image 14.18 Like M63, NGC6015 is a tightly wound Sc spiral. NGC6015 has a magnitude of 11. The image was taken with the same equipment as above with a 160-min exposure. NGC6015 is 44 Mly away compared to 29 Mly away for M63

14 Galaxies

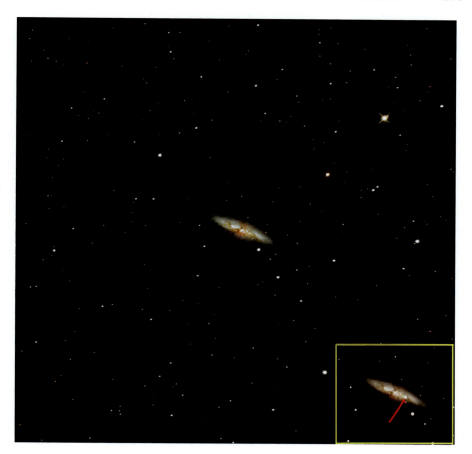

Image 14.19 M82 is an Sd spiral galaxy. This class of spirals has a smaller core and galactic bulge for the size of the galaxy. The image was captured with an 8-inch f/8 Ritchey–Chrétien Cassegrain with a Televue 0.8× focal reducer/field flattener yielding f/6.4 using a SBIG ST-4000XCM CCD camera. The exposure was 180 min. The author photographed a supernova in M82 on January 30, 2014, as shown in the insert in the lower right-hand corner. The red arrow points to the exploding star, which outshone the galactic core

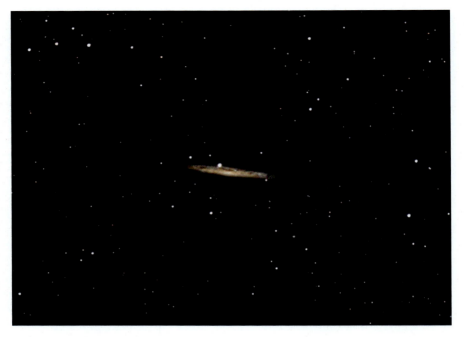

Image 14.20 NGC4517 is an Sc galaxy seen nearly edge on. The southern side of the galaxy is slightly open to our vantage point, revealing the galactic core and some of the galactic bulge. This image was captured with a 190-mm f/5.3 Maksutov-Newtonian using an SBIT ST-2000XCM CCD camera. The exposure was 120 min. The galaxy has a magnitude of 10.9. The brightest star in the image, just above and to the left of the galactic core is a magnitude 10.9 foreground star

All of the galaxies in Images 14.1 to 14.20, except for the Milky Way, are normal spiral galaxies. Another type of spiral galaxy is the barred spiral galaxy (Images 14.21, 14.22, 14.23, 14.24, 14.25, 14.26, 14.27, and 14.28). Normal may not be the correct term for unbarred spiral galaxies as up to 65% of all spiral galaxies have a bar running through their cores.

The central bar is not solid but is composed of stars that tend to rotate in such a way that the appearance of a bar is maintained. In unbarred spiral galaxies, the spiral arms originate at the cores. In barred spiral galaxies, the spiral arms originate from both ends of the bar.

Edwin Hubble gave barred spiral galaxies the classification SB. The two uppercase letters are followed a lowercase a, b, or c. An SBa spiral galaxy has tightly wound spiral arms, whereas an SBc galaxy has loosely wound spiral arms. SBb galaxies are intermediate between SBa and SBc. Similar to unbarred spiral galaxies, modern classification schemes break barred spirals into four classes, SBa, SBb, SBc and SBd. In addition, SBab, SBbc, and SBcd are used to provide more resolution in barred spiral distinctions.

14 Galaxies 273

Image 14.21 M95 (right) and M96 are paired close to each other in the constellation Leo. M95 is a SBb galaxy while M96 is a SABab galaxy. They were captured with a William Optics GTF102 102-mm f/6.9 apochromatic refractor using a SBIG ST-2000XCM CCD camera. The exposure was 110 min

Image 14.22 M65 (left) and M66 are another galaxy pair in Leo. M65 is a SABa galaxy while M66 is a SABb galaxy. They were captured with a 132-mm f/7 apo with a Televue 0.8× focal reducer/field flattener to yield f/5.6 using a SBIG ST-2000XCM CCD camera. The exposure was 120 min

Image 14.23 NGC1055 is a magnitude 10.6 SBb spiral galaxy in Cetus. The image was taken with a 10-inch f/6 Newtonian with a Televue Paracorr Type 2 coma corrector with a SBIG ST-2000XCM CCD camera. The exposure was 210 min. The long axis of the galaxy is 6.9 arcminutes

Image 14.24 Another SBb galaxy is magnitude 9.2 NGC4565 in Coma Berenices. This image was captured with an 8-inch f/8 Ritchey–Chrétien with a 0.8x focal reducer/field flattener. The 210-min exposure was made with a SBIG ST-2000XCM CCD camera. The long axis of the galaxy is 16.6 arcminutes

The galaxies in Images 14.23, 14.24, and 14.25 are all viewed edge on. One might be confused about how a bar is detected in edge-on galaxies. Astronomers can determine whether an edge-on galaxy has a bar by examining the rotational characteristics of the galaxy and asymmetries in the brightness from one side to another, which can indicate the presence of the edge of a bar. Although we see these galaxies in visible light, studies are conducted at all wavelengths, revealing much more information than what we can discern using only visible light.

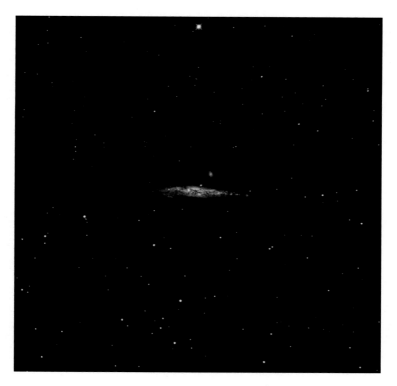

Image 14.25 NGC4631 is sometimes called the Whale Galaxy. This is an SBcd galaxy in Canes Venatici. The galaxy has a magnitude of 8.4 and is 15.0 × 3.3 arcminutes in size. Above the Whale is the Pup, NGC4627, a magnitude 12.3 companion galaxy. They were captured with an 8-inch f/8 Ritchey–Chrétien with a 0.8× focal reducer/field flattener. The 120-min exposure was made with a SBIG ST-2000XCM CCD camera

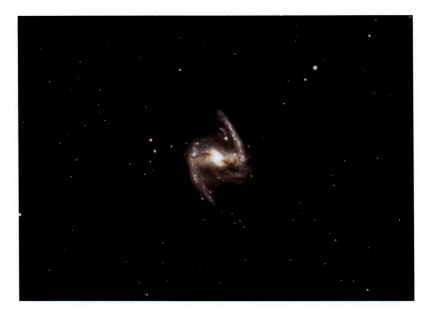

Image 14.26 NGC1365 is a magnitude 10 SBb spiral in the southern constellation Fornax. The image was taken with a 10-inch f/6 Newtonian with a Televue Paracorr Type 2 coma corrector and a SBIG ST-2000XCM CCD camera. The exposure was 240 min

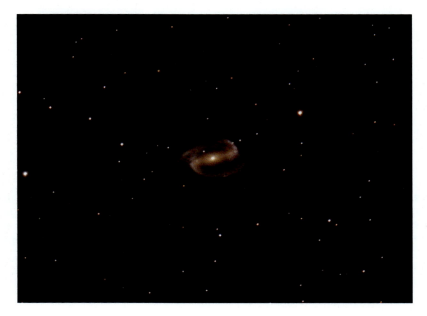

Image 14.27 NGC1300 is a magnitude 10.4 SBbc spiral in Eridanus. This galaxy was captured with the same equipment and exposure as the previous image

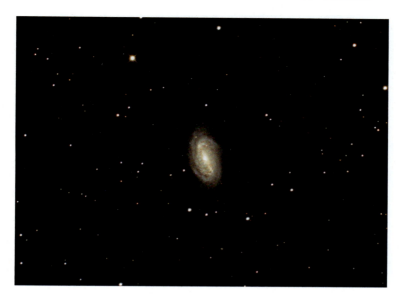

Image 14.28 NGC2903 is a magnitude 8.85 SBbc galaxy in Leo. The galaxy measures 11.8 × 5.1 arcminutes. The 120-min exposure was made with a SBIG ST-2000XCM CCD camera attached to an 8-inch f/8 Ritchey–Chrétien with 0.8× focal reducer/field flattener

It is unclear how bars are formed in spiral galaxies and whether they are permanent or temporary structures. In the vicinity of our home galaxy, there are more barred spiral galaxies than unbarred spiral galaxies. In fact, our Milky Way galaxy is an SBb (or SBbc) barred spiral galaxy. As we look at very distant galaxies, looking back in time 10 billion years (remember the further away a galaxy is, the longer it takes the light to reach us), only 20–25% of the spiral galaxies have bars. This indicates that galaxies may take a couple of billion years to form bars. Therefore, unbarred spiral galaxies may turn into barred spiral galaxies. The process of how this happens is not yet known.

In the year 1959, the French astronomer Gerard de Vaucouleurs (1918–1995) expanded the Hubble classifications for spiral galaxies. Unbarred spirals were given the designation SA, instead of just S, with the usual lower-case letters a, b, c, and d as explained above. Barred spiral galaxies remained designated as SBa, SBb, SBc, and SBd, respectively. De Vaucouleurs added an intermediate classification for galaxies that were between unbarred and barred (Images 14.29, 14.30, 14.31, 14.32, 14.33, 14.34, 14.35, 14.36, and 14.37). These galaxies were classified as SAB. He also classified lenticular galaxies, which are spiral disk galaxies that do not have spiral arms, as SA0, SB0, or S0. SA0 is used for unbarred lenticular galaxies, SB0 is used for barred-lenticular galaxies, and S0 is used for those where no bar determination can be made.

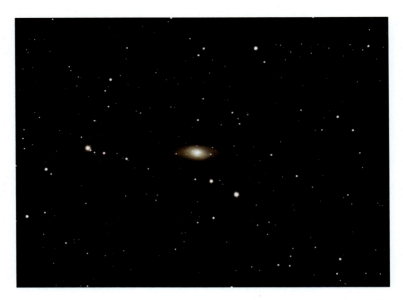

Image 14.29 NGC1023 is a lenticular galaxy with the SB0 classification. This magnitude 8.6 galaxy is in Perseus. The image was taken with a 10-inch f/6 Newtonian with a Televue Paracorr Type 2 coma corrector with a SBIG ST-2000XCM CCD camera. The exposure was 60 min

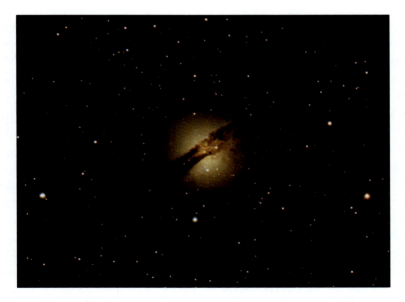

Image 14.30 NGC5128, also called Centaurus A, is sometimes classified as a peculiar S0 galaxy. The dark dust lane may mean that it collided with a spiral galaxy. The galaxy was captured with the same equipment as the previous image with a 180-min exposure

14 Galaxies 279

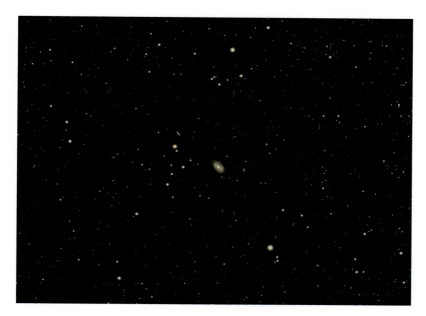

Image 14.31 NGC4725 is a magnitude 9.2 SABa galaxy in Coma Berenices. The image was taken with a Stellarvue SV70T 70-mm f/6 refractor with a SBIG STF-8300C CCD camera using an 80-min exposure

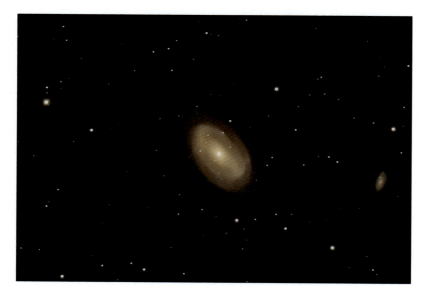

Image 14.32 An zoomed in view of NGC4725 and its companion galaxy NGC4712 (SAbc) taken with an 8-inch f/8 Ritchey–Chrétien each with a 0.8× focal reducer/field flattener and a SBIG ST-2000XCM CCD camera with a 240-min exposure

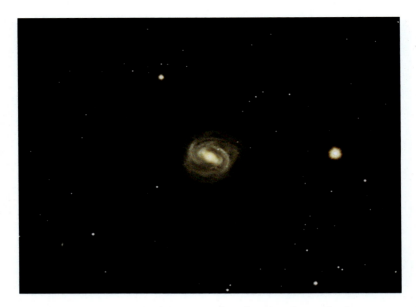

Image 14.33 M58 is a magnitude 10.5 SABb galaxy in Virgo. The image was taken with a 10-inch f/6 Newtonian with a Televue Paracorr Type 2 coma corrector with a SBIG ST-2000XCM CCD camera. The exposure was 180 min. The galaxy measures 5.9 × 4.7 arcminutes

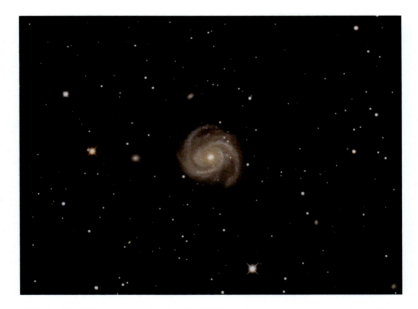

Image 14.34 M100 is a magnitude 9.3 SABb galaxy in coma Berenices. It measures 6.0 × 5.5 arcminutes. The image was taken with an 8-inch f/8 Ritchey–Chrétien each with a 0.8x focal reducer/field flattener and a SBIG ST-2000XCM CCD camera. The exposure was 240 min

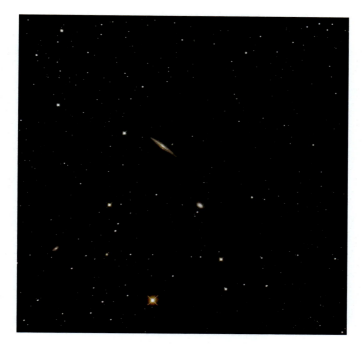

Image 14.35 The nearly edge-on SABb galaxy is NGC5965. The magnitude 11.9 galaxy is in the constellation Draco and measures 6.2 × 0.84 arcminutes in size. The image was taken with an 8-inch f/8 Ritchey–Chrétien with a 0.8× focal reducer/field flattener and a SBIG ST-4000XCM CCD camera. The exposure was 80 min

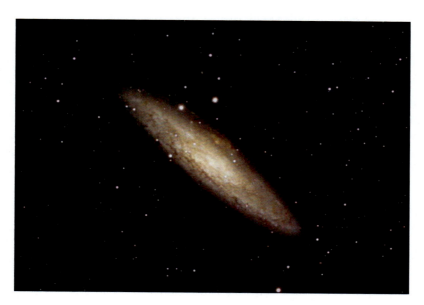

Image 14.36 NGC253 in Sculptor is sometimes called the Sculptor Galaxy. The SABc galaxy has a magnitude of 7.1 and a whopping size of 26.9 × 4.6 arcminutes. This 60-min exposure was taken with a 190 mm f/5.3. Maksutov-Newtonian with a SBIG ST-2000XCM CCD camera

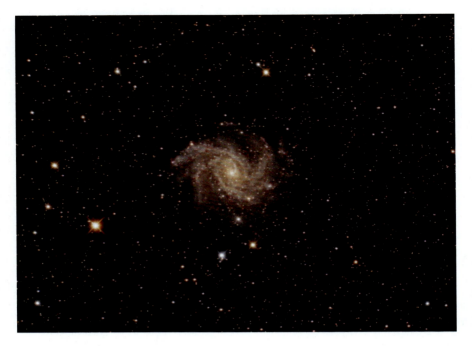

Image 14.37 Another SABc galaxy is NGC6646 in Cygnus. This magnitude 9.0 spiral is also called the Firework Galaxy due to the number of supernovae spotted in it. The image was taken with an 8-inch f/8 Ritchey–Chrétien with a 0.8× focal reducer/field flattener and a SBIG ST-2000XCM CCD camera. The exposure was 220 min

Elliptical galaxies have the apparent shape of ellipses. While we only observe a two-dimensional view of elliptical galaxies, their shapes are truly three-dimensional ellipsoids. If an elliptical galaxy was observed in the orientation shown in Fig. 14.1, it would appear very elongated. The same elliptical galaxy observed from the right or left side might appear more spherical. Therefore, how elongated an elliptical galaxy appears to us depends on how it presents itself to our line of sight.

Fig. 14.1 An ellipse with a major axis (**a**) and a minor axis (**b**). When both axes of an ellipse have the same length, the ellipse becomes a circle

Using the Hubble classification, elliptical galaxies are classified by how elongated they appear from our vantage point. They are denoted by the letter E followed by a number 0–7. An E0 galaxy appears spherical. An E7 galaxy has the greatest elongation. Hubble used the formula:

$$E = 10 \times \left[1-(a/b)\right]$$

to determine the number following the E. The calculation was rounded to the nearest whole number. For instance, if the ellipsoid has a major axis twice the length of the minor axis, a/b = 0.5. The formula yields 10 × 0.5 = 5. So, any galaxy with an apparent major axis twice the length of the minor axis is designated an E5 galaxy.

Several elliptical galaxies have already been featured in this chapter. Galaxy M110 in Image 14.3 is an E5 galaxy. M32 in Images 14.3 and 14.4 is an E2 galaxy.

Image 14.38 Two elliptical galaxies appear in this image. Near the center is M86, a magnitude 8.9 galaxy, 8.9 × 5.8 arcminutes in size. The galaxy was originally classified as E3. Some astronomers think it may not be an elliptical galaxy, but rather an S0 lenticular galaxy. Near the right edge is M84. M84 is either an E1 or a S0 galaxy. M84 shines at magnitude 9.1. This image was taken with a William Optics 132-mm f/7 apo with a Televue 0.8× focal reducer/field flattener to yield f/5.6 using a SBIG ST-2000XCM CCD camera. The exposure was 60 min

Image 14.39 M87 is a supergiant E0 galaxy in Virgo. The galaxy may have several trillion stars. It may be the largest galaxy in the Virgo Supercluster of galaxies, which contains the Local Group along with the Milky Way. The galaxy shines at magnitude 8.6. It is located 54 Mly away. The two faint dots lined up at the edge of the galaxy in the 5 o'clock position are knots in a jet of material coming from the galaxy caused by the supermassive black hole at its core. This image was captured with the same equipment as the previous image with a 60-min exposure

NGC770, the small galaxy below NGC772 in Image 14.14, is an E3 galaxy. NGC4627, the Pup companion to the Whale Galaxy in Image 14.25, is an E4 galaxy. Finally, NGC5128, in Image 14.30, is sometimes classified as an E0 galaxy. Other elliptical galaxies are shown in Images 14.38, 14.39, and 14.40.

Elliptical galaxies do not have spiral arms and in most cases are not flattened into a disk. The largest are giant elliptical galaxies that can extend a million light years across and have up to ten trillion stars. Similarly, the smallest galaxies known are dwarf elliptical galaxies, which can be up to 10% the size of the Milky Way Galaxy. Many appear as super-sized, dense globular clusters. Dwarf elliptical galaxies outnumber giant elliptical galaxies by a factor of ten. However, there are more stars in all the giant elliptical galaxies than in all of the dwarf elliptical galaxies. Astronomers estimate that 60% of all galaxies are elliptical.

Elliptical galaxies are much older than spiral galaxies. They contain little gas or dust. Thus, they typically have no stellar nurseries. They are devoid of massive O and B stars. They contain mostly red dwarfs. Therefore, these galaxies appear redder than spiral galaxies.

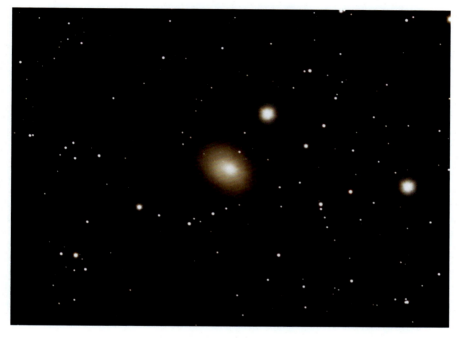

Image 14.40 The galaxy NGC3077 may be a satellite galaxy of the larger M81. It is an elliptical galaxy that has been distorted and has picked up large amounts of dust from interactions with M81 and/or other galaxies in that group. The image was taken with a 10-inch f/6 Newtonian with a Televue Paracorr Type 2 coma corrector with a SBIG ST-2000XCM CCD camera. The exposure was 100 min

The final classification of galaxies from Edwin Hubble's original scheme is irregular galaxies (Images 14.41 and 14.42). Irregular galaxies lack any structure. Some are flat and rotate, but they do not have enough mass to form into spiral galaxies. Most irregular galaxies are very small in size and therefore are called dwarf galaxies. In general, they tend to be more massive than dwarf elliptical galaxies. However, they are not as compact as dwarf ellipticals. Therefore, they have lower surface brightness.

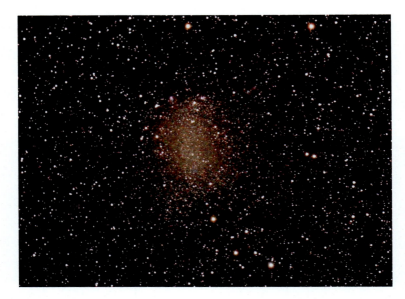

Image 14.41 NGC6822, sometimes called Barnard's Galaxy, is an irregular galaxy in the constellation Sagittarius that is a member of the Local Group. The galaxy shines at magnitude 9.3. Due to its large size, 15.5 × 13.5 arcminutes, the light is spread out over a large area making the galaxy very difficult to see. The galaxy spans approximately 7000 light years. With averted vision, you might notice a bar running north-south (vertical) in the galaxy. It is somewhat apparent in the above image. Bernard's Galaxy is classified as a barred irregular galaxy (IrrB). This image was taken with a 190-mm f/5.3 Maksutov-Newtonian telescope with a SBIG ST-2000XCM CCD camera. The exposure was 170 min

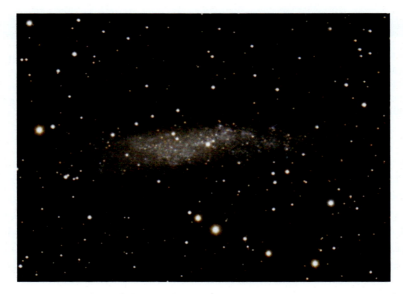

Image 14.42 A member of the Local Group, NGC3109 appears to be an irregular galaxy. It is found in the constellation Hydra and has an integrated magnitude of 11.4. The galaxy is 4.34 Mly away. The galaxy measures 19.3 × 3.7 arcminutes in size. It took 440 min to capture this image using a 10-inch f/6 Newtonian with a Televue Paracorr Type 2 coma corrector and a SBIG ST-2000XCM CCD camera

Although galaxies are fairly isolated in space, most tend to exist in gravitationally bound groups. We have already discussed the Local Group, which consists of three large spiral galaxies—the Milky Way, M31, and M33—along with scores of smaller galaxies. Image 14.21 shows M95 and M96. This group contains at least eight galaxies including M105, NGC3373, and NGC 3385. Likewise, Image 14.22 shows M65 and M66, which are in a galaxy group with NGC3628 (Image 14.11).

The gravitational dynamics of galaxies that form a group are complex. Sometimes, two or more galaxies in a group have close encounters (Images 14.43, 14.44, 14.45, 14.46, and 14.47) and may even merge to form a larger galaxy. The Milky Way and M31 are on a collision course and will encounter each other sometime in the next 4–6 billion years. Some models predict that M33 may merge with the Milky Way before this collision, or that it may merge with M31 before it collides with the Milky Way. Other models predict a complete M31-Milky Way merger followed by M33 joining the party.

Due to the vast amount of space between stars in a galaxy, when two galaxies do collide, there are very few actual collisions between stars, if any. The combined masses of the galaxies, including stars, gas, and dust, become gravitationally bound to each other. Astronomers believe that the merge of two spiral galaxies may create large elliptical galaxies.

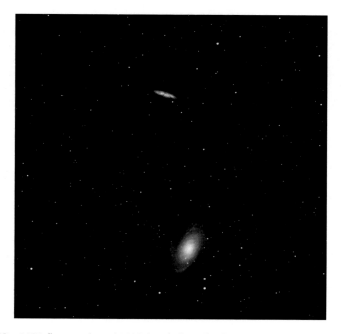

Image 14.43 M81 (bottom) and M82 (top) described in previous images are grouped together in one image. They were acquired with a William Optics 132-mm f/7 apochromatic refractor with a 0.8x focal reducer/field flattener to yield f/5.6 using a SBIG ST-4000XCM CCD camera. The exposure was 120 min

The closest galaxy group to the Local Group is the M81 group (Image 14.43). This group includes M81, M82, and NGC3077, found in Images 14.10, 14.19, 14.40 and 14.43. The group has more than 30 additional members and is centered approximately 12 Mly away in the constellation Ursa Major.

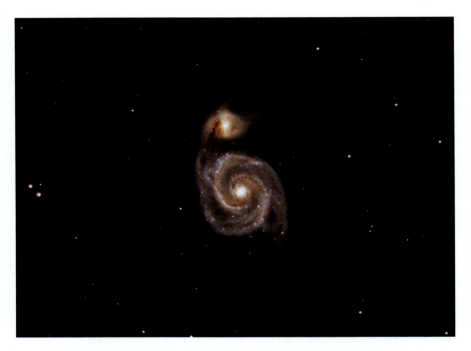

Image 14.44 Spiral galaxy M51 and its companion NGC5195 are a pair of interacting galaxies in Canes Venatici. These two galaxies are 28 Mly away. There are at least five additional galaxies in the M51 group. This image was taken with an 8-inch f/8 Ritchey–Chrétien Cassegrain with a 0.8× focal reducer/field flattener yielding f/6.4 using a SBIG ST-2000XCM CCD camera. The exposure was 240 min

Image 14.45 Elliptical galaxy NGC3226 is interacting with spiral galaxy NGC3227. The galaxies have magnitudes 11.4 and 10.7, respectively. They are located in the constellation Leo. They were captured with a William Optics 132 mm f/7 apochromatic refractor with a 0.8× focal reducer/field flattener to yield f/5.6 using a SBIG ST-2000XCM CCD camera. The exposure was 120 min

Image 14.46 Spiral galaxies NGC3395 (right) and 3396 (left) each show considerable distortion due to their gravitational interactions with each other. These two 12th magnitude galaxies are in Leo Minor. The image was taken with a Discovery 10-inch f/6 Newtonian with a Televue Paracorr Type 2 coma corrector and a SBIG ST-2000XCM CCD camera. The exposure was 150 min

Image 14.47 NGC1 and NGC2 are the first two entries in the New General Catalog (see Chap. 3). They are magnitude 12.8 and 14.1, respectively. A brighter galaxy NGC16 and a fainter galaxy NGC22 are in the same field of view. None of these galaxies are at the same distance. Taken with the same equipment as Image 14.47 but with a 200-min exposure

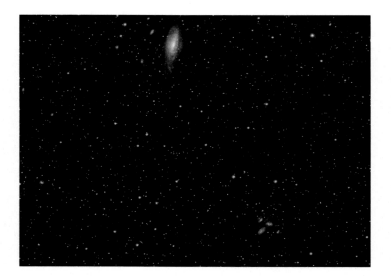

Image 14.48 Near the top of this image is the Deerlick Galaxy Group. The largest member is NGC7331, sometimes called the Deerlick Galaxy. Near the bottom right is a group of faint galaxies known as Stephan's Quintet. All of these galaxies are found in Pegasus. A 14-inch telescope with transparent dark skies is required to see Stephan's Quintet and the fainter galaxies in the Deerlick Group. Under ideal conditions, NGC7331 can be seen with a 4-inch telescope. The galaxy is magnitude 9.3 and measures 9.3 × 3.8 arcminutes in size. The galaxies were captured with a William Optics 132-mm f/7 apochromatic refractor with a 0.8× focal reducer/field flattener to yield f/5.6 using a SBIG ST-2000XCM CCD camera. The exposure was 110 min

The first compact group of galaxies to be discovered was Stephan's Quintet. The group was discovered by the French astronomer Édouard Stephan (1837–1923) in 1877. The five galaxies in the group (Images 14.48 and 14.49) are NGC7317, NGC7318A, NGC7318B, NGC7319, and NGC7320. All but NGC7320 are true members of the group. NGC7320 is a foreground galaxy. There is galaxy off to the east of the Quintet, NGC7320C, which is actually the same distance as the four true members of the compact group. Therefore, this galaxy group does have a quintet of members.

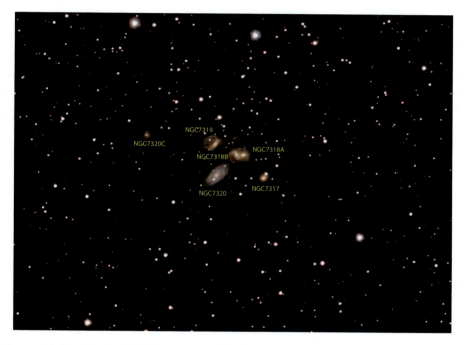

Image 14.49 Stephan's Quintet captured with a 10-inch f/6 Newtonian with a Televue Paracorr Type 2 coma corrector using a SBIG ST-2000XCM CCD camera. The exposure was 230 min

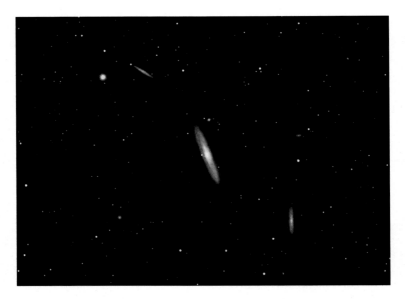

Image 14.50 Three edge-on spiral galaxies are the brightest in a group lying 45–65 Mly away. They are (L-R) NGC4222, NGC4216, and NGC4206. The image was taken with a 190-mm f/5.3 Maksutov-Newtonian using a SBIG ST-2000XCM CCD camera. The exposure was 120 min

Galaxy groups usually contain 50 or fewer members (Images 14.50 and 14.51). Larger groupings of galaxies are called galaxy clusters (Images 14.52, 14.53, and 14.54). Galaxy cluster can contain from scores to thousands of galaxies. Larger galaxy clusters may have isolated galaxy groups within the cluster. Galaxy clusters are the largest gravitationally bound galaxy groupings that exist. Astronomers sometimes classify groups of 3–10 clusters as superclusters, to describe the largest scales of the universe.

Galaxies are fascinating to look at. To think each has millions to trillions of stars and probably countless planets and moons. They may be teeming with life. The vast space separating them from us means we will never know who may live there. Someday, we may have access to stars and planets near us, but even our home galaxy is too large to ever be explored in person from end to end. However, that will not stop us from looking, wondering, and enjoying the views.

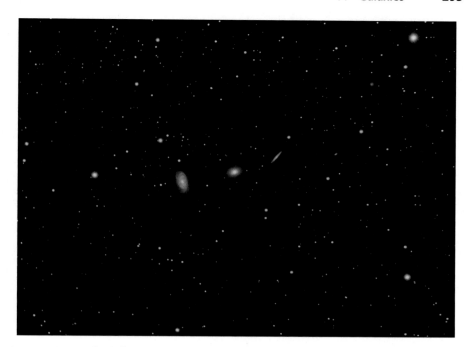

Image 14.51 The left galaxy is NGC5985 (Sb, magnitude 11.2) and the right galaxy is NGC5981 (SBbc, magnitude 12.9). These two galaxies are located in a small group 160–170 Mly away. Other members are too faint to be seen here. The elliptical galaxy between these two is NGC5982 (E3, magnitude 11.0), a foreground galaxy. These galaxies are located in the constellation Draco. The image was taken with a Stellarvue 102-mm apochromatic refractor at f/6.3 using a Televue 0.8x focal reducer/field flattener. The exposure was 120 min using a SBIG ST-2000XCM CCD camera

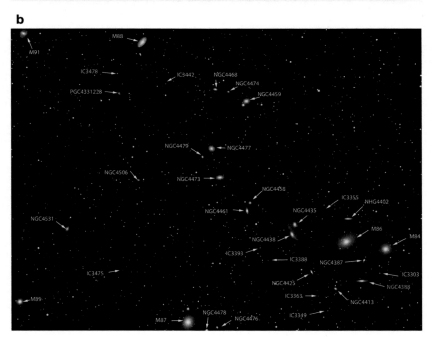

Image 14.52 (a) These galaxies are members of the Virgo Cluster spanning the constellations Coma Berenices and Virgo. The arcing chain of brighter galaxies from the lower right to the center of the image is known as Markarian's Chain after the Kartvelian astronomer Benjamin Egishevitch Markarian (1913–1985). Thirty-five galaxies are labeled in the lower image. (b) The galaxy cluster was captured with a William Optics 71-mm f/4.9 quadruplet refractor using a SBIG SFT-8300C CCD camera. The exposure was 100 min

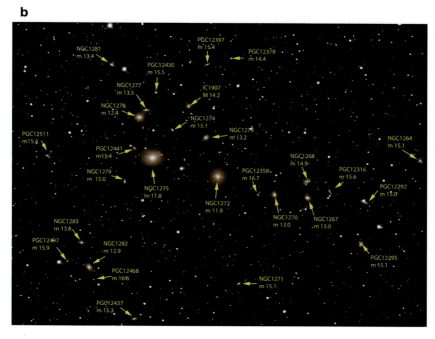

Image 14.53 (a) The Perseus Galaxy Cluster is centered on NGC1272. The brightest and largest galaxy in the image is Perseus A (NGC1275). Most of the fuzzy or elongated stars in this image are galaxies. The Perseus Cluster is more than 250 Mly away and contains thousands of galaxies. Twenty-eight of them are labeled in the lower image. (b) The cluster was captured with an 8-inch f/8 Ritchey–Chrétien Cassegrain with a Televue 0.8× focal reducer/field flattener yielding f/6.4. This 120-min exposure was made with a SBIG ST-2000XCM CCD camera

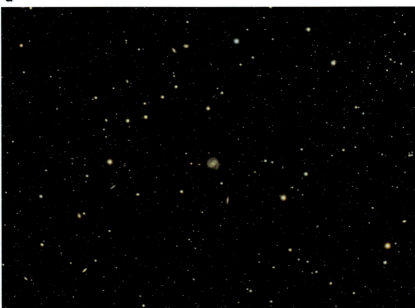

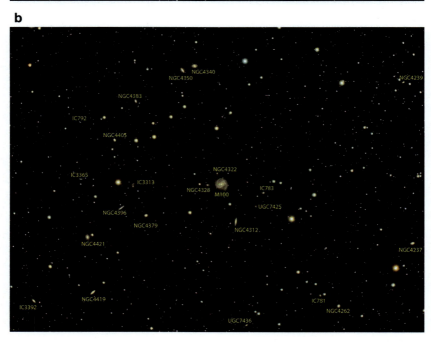

Image 14.54 (a) More galaxies in the Virgo Cluster. This field of view is in Coma Berenices north of the galaxy field in Image 14.54. The image is centered on galaxy M100 (see Image 14.34). (b) The cluster was captured with Stellarvue 70-mm f/6 apochromatic refractor with a 0.8× focal reducer/field flattener to yield f/4.8. This 210-min exposure was made with a SBIG ST-2000XCM CCD camera

Index

A

absolute magnitude, 100, 214
absorption spectrum, 89, 90, 171
achromat, 3, 4, 18, 19
Airy, 50
Andromeda Galaxy, 10, 33, 74, 75, 242, 247, 300
annular eclipse, 140, 142
antiumbra, 133, 134, 140
apochromat, 4
apparent magnitude, 100, 103, 108
ascending node, 134
astronomical seeing, 93
astrophotography, 19, 23–47
autoguide, 40

B

barred spiral, 304–306
binary star, 54, 55, 103–107, 155
blackbody, 87
brown dwarf, 212

C

California Nebula, 193
carbon fusion, 152, 157
Cassegrain, 4–8, 11, 12, 17, 20, 85, 121, 122, 158, 160, 162, 163, 201, 229, 252, 304, 316, 341, 350
CCD, 10, 12, 23, 36–39, 43–45, 47, 85, 115, 130, 138, 150–153, 155, 157–164, 166–170, 172–179, 183, 185–190, 192, 194–197, 201, 202, 206, 208, 210, 212–216, 219, 222, 223, 225, 227–229, 231, 235, 238–242, 248–253, 256–261, 263–267, 270–273, 275, 277, 281, 288, 295, 301–304, 307, 308, 310, 312, 314, 316–323, 325, 326, 328–335, 337–343, 345–351
celestial charts, 52, 53
celestial nomenclature, 49–82
celestial sphere, 14, 16, 51–53, 56, 59, 64, 73, 76, 89, 118, 223, 282, 297

© The Editor(s) (if applicable) and The Author(s), under exclusive license to Springer Nature Switzerland AG 2024
J. Dire, *Exploring the Universe*, The Patrick Moore Practical Astronomy Series,
https://doi.org/10.1007/978-3-031-65346-9

298 Index

Charles Messier, 56, 149, 166, 246
chromatic aberration, 2–4, 19
chromosphere, 125, 128, 131
CMOS, 23, 24, 36, 38
Cocoon Nebula, 201
color index, 93, 94
coma, 5, 6, 8, 9, 20, 21, 115, 151, 153,
 155, 166, 175, 183, 192, 194,
 202, 242, 251, 253, 257, 266,
 267, 271, 273, 277, 279, 280,
 288, 291, 295, 302, 307, 310,
 314, 320, 323, 326, 328, 330,
 337, 339, 343, 346, 349, 351
comet, 28, 56, 66, 246, 279–295
Comet Halley, 281, 283, 284
Comet Lovejoy, 281, 284
constellations, 49–82, 99, 150–155,
 158, 161, 163, 165, 169, 175,
 176, 186, 194, 199, 201, 206,
 210, 216, 220, 223–225, 229,
 231, 239, 241, 248–250, 252,
 256, 257, 260, 261, 266, 268,
 270, 271, 274, 275, 277, 278,
 281–283, 299, 309, 310, 313,
 318, 323, 332, 338, 339, 342,
 348, 349
continuous spectrum, 89, 90
convection zone, 125, 126
corona, 128, 131, 132, 141, 143,
 144, 147
Crab Nebula, 159, 160, 166
crater, 35, 78, 81, 112, 113,
 115–118, 122

D

Dall-Kirkham, 6, 8
dark nebula, 171–206, 211, 256
declination, 16–18, 40, 51, 52, 54, 58,
 61, 67, 71, 77, 95, 118
descending node, 135
diffraction, 11, 13, 19, 20, 84, 85
Doppler shift, 87, 88, 104, 128

Double Cluster, 231
double star, 14, 19–21, 59–61,
 103, 105
dust tail, 279, 280, 286, 293

E

Eagle Nebula, 186
eclipse, 104, 105, 132–147
eclipse season, 135, 136
eclipsing binary, 104
electromagnetic waves, 83–85
elliptical galaxy, 247, 306–310, 335,
 337, 342, 348
emission nebula, 171–174, 176–178,
 190, 192, 194, 195, 228, 303
emission spectrum, 89, 90, 162

F

first quarter Moon, 112, 113, 115
Flamsteed, 55, 58
full Moon, 10, 25, 111, 113, 120, 137,
 140, 206, 246

G

galactic bulge, 301–304, 316, 317
galactic cluster, 217, 298
galactic halo, 302, 303
galaxies, 10, 14, 19, 21, 43, 46, 47, 52,
 54, 56, 59, 62, 68, 72, 74, 75,
 103, 154, 155, 157, 159, 207,
 208, 215–217, 245, 247,
 249–252, 265, 297–351
galaxy cluster, 62, 303, 311, 349
galaxy group, 309–311
globular clusters, 52, 73, 245–252,
 257, 258, 261–264, 266, 268,
 271, 275, 278, 282, 286,
 303, 308
globular star clusters, 56, 74, 155, 156,
 181, 187, 207, 245–278

H

Hale-Bopp, 292–294
Halley's Comet, 280–286
Harlow Shapley, 248
Heart Nebula, 190, 191
Helen Sawyer, 248
helium fusion, 150, 152
Henry Draper, 55
Hertzsprung-Russell (HR) diagram, 68, 102, 212, 243
Hipparchus, 49, 50
Horsehead Nebula, 182
Hyakutake, 291
hydrogen fusion, 157, 210, 211

I

ion tail, 279, 280, 293
irregular galaxy, 309, 338, 339

K

Kirchhoff, 90
Kuiper Belt, 287, 288

L

Lagoon Nebula, 177, 179
light, 83
line of nodes, 135
lunar eclipse, 133–136, 138–140
lunar phases, 111, 114, 117

M

M13, 252, 262, 266
M15, 256
M22, 246, 258, 266
M53, 261, 262
M62, 250, 264, 265
Magellanic Clouds, 247, 251, 271, 299
main sequence, 102, 103, 211

maria, 115, 116
Milky Way, 51–53, 58–61, 67, 74, 123, 154, 174, 181, 187, 211, 217, 245–247, 249, 250, 257, 259, 261, 262, 264, 271, 276, 278, 282, 289, 297–305, 308–310, 336
molecular cloud, 85, 174, 175, 205, 207, 208, 213, 214
Moon, 10, 26, 83, 100, 111, 131, 133, 178, 223, 246, 279, 311
Moon phases, 111, 114, 117

N

nebula, 19, 21, 52, 54, 56, 58, 59, 74, 149–154, 156, 158–165, 167, 171–173, 177, 178, 186, 189, 193–195, 199, 201, 206, 207, 298, 299
NEOWISE, 31, 294, 295
neutron degeneracy, 158, 160
New General Catalog (NGC), 56–58, 62, 63, 68, 246, 251, 344
new Moon, 111–114, 135
Newtonian, 4–8, 11, 13, 15, 19–21, 115, 143, 151, 153, 155, 166, 175, 183, 192, 194, 202, 212, 215, 227, 242, 251, 253, 257, 266, 267, 271, 273, 277, 302, 307, 310, 314, 320, 323, 326, 330, 337, 339, 343, 346
North America Nebula, 100, 196, 198
nuclear fusion, 125, 150, 153, 155, 158, 210, 212, 248, 303

O

Omega Centauri, 247, 248, 286
Oort Cloud, 289
open cluster, 207, 226, 234
Orion Nebula, 172

300 Index

P

parsec, 98–100
partial eclipse, 134, 140, 141
Pelican Nebula, 197, 198
penumbra, 126, 127, 133, 134, 136, 138, 140
periodic comet, 284
photosphere, 123, 125–128, 130, 131, 152, 210
planetary nebulae, 14, 53, 74, 149–171
Pleaides, 52, 121
prime focus imaging, 129
Ptolemy's Cluster, 211
pulsar, 160

R

radiation zone, 125
red dwarf, 102, 103, 213, 302, 309
red giant, 103, 114, 152, 161
red supergiant, 153, 161, 210
reflection nebula, 171, 173–175, 178, 189, 195, 199, 200, 202–204, 219, 241
reflector, 1, 4, 6, 7, 9, 11, 21
refraction, 84
refractor, 1–4, 6, 7, 11, 16–21, 38, 42–44, 56, 84, 112, 113, 116–118, 120, 129, 130, 136, 138, 144, 146, 151, 157, 159, 161, 167–169, 172, 173, 177–179, 186, 187, 189, 190, 195–197, 206, 210, 216, 222, 223, 228, 231, 239, 241, 246, 250, 258, 259, 261, 264, 281, 288, 289, 295, 318, 328, 340, 342, 345, 348, 349, 351
right ascension, 16–18, 28, 31, 40, 51, 52, 54–56, 58, 61, 64, 67, 71, 77, 111, 113

Ritchey–Chrétien, 6, 7, 12, 34, 39, 85, 151, 152, 158, 160, 162, 163, 170, 174, 176, 201, 213, 229, 235, 238, 240, 248, 252, 259, 263, 265, 270, 272, 275, 304, 316, 321, 322, 325, 329, 331, 332, 334, 341, 350

S

Schmidt-Cassegrain, 8, 21, 121, 127, 131, 135, 141, 145
solar eclipse, 16, 29, 111, 118, 128, 131–135, 138, 140, 141, 143–146
solar filter, 34, 141, 143, 145
spectral class, 101, 103, 107, 212, 213, 248, 302
spectroscopy, 89, 90, 101, 154, 164
spiral arms, 208, 300–304, 306, 308
spiral galaxy, 300, 301, 304, 305, 313, 314, 316, 320, 327, 341, 342
star association, 207, 242
Star atlas, 49–82
Stefan-Boltzmann, 101, 209
stellar parallax, 98
Sun, 28, 32, 34, 50, 52, 54, 97, 98, 100, 102, 103, 108, 109, 111–114, 118, 123–135, 138, 140, 143, 150, 152, 153, 155–159, 162, 194, 209–213, 215–217, 247, 279–281, 283, 284, 287–289, 302, 303
sunspot, 126–129
sunspot cycle, 128
supernova, 159–162, 166, 167, 169, 171, 208, 213, 214, 218, 303, 316, 334
supernova remnant, 149–170
synodic period, 114, 136

Index 301

T

telescope, 1
third quarter Moon, 113
tidal lock, 114
Trifid Nebula, 178, 179

U

umbra, 126, 127, 133, 134, 136–140

V

volcanism, 116

W

white dwarf, 103, 153, 157, 158, 161, 165
Wild Duck Cluster, 212